Washington, D.C.

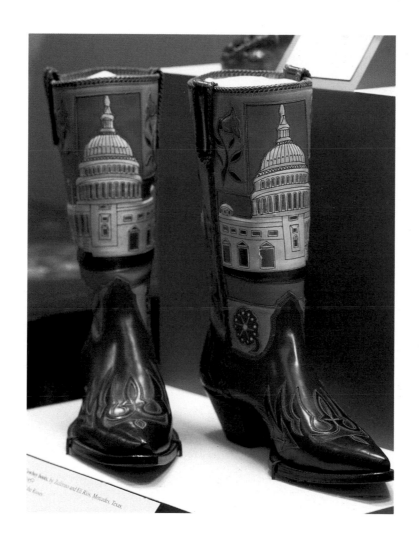

Cowboy boots, by Zulema and El Rios, Mercedes, Texas

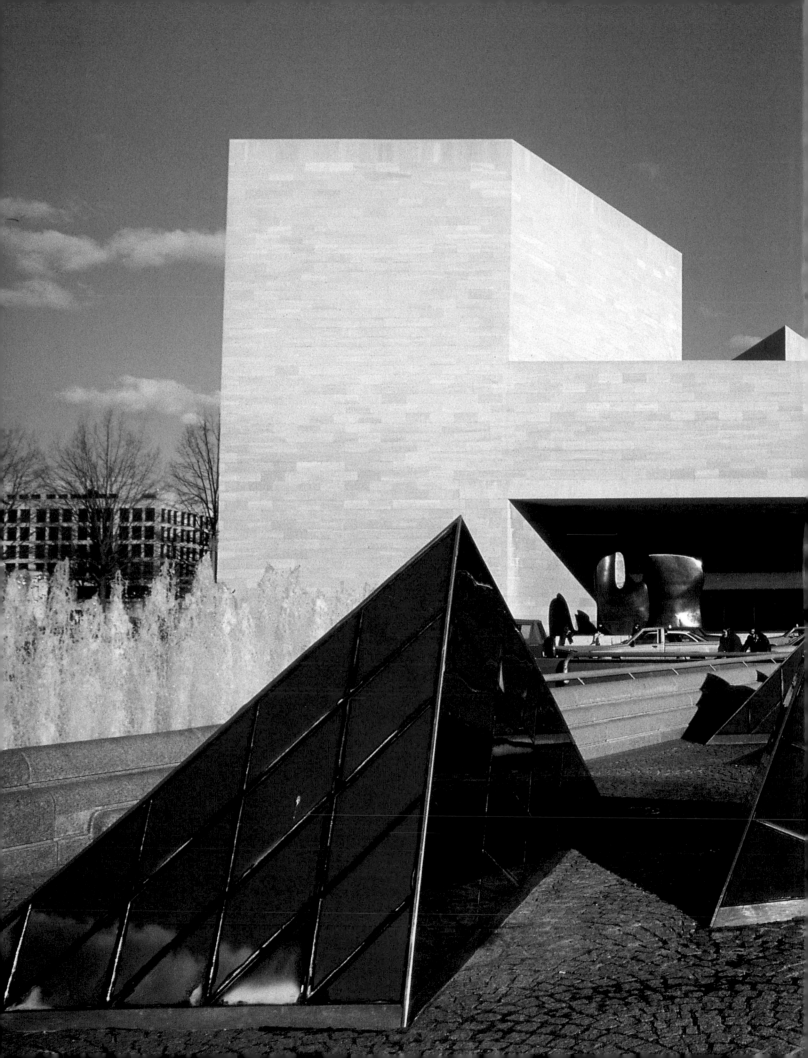

Washington, D.C.

PHOTOGRAPHS BY

Santi Visalli

FOREWORD BY

Diane Rehm

UNIVERSE

THIS PAGE: *Washington skyline over the Potomac*

PAGE I: *Custom cowboy boots made for President Eisenhower*

PRECEEDING OVERLEAF: *The National Gallery of Art, East Building*

Published in the United States of America in 1996 by
Universe Publishing
A Division of Rizzoli International Publications, Inc.
300 Park Avenue South
New York, NY 10010

Library of Congress catalog number: 96-60684

Design by Jack* Design
Printed in Singapore

In memory of my dear friend Gino Gullace, who understood power so well that he stayed away from it all his life

Diane Rehm

WASHINGTON is a magnificent city. It's also a great town. The city is made up of official buildings and monuments, handsome bridges, and wide avenues. The town consists of neighborhoods with distinct characteristics, tree-lined streets and playgrounds, small shops, and corner grocery stores. In its duality, I know Washington well because I've lived here all my life.

Washington is my town. Those of us who were born and raised here have a possessive sense of Washington, an emotional connection that blends memories of events past with an awareness of an ever-changing future. But even as the political fates of individuals shift from powerful to powerless, the city's most famous architectural and natural landmarks remain unchanged. What is changing is that new memorials, museums, and gardens are being added to create an even more stunning landscape.

Washington is the center of the free world, and it's also a town of individual communities. The White House, the Capitol building, the official monuments, all presented here through the perceptive eye of Santi Visalli, remind us yet again what an extraordinarily beautiful city this is. Each time I land at National airport just outside the city and take the George Washington Parkway along the Potomac River, the view of the Washington Monument and the Jefferson and Lincoln Memorials takes my breath away. This vista places the nation's capital among the most stunning cities in the world.

Beyond the "official" landmarks, however, what makes Washington such a special place is its neighborhoods. I grew up in what is now called the Petworth section of town, in Northwest Washington. When I was younger, our neighborhoods didn't have such clear delineations. Streets with names like Varnum, Upshur, Taylor, Randolph and Shepherd were my landmarks. The houses on my street, and on the streets around us, looked very much like each other: neat row houses with columned front porches. On summer evenings practically everyone in the neighborhood could be seen simply by walking out onto the cool, shaded porch and gazing to the left or right. As kids, we played sidewalk games while our parents and grandparents sat, rocking and watching.

My father and his brothers and sisters came to this country in the early part of the century from Beirut, Lebanon. Later on, my mother arrived from Alexandria, Egypt. There was (and still is) a large community of Arab-Americans in Washington, and practically all of them were, or felt like, relatives. At 19th and Wyoming Avenues, N.W., my father and his brothers owned a grocery store, an old-fashioned market that provided personal service to its clientele.

Buses ran (and still run) north and south along 16th Street. But my favorite mode of transportation was the streetcars, those lumbering green-and-white cylinders attached to overhead electric cables that gave off noisy sparks as the cars approached. Now, more than forty years later, many environmentally-conscious D.C. residents regret the loss of the streetcar. Part of my Sunday ritual was to join my father for a bus ride from our home down to 17th and R Streets, where we visited three of my aunts who each lived with their families, all within one block of each other.

I was fortunate enough to be able to walk to my

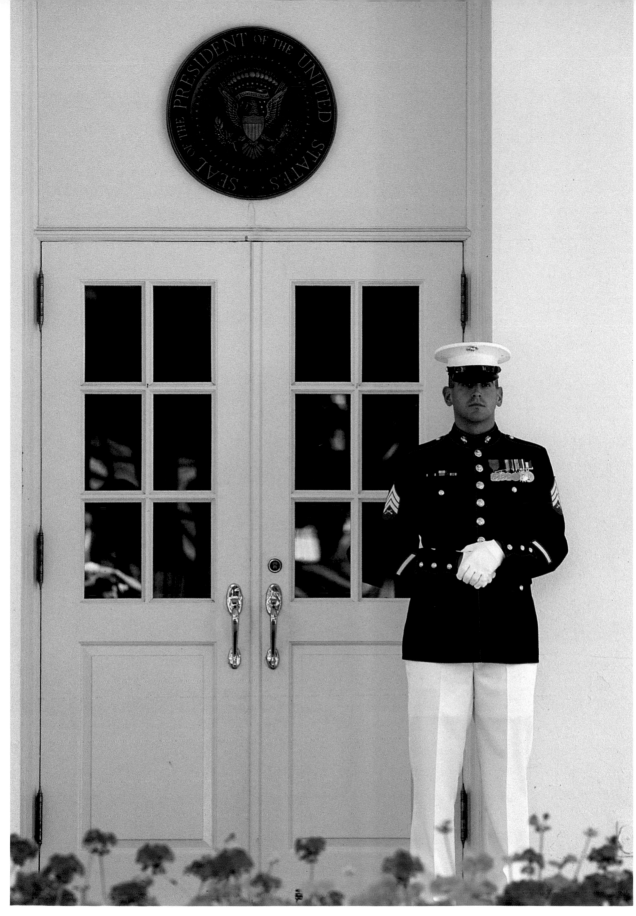

West wing entrance of the White House, guarded by a U.S. marine

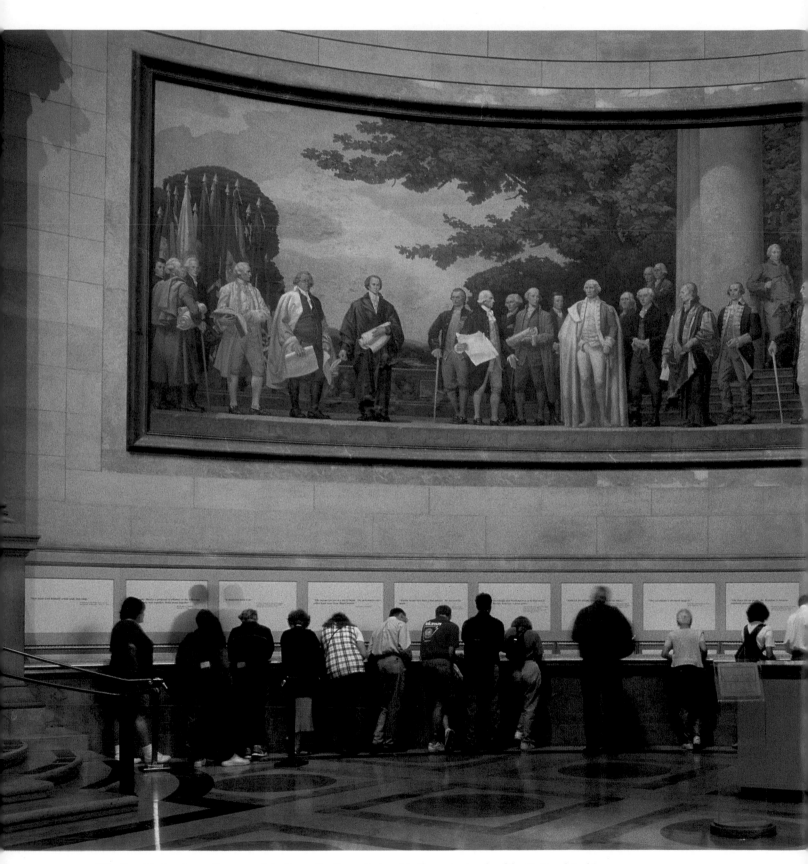

"The Constitution," one of two murals by Barry Faulkner displayed in the vast rotunda of the National Archives

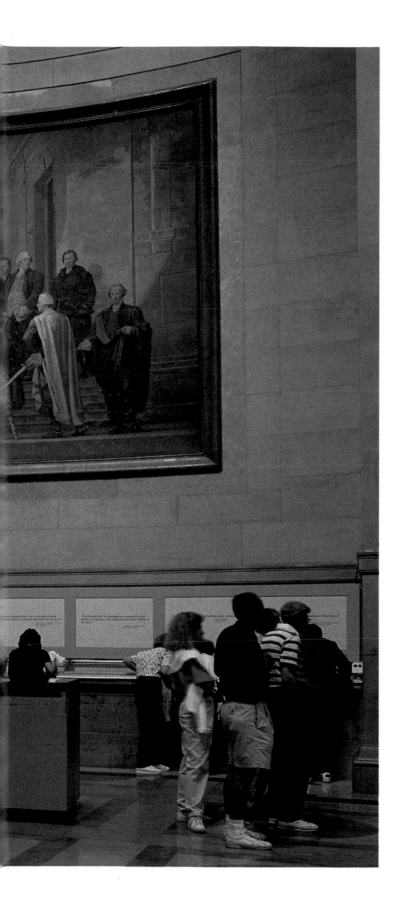

elementary, junior high, and high schools, each no more than ten minutes from my home. The after-school and summertime hangout was the Twin Oaks Playground (now the Department of Recreation's Youth Garden Center), at 14th and Taylor Streets, where kids from all over the area gathered for daily softball, tennis, basketball, or kickball games. In the heat of the day there was always a loud game of hearts. In that innocent era, despite our different cultures and athletic abilities, it felt as though we all existed on a level playing field.

But there was an even more expansive "playground" just a short bike ride away. That was Rock Creek Park, entered from Arkansas Avenue, just off 16th Street. I can still remember the distinct drop in temperature as we coasted down the hill, beneath the 16th Street Bridge, and into the shady, quiet glen. The sounds changed as well. In those days before commuters began using roadways in the park, you could hear the water moving over the rocks in the creek. If we felt really energetic, we could pedal all the way to the zoo. On hot summer evenings, a number of neighborhood families would take suppers down to the park and cook hot dogs in the stone fireplaces maintained by the city. In winter, the hills leading up to 16th Street gave us the perfect spot for exciting sledding.

Movies were an important part of growing up here in Washington. The old Tivoli Theatre at 14th and Park Road, N.W., and two blocks away at Irving, the Savoy (no longer standing), were meeting places for all my friends. A number of years ago, the D.C. government considered restoring the Tivoli, a grand old theater with ornate mirrors and chandeliers in the lobby. But the project never really got off the ground. After a movie there was always the Hot Shop on Park Road, the first in a chain of eateries established by the Marriott family (now the Marriott Corporation). What was originally a simple lunch

stand later became a full-fledged and enormously popular restaurant. For my money, the hot fudge sundaes and the onion rings there can never be equaled.

Like most school children, one of my favorite activities was taking field trips to visit the city's special buildings. Perhaps my first such memory centers around the Pan American Union, one of Washington's loveliest structures, though I did not appreciate the architecture at the time. What I do recall are the brilliant and exotic parrots housed inside, all chattering away, quite comfortable as they looked down on us from their high perches.

Another vividly remembered excursion came a bit later, with a group of teenage friends. It was a trip to the Capitol building, at a time when the dome was still open to visitors. As teenagers will do, we all determined to climb the many steps as far as rules would allow. There was just one problem: on the way up, with my friends and other visitors behind me, I realized I was experiencing dizziness and an overpowering fear. That ascent is no longer open to tourists, and perhaps that's just as well.

At the foot of the Capitol is the U.S. Botanic Garden, the living museum chartered by Congress in 1820, and the oldest botanic garden in North America. I recently returned there for the first time since my school days, marveling once again at the great variety of orchids and other tropical plants. Most of all, I came to appreciate that Presidents George Washington and Thomas Jefferson had such foresight as to recognize the importance of plants for the well-being of humankind and for the fragile ecosystems that support all life. They were indeed the new nation's first environmentalists.

Just west of the Capitol is Union Station, where so many travelers are introduced to the city. And what a magnificent introduction it is, now that the building has been totally renovated. There is a perhaps apocryphal tale claiming that when the station was originally opened in 1903, it had to be closed immediately, because there were strenuous objections to the fact that the statues around the high inner rim were naked. It took several years and the addition of strategically placed shields before the public was once again permitted inside.

The world's largest free-standing globe, 11 feet in diameter, The National Geographic Society Explorers Hall

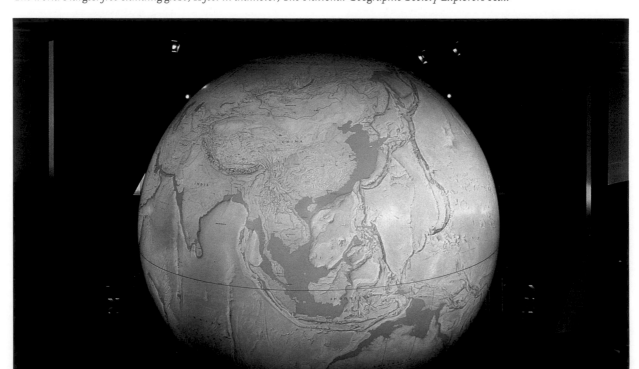

The arched ceiling stands some nine stories high, with inset squares of shimmering gold that alone cost over one half million dollars. With restaurants, shops and theaters, Union Station is truly a must to visit.

One of the most famous buildings in Washington is the Smithsonian Castle, with its distinctive turrets and its reddish color. A new reason to admire the Castle now is the recent construction of the Haupt Garden, which presents a wonderful variety of seasonal flowers and sets off the castle even more dramatically. Two new museums have also been added to that area, both underground: the Sackler, which specializes in oriental art, and the Museum of African Art. What's extraordinary about these two museums is that each has been so beautifully designed that you almost have a sense of being above ground, rather than beneath.

The grassy lawns at the heart of the city, including the Mall, hold very special memories for me. I remember coming down for July 4th celebrations as a young girl, lying on a blanket near the Washington Monument, watching the fireworks burst overhead. Then, as a young woman working in the State Department, I began playing second base for the women's softball team. At the time, John Rehm was an attorney working on foreign aid agreements, also at the State Department. He was the pitcher for the men's softball team. We found we had a great deal in common, in addition to softball. Now, thirty-seven years later, my husband and I take pleasure in seeing the Mall used for all sorts of activities, including soccer, polo, and volleyball. Add to all this the National Folklife Festival, which draws visitors each year from around the country to celebrate our rich cultural heritage.

One of many controversies confronting the city and the federal government is the closing of Penn-sylvania Avenue in front of the White House. Previously, cars, trucks, and pedestrians could move freely in front of that grand mansion. Now that it's been sealed off, traffic is kept away, while pedestrians, bikers, and rollerbladers have several blocks to themselves. While that may be an inconvenience for those who've grown accustomed to using Pennsylvania Avenue as a thoroughfare, I'm delighted that so many people can now enjoy that area as they stroll, rollerblade, or bicycle by the White House.

Leaving the downtown area and moving north through the city, I'm always impressed by how handsomely the city has been laid out, with its wide, tree-lined avenues and residential side streets. Massachusetts Avenue is called Embassy Row because of all the beautiful chanceries and residences belonging to foreign dignitaries. There are also a number of handsome "circles" that may delight and confuse newcomers. One in particular, Sheridan Circle, is a favorite of mine. Several years ago, as my family and I were driving past it, we saw an incredible sight: a perfect circle of mushrooms, known to many as a "fairy ring," so called because legend says it was created by the dancing of fairies. We were so excited that we all got out of the car and marveled at the perfection of this natural creation amid Washington's stately, urban sprawl. Later, we drove back along the same route, but to our dismay, the District of Columbia had chosen that very day to cut the grass, and with it, the fairy ring; but not before an enterprising photographer had captured it on film. The fairy ring and its premature demise were chronicled in the next day's *Washington Post*.

Indeed, photographs are often the finest storytellers, and in these elegant images by Santi Visalli, I know you will appreciate both the public grandeur and the personal beauty that this wonderful city-and town has to offer.

OVERLEAF: *The Spirit of St. Louis, Air & Space Museum*
SECOND OVERLEAF: *Air & Space Museum, Smithsonian Institution; The National Museum of Women in the Arts*

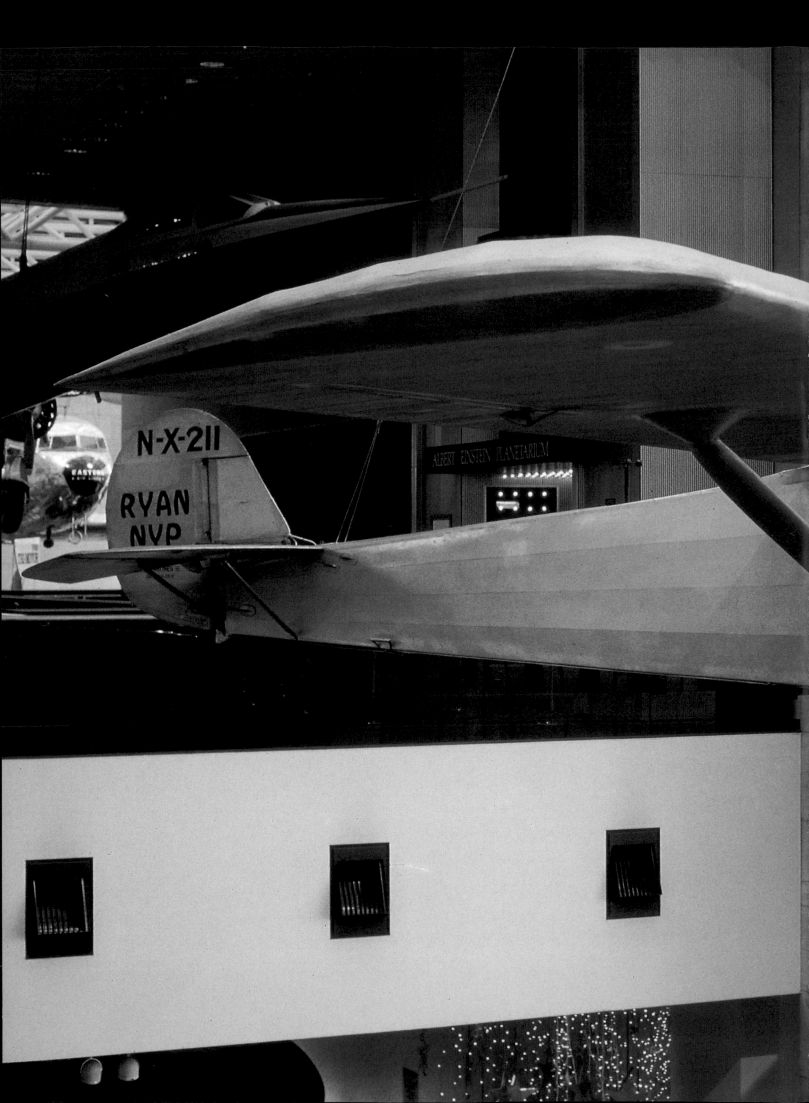

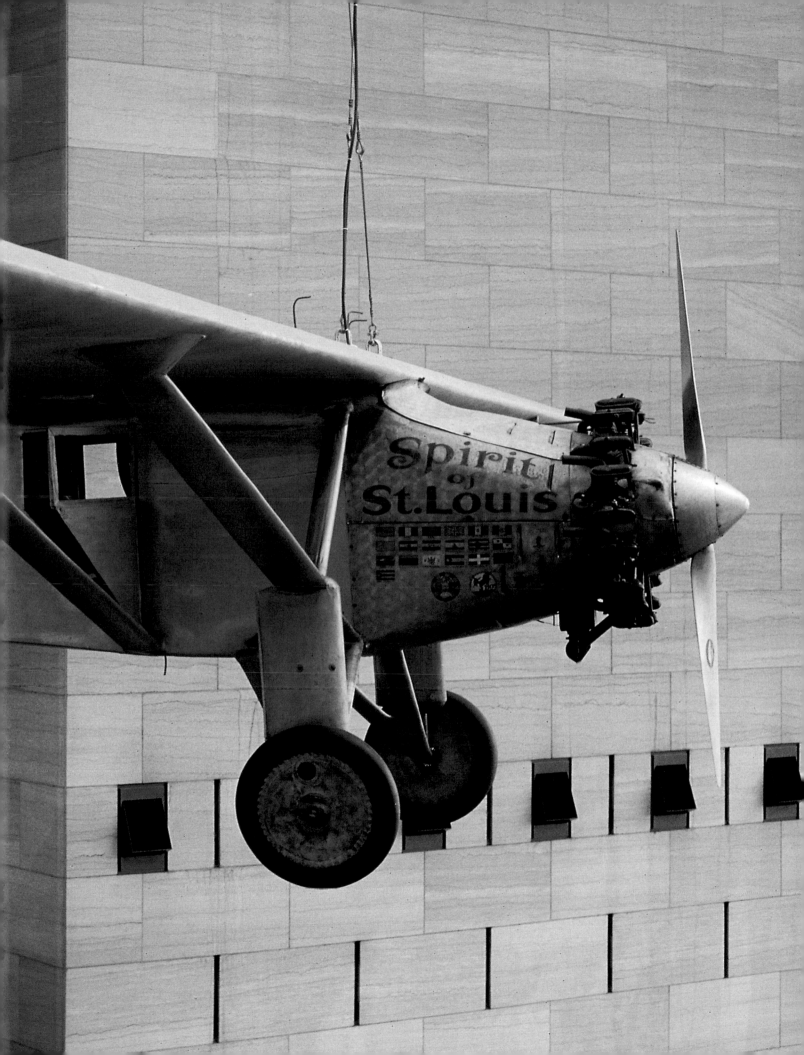

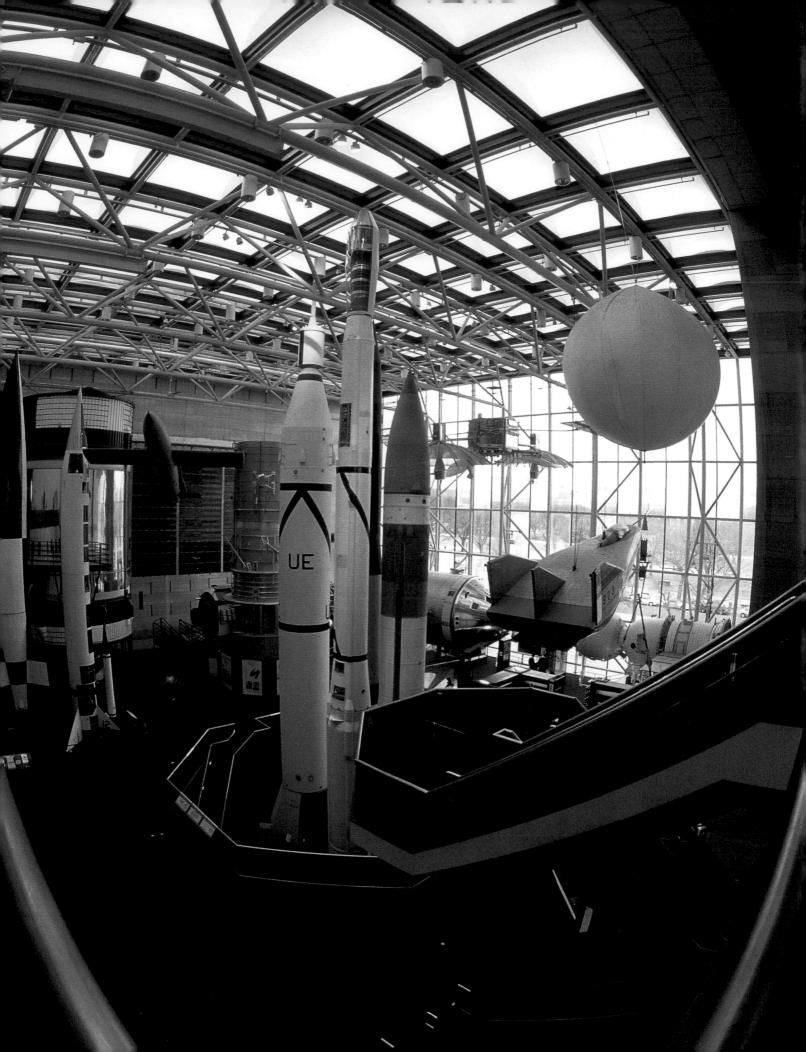

ABOVE AND RIGHT: *The National Museum of Women in the Arts*

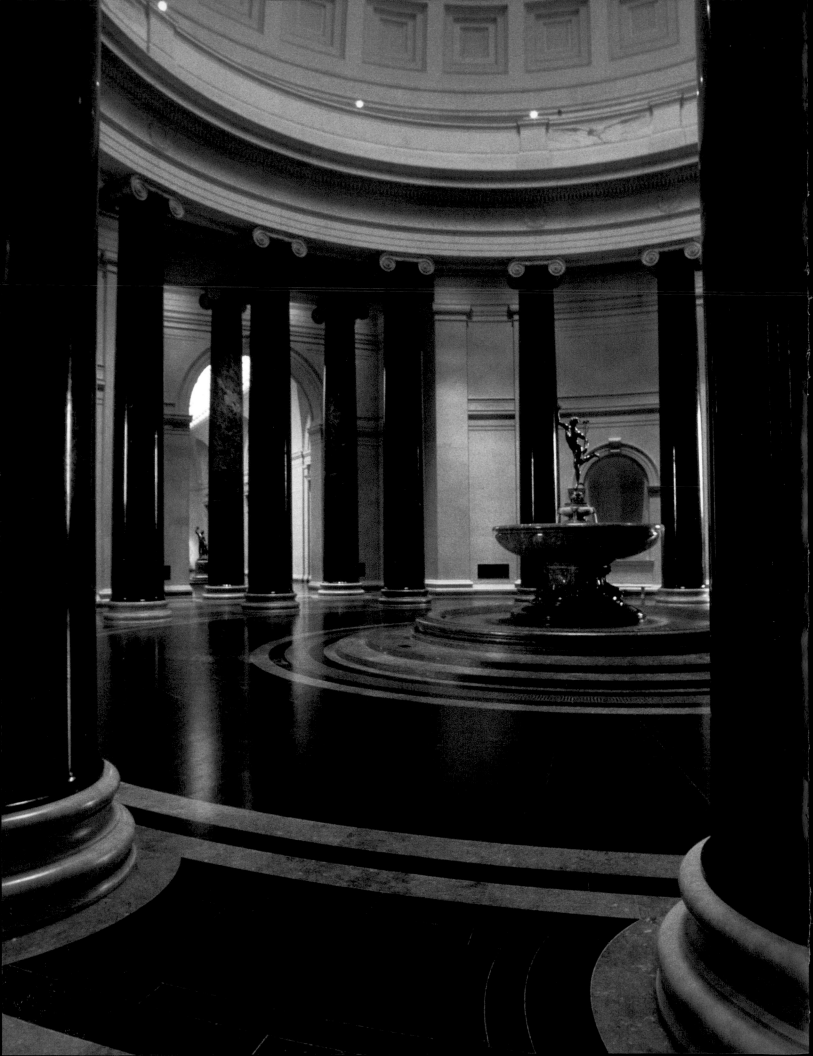

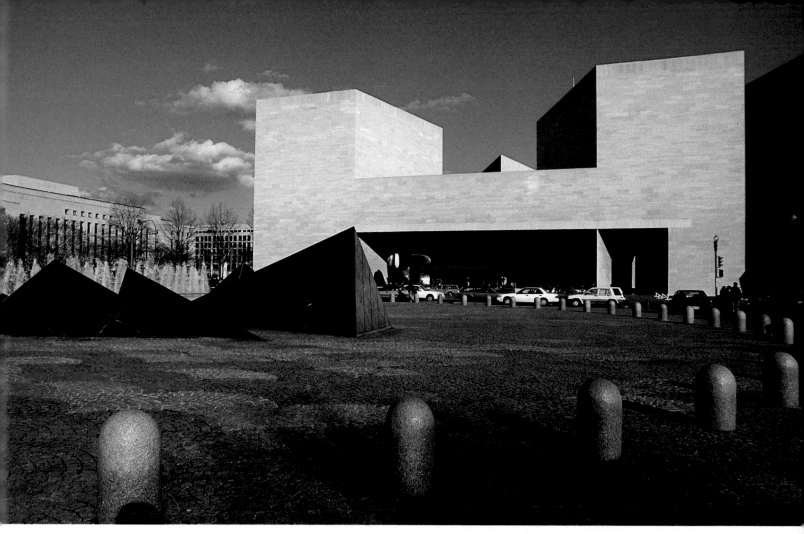

LEFT: *The National Gallery of Art, West Building* ABOVE: *The National Gallery of Art, East Building*

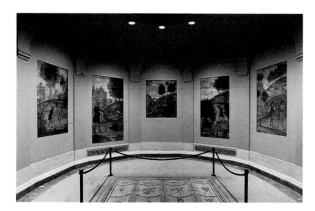

Roman floor mosaic, 3rd century A.D., The National Gallery of Art, West Building

OVERLEAF: *The Arts and Industries Building, Smithsonian Institution*

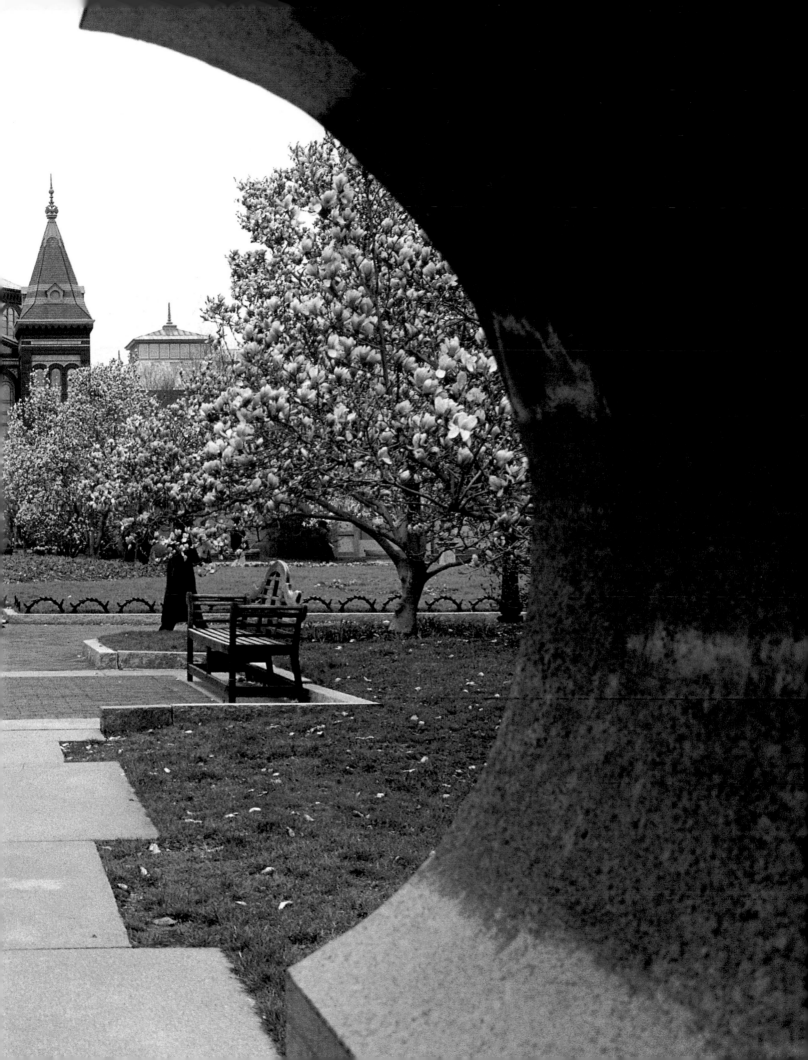

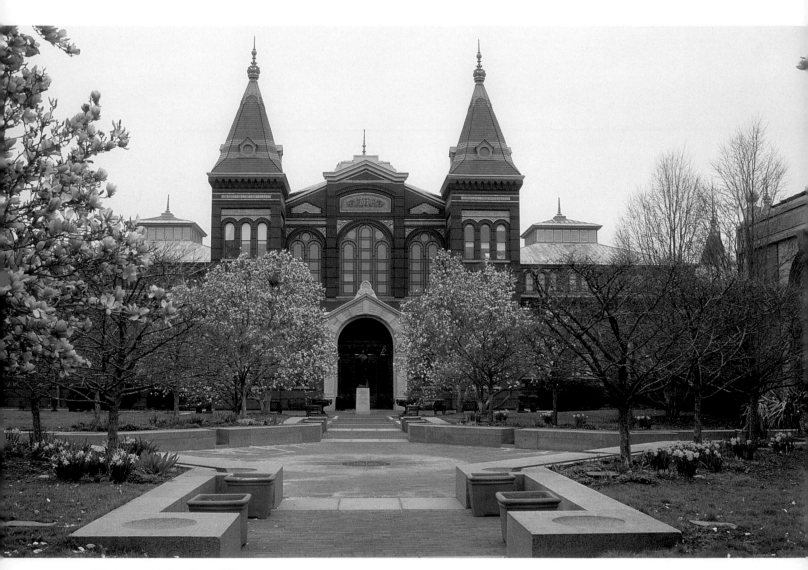

The Arts and Industries Building

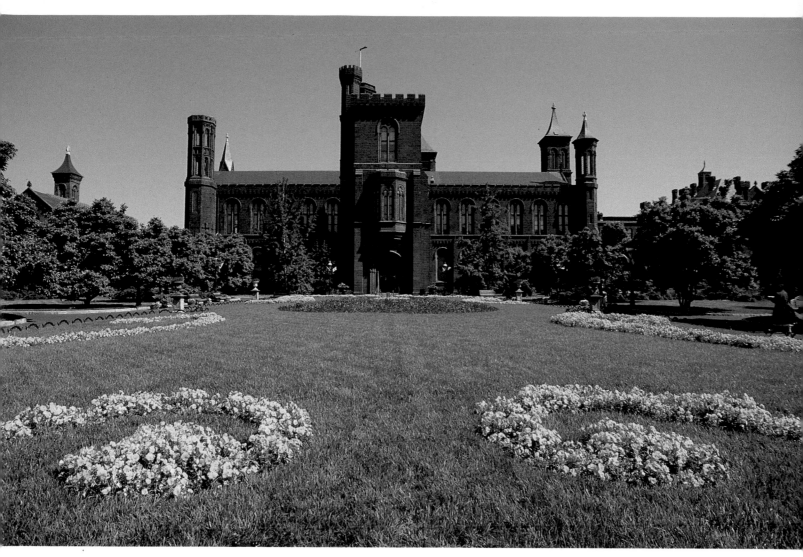

The Victorian gardens of the Castle

OVERLEAF: *The Hirshhorn Museum and Sculpture Garden, Smithsonian Institution*
SECOND OVERLEAF: *The National Building Museum, Smithsonian Institution*

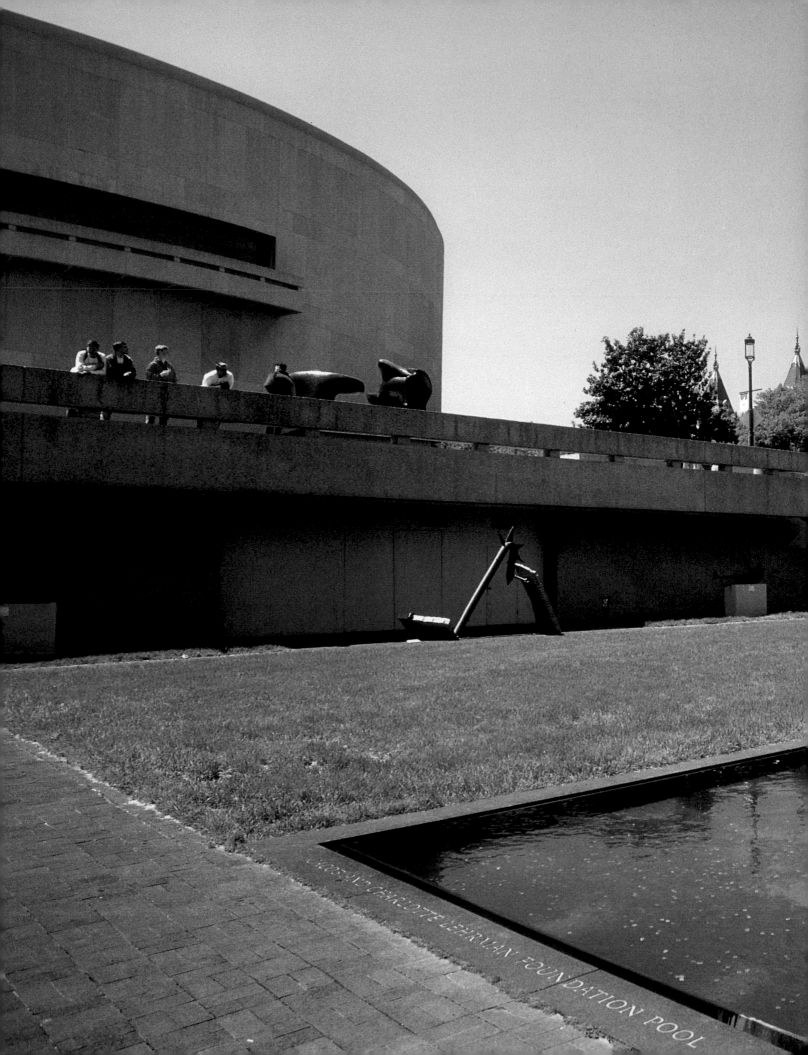

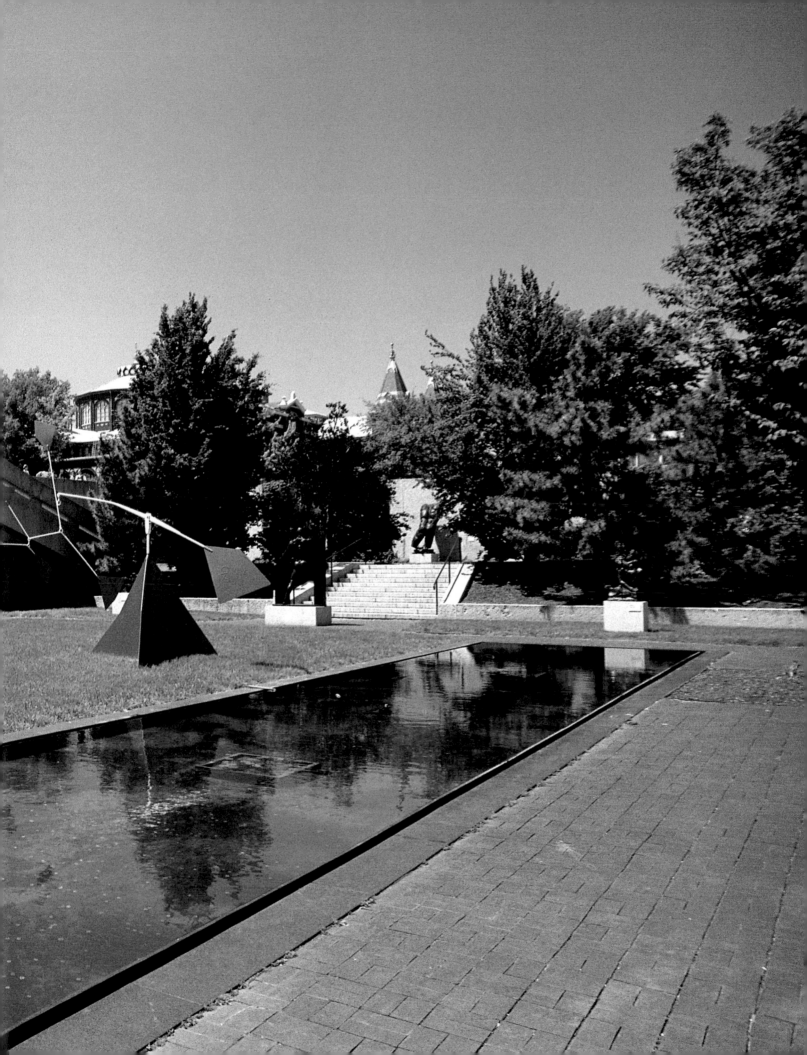

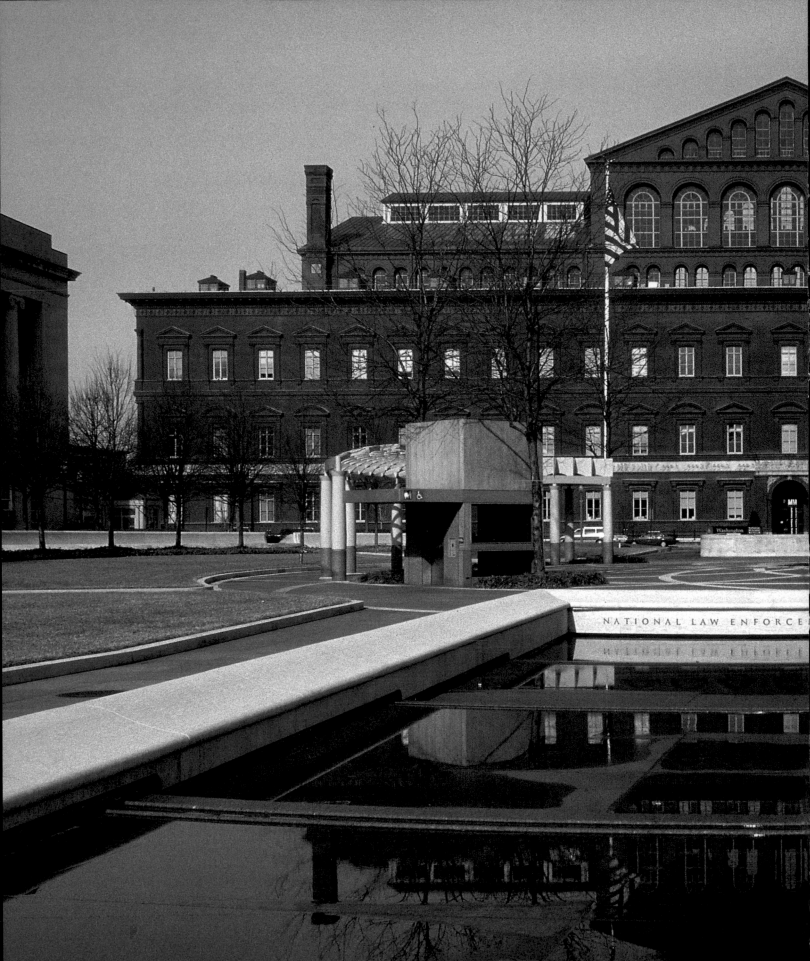

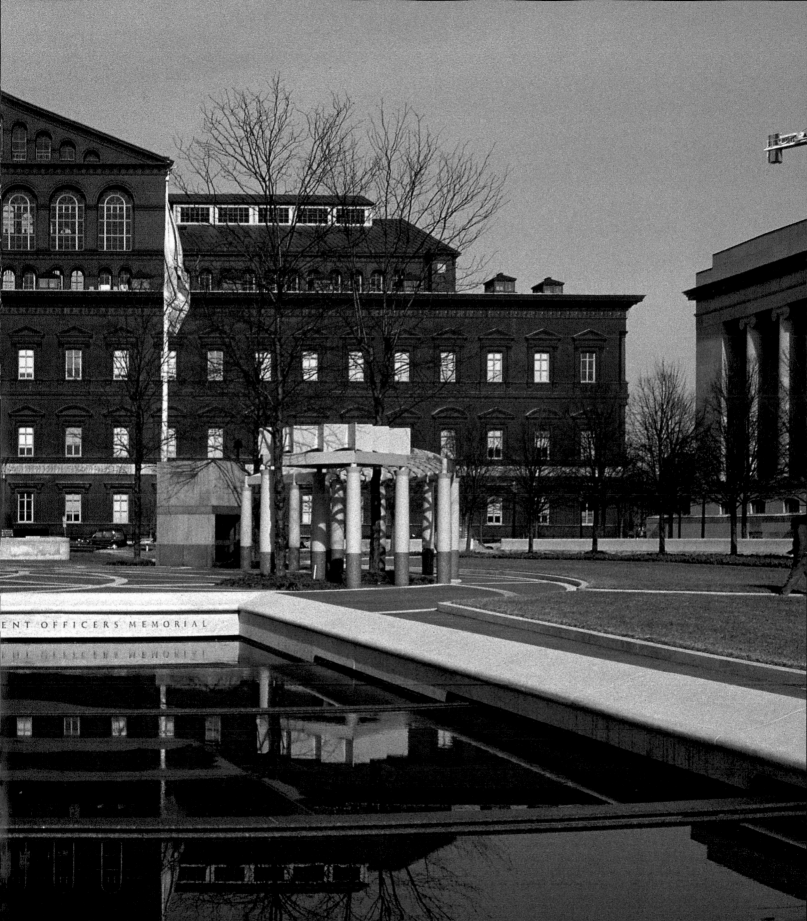

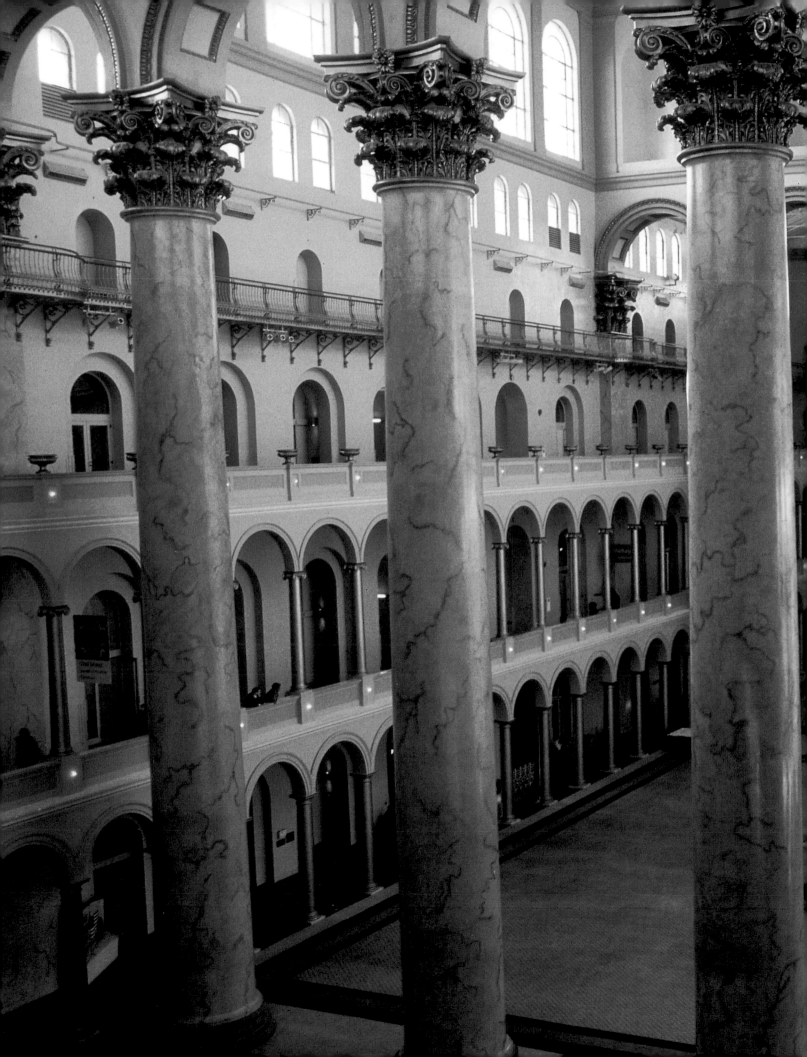

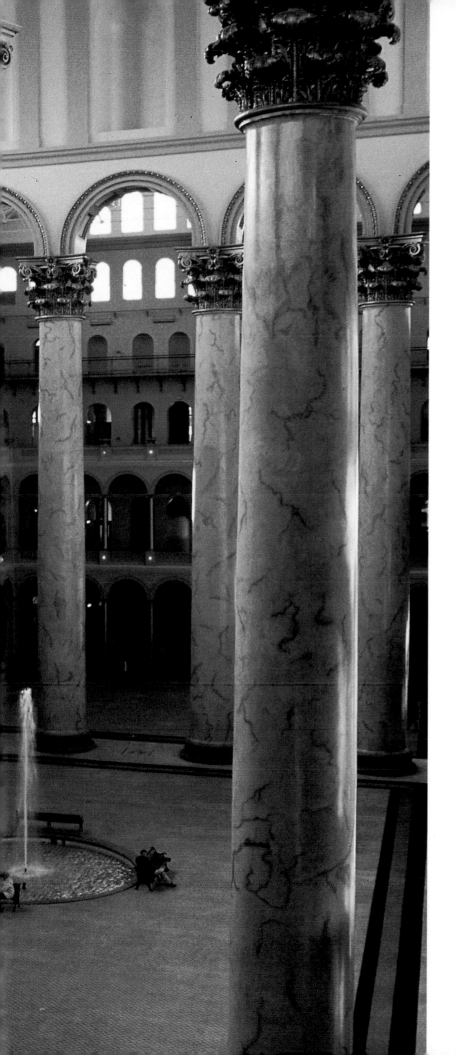

ABOVE: *Detail of the National Building Museum*
LEFT: *The Great Hall of the National Building Museum*

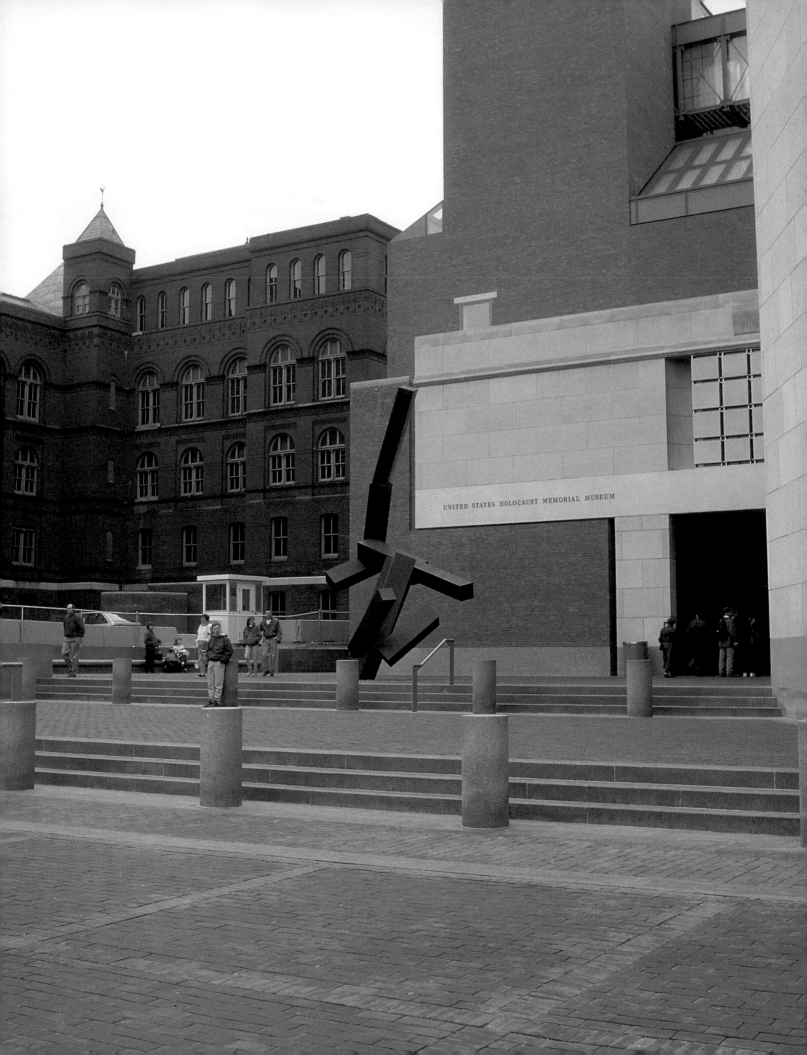

UNITED STATES HOLOCAUST MEMORIAL MUSEUM

LEFT: *United States Holocaust Memorial Museum* ABOVE: *Renwick Gallery*

OVERLEAF AND SECOND OVERLEAF: *The Library of Congress*

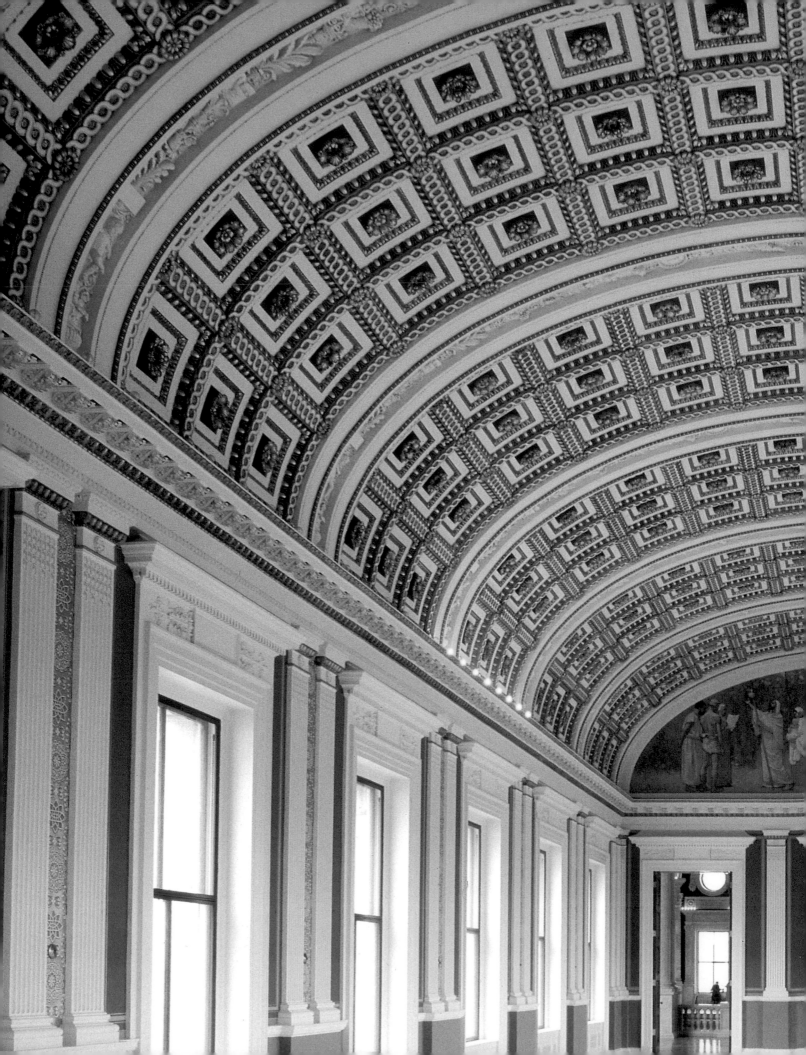

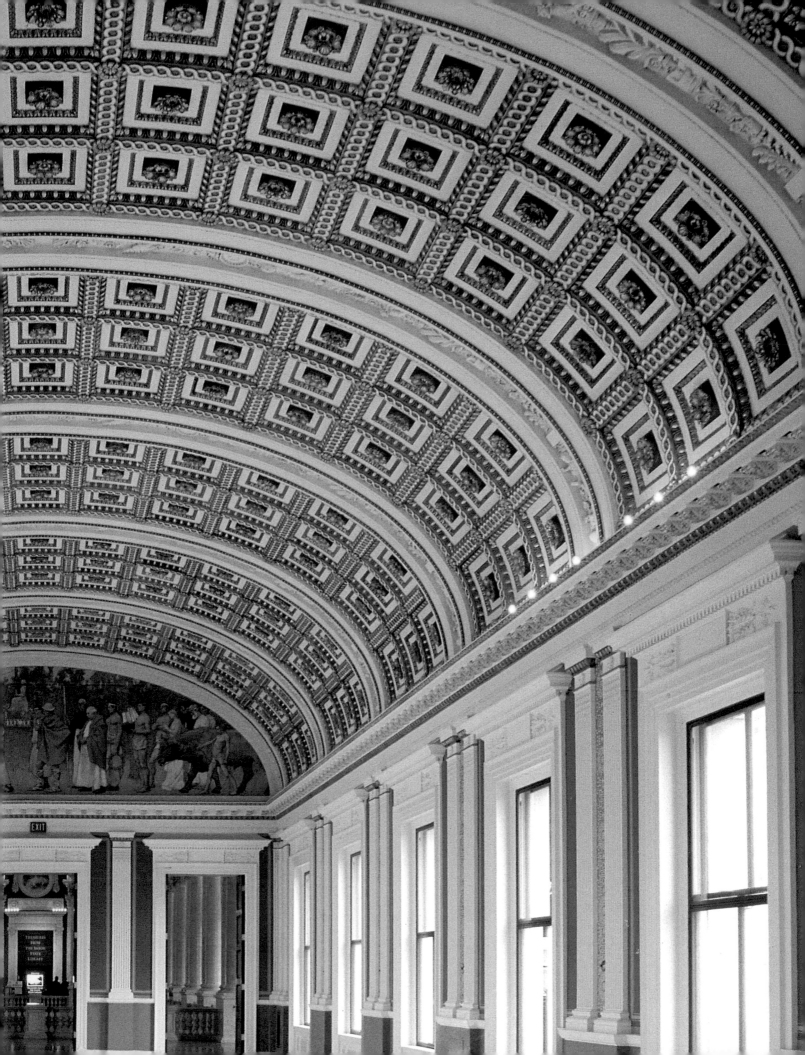

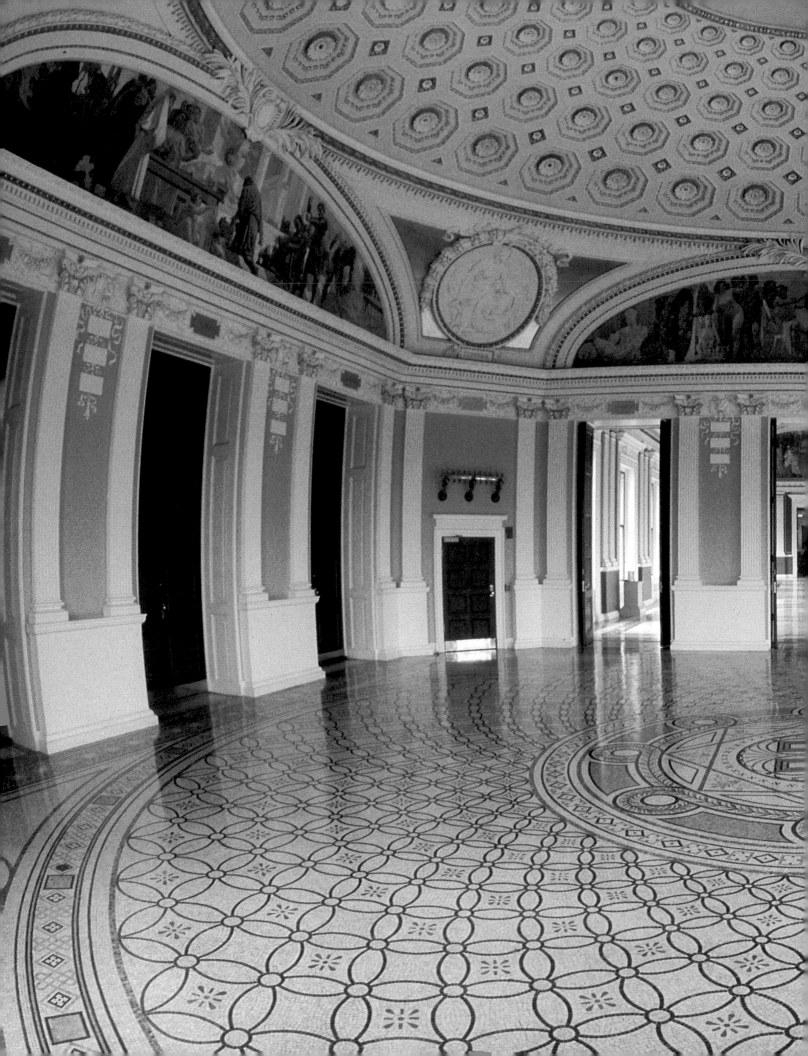

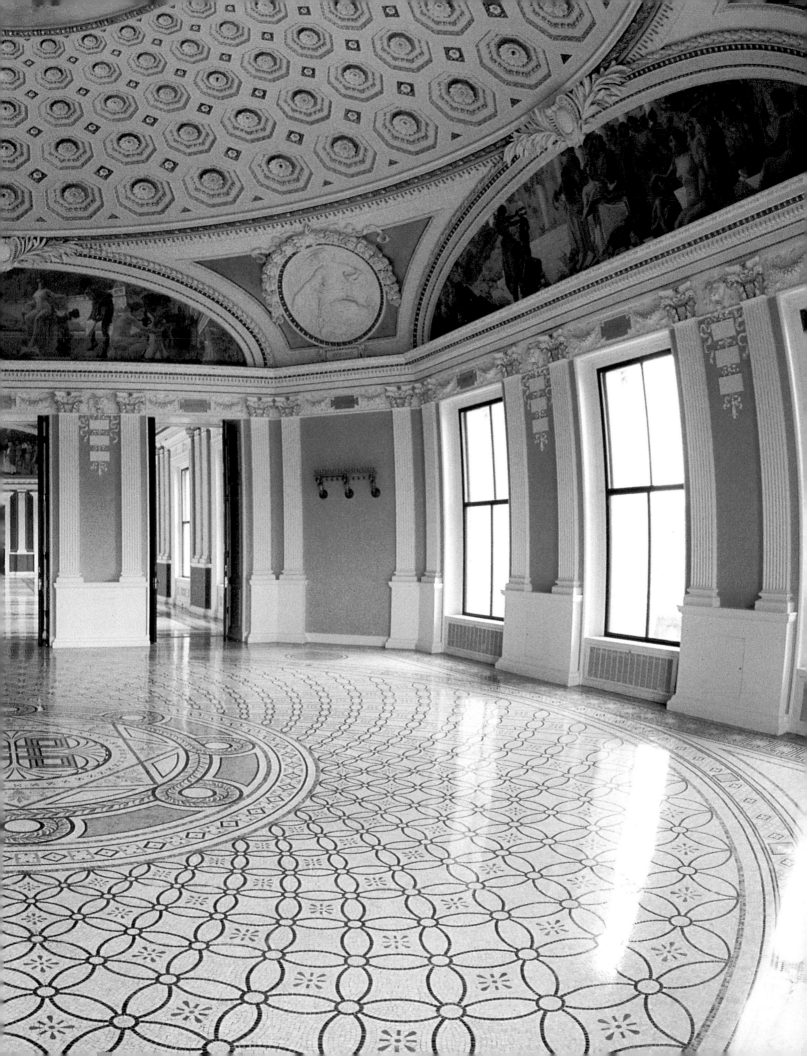

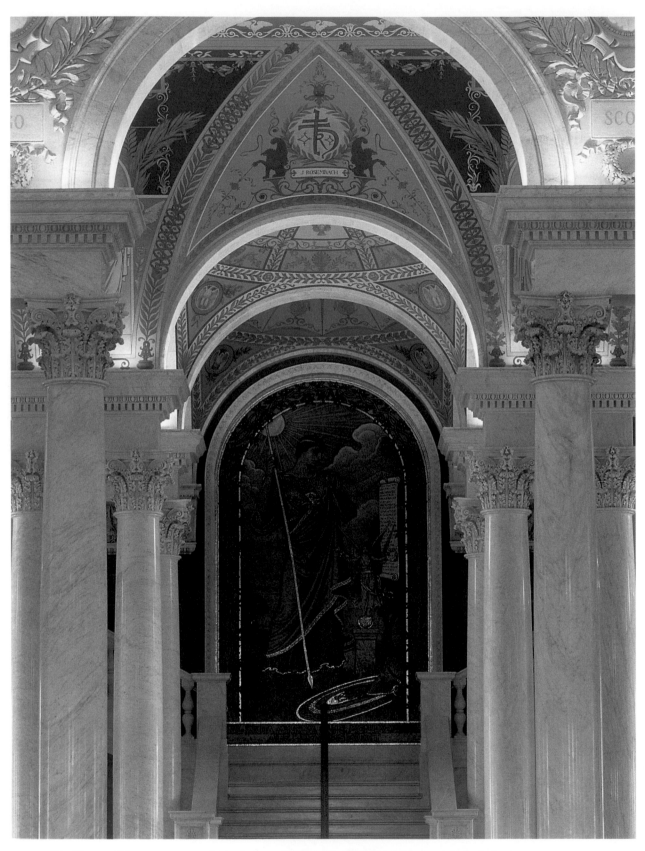

ABOVE: *The Library of Congress* RIGHT: *Stained-glass windows of the Washington National Cathedral*

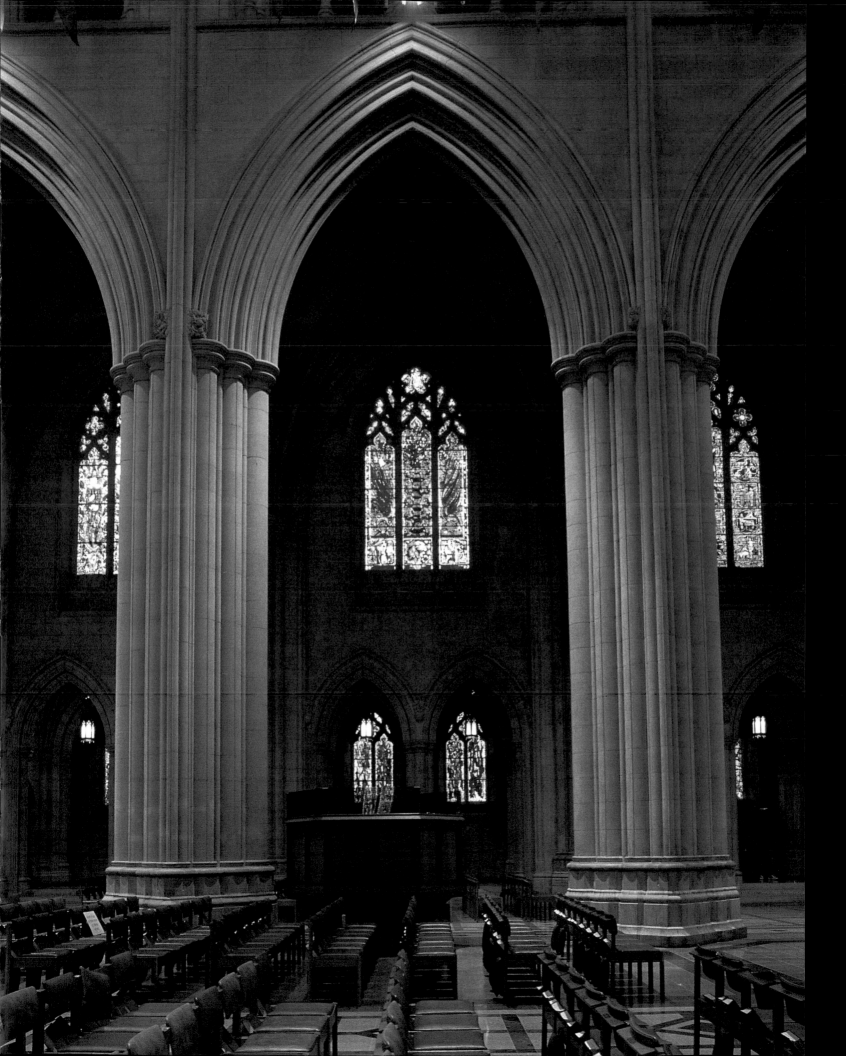

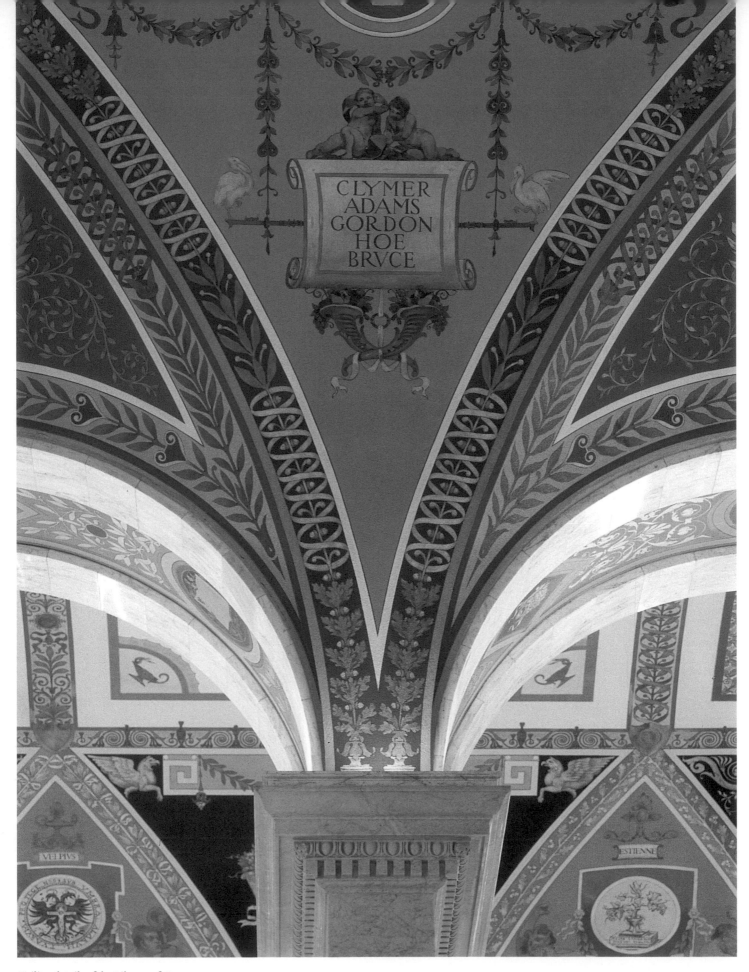

CLYMER
ADAMS
GORDON
HOE
BRVCE

Ceiling details of the Library of Congress

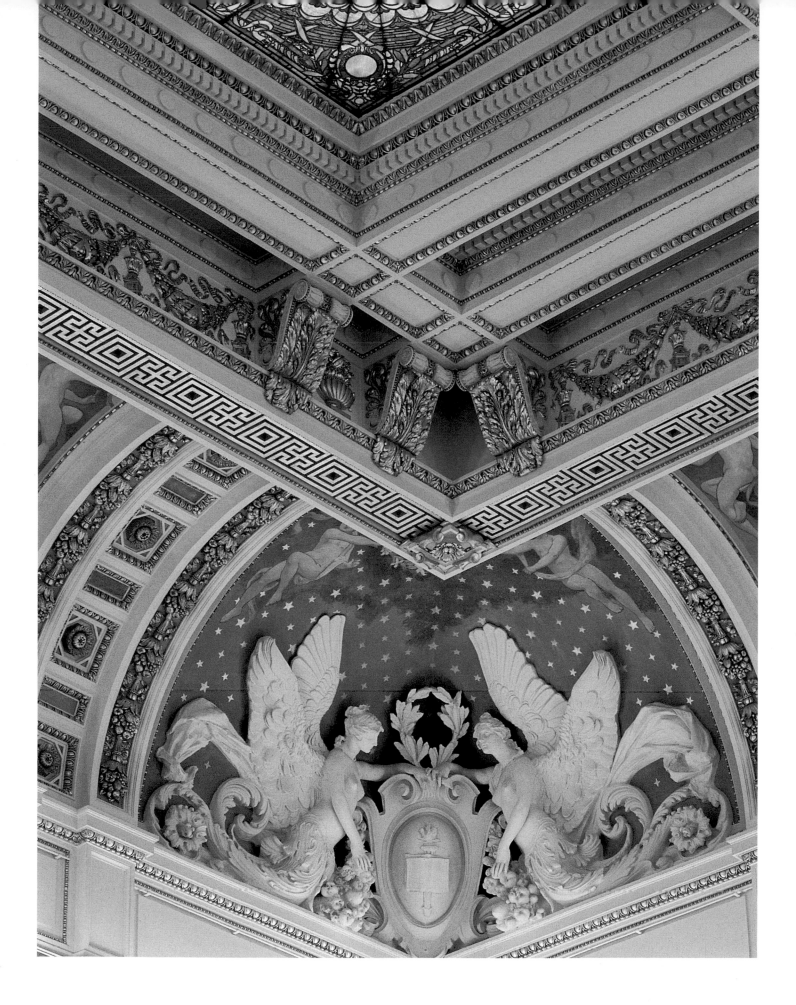

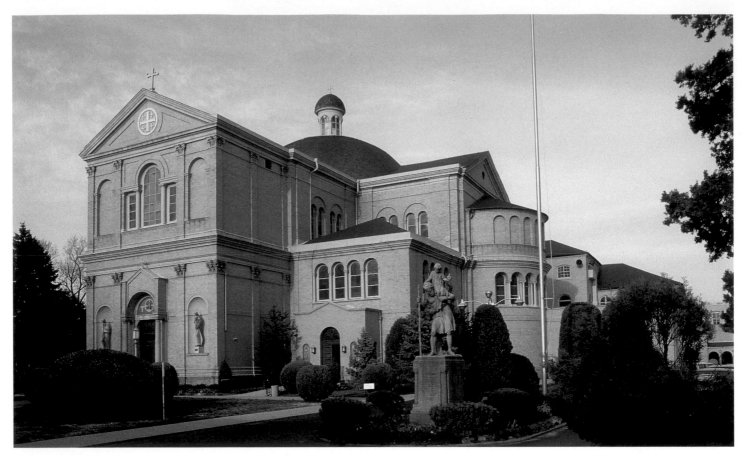

Franciscan Monastery, a replica of the Holy Sepulcher in Jerusalem

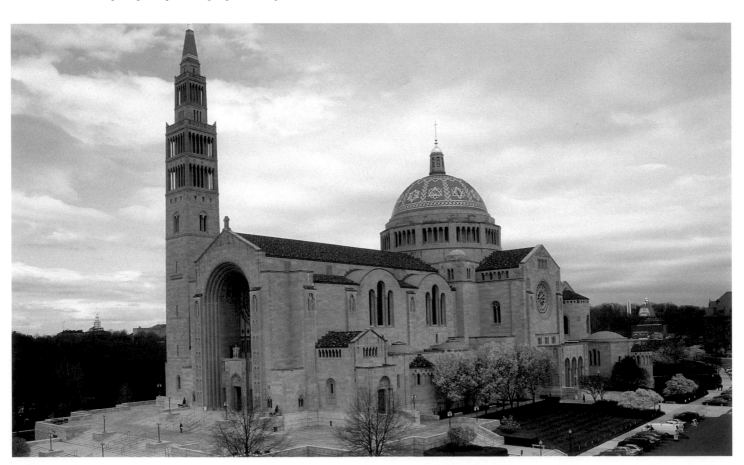

Basilica of the National Shrine of the Immaculate Conception

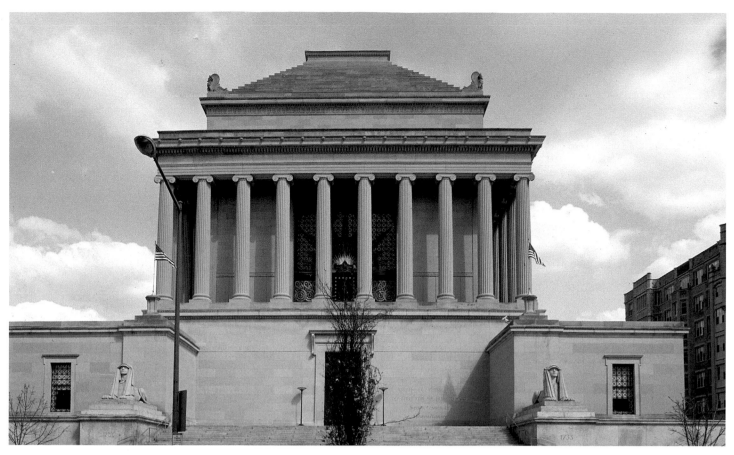

Scottish Rite Masonic Temple

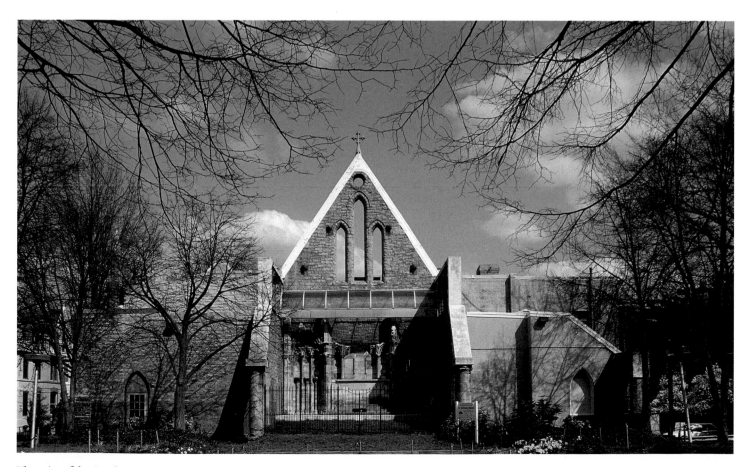

The ruins of the St. Thomas Episcopal Church, known as "the burned-down church"

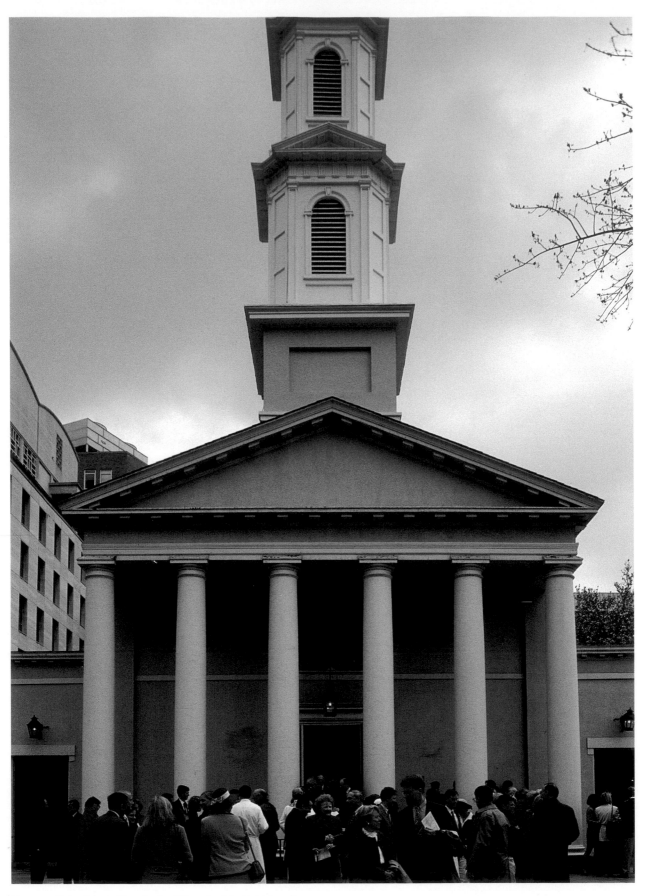

Easter at Saint John's Church, the "Church of the Presidents"

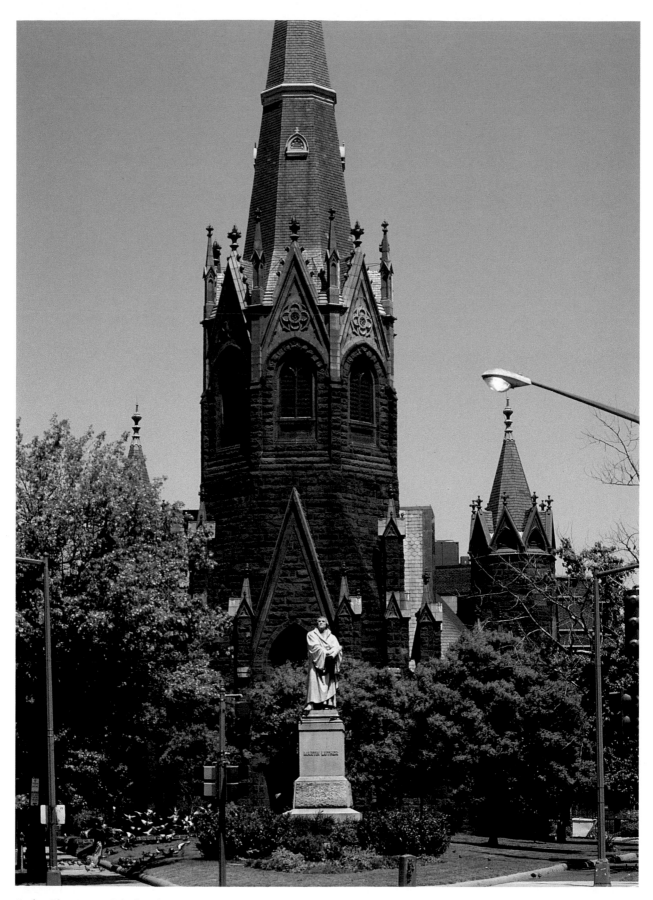

Luther Place Memorial Chapel

OVERLEAF AND SECOND OVERLEAF: *The windows of the Washington National Cathedral, one of which is inlaid with a moon rock*
THIRD OVERLEAF: *Marilyn Monroe mural on Connecticut Avenue*

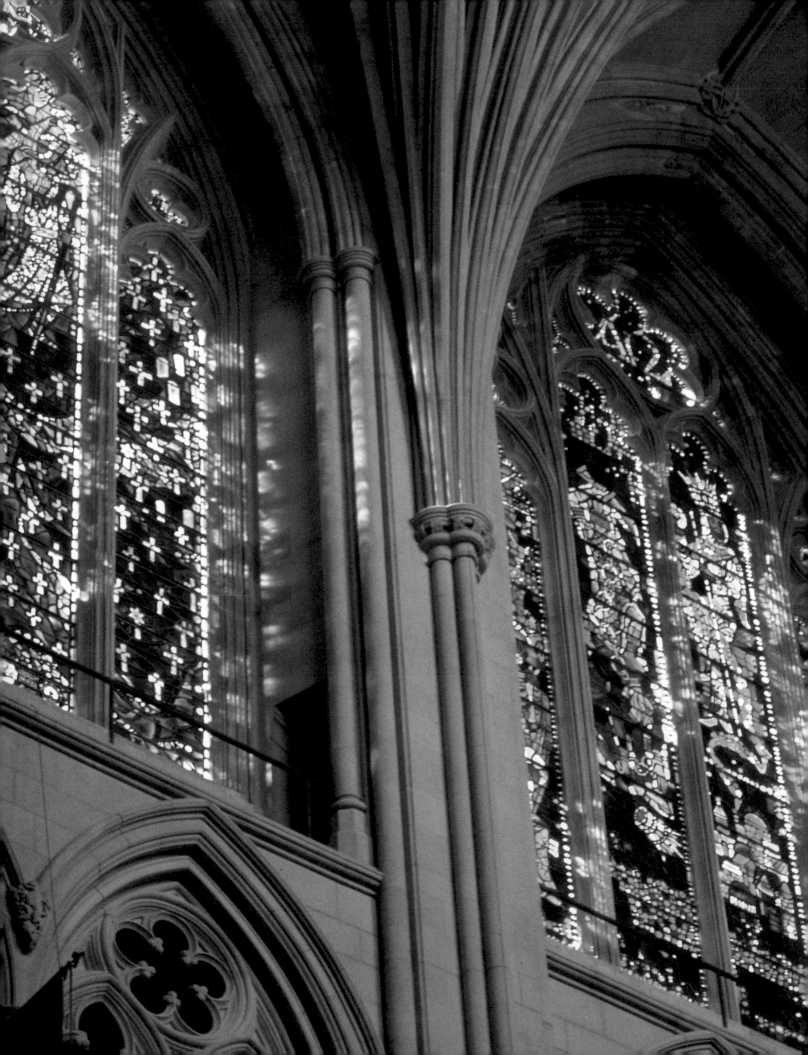

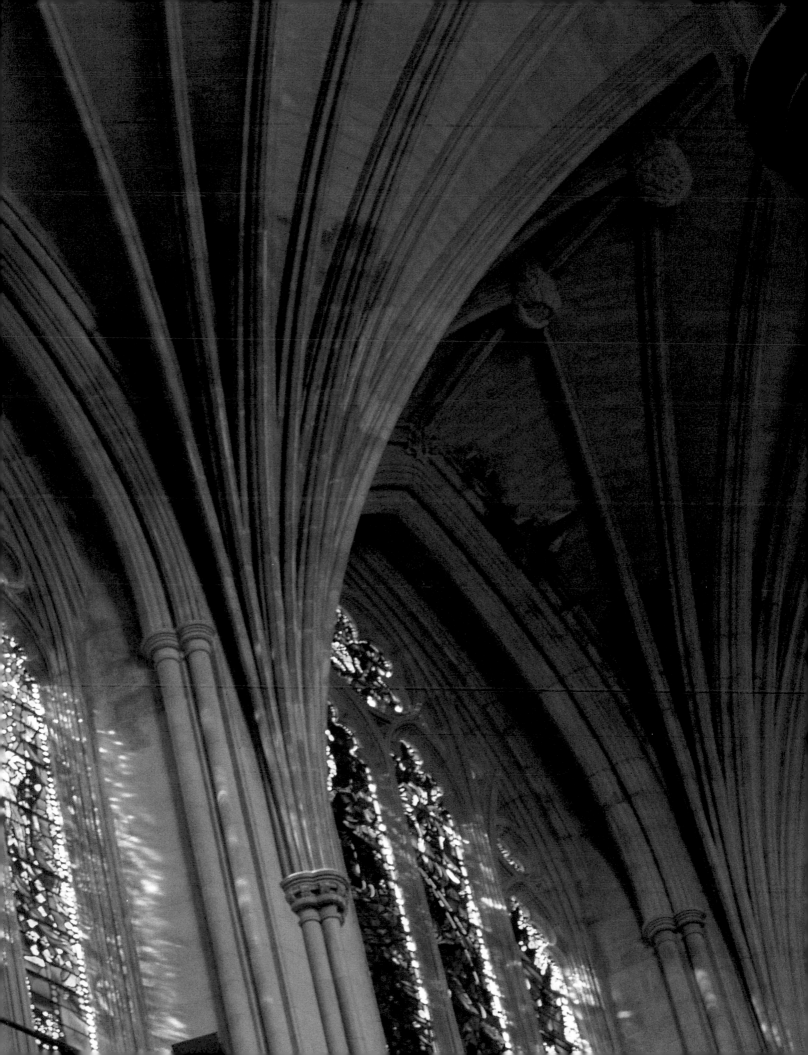

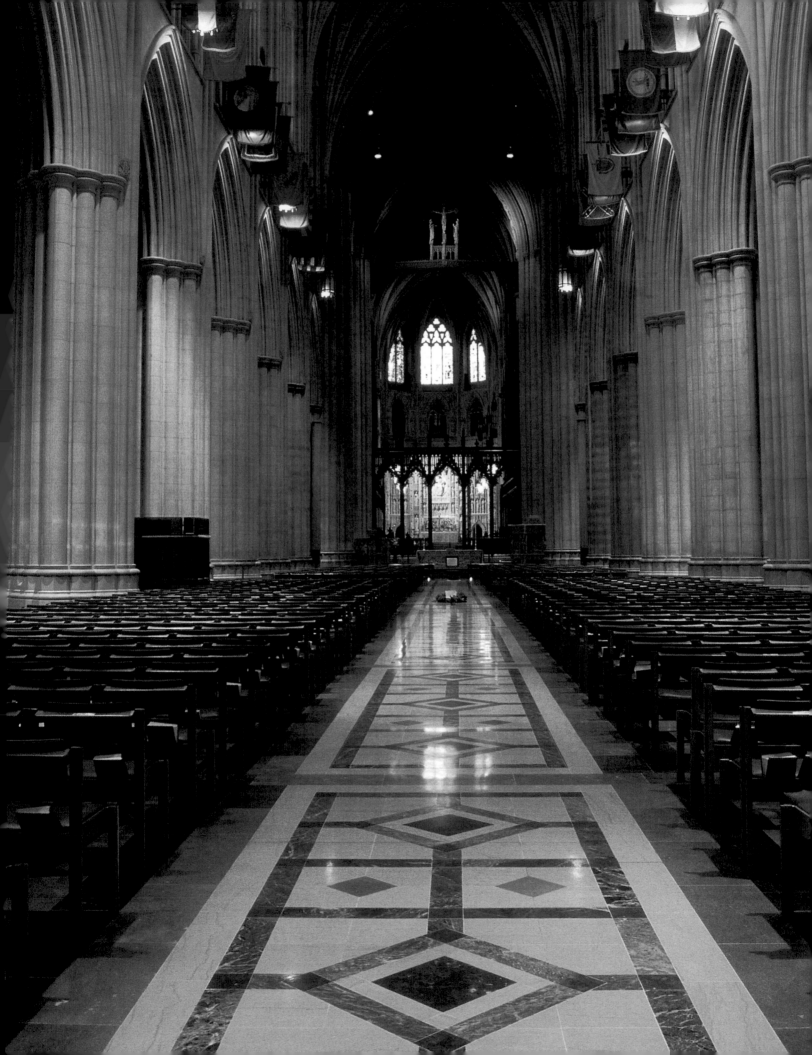

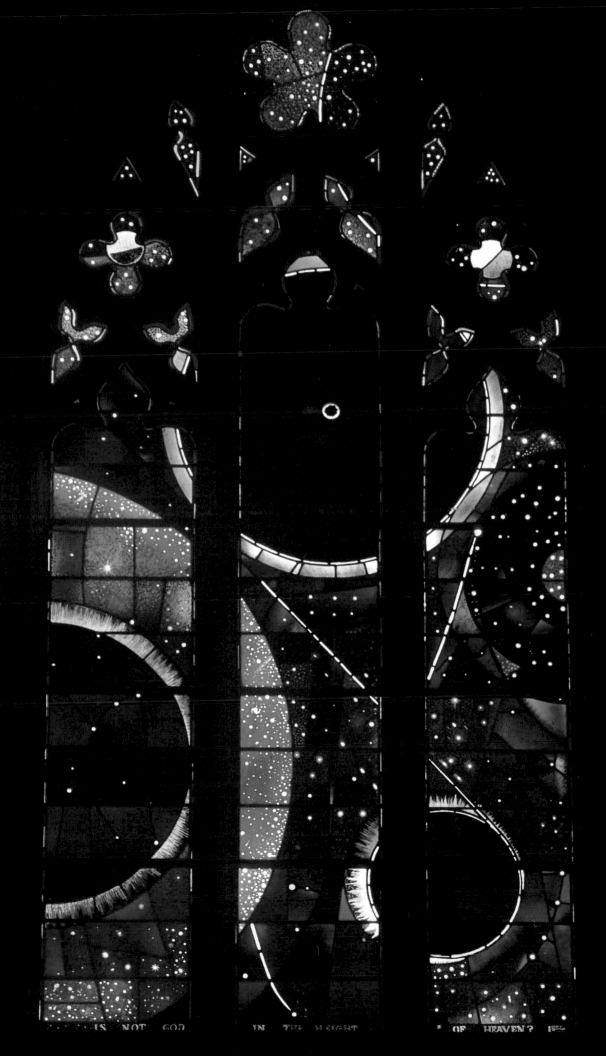

IS NOT GOD IN THE HEIGHT OF HEAVEN?

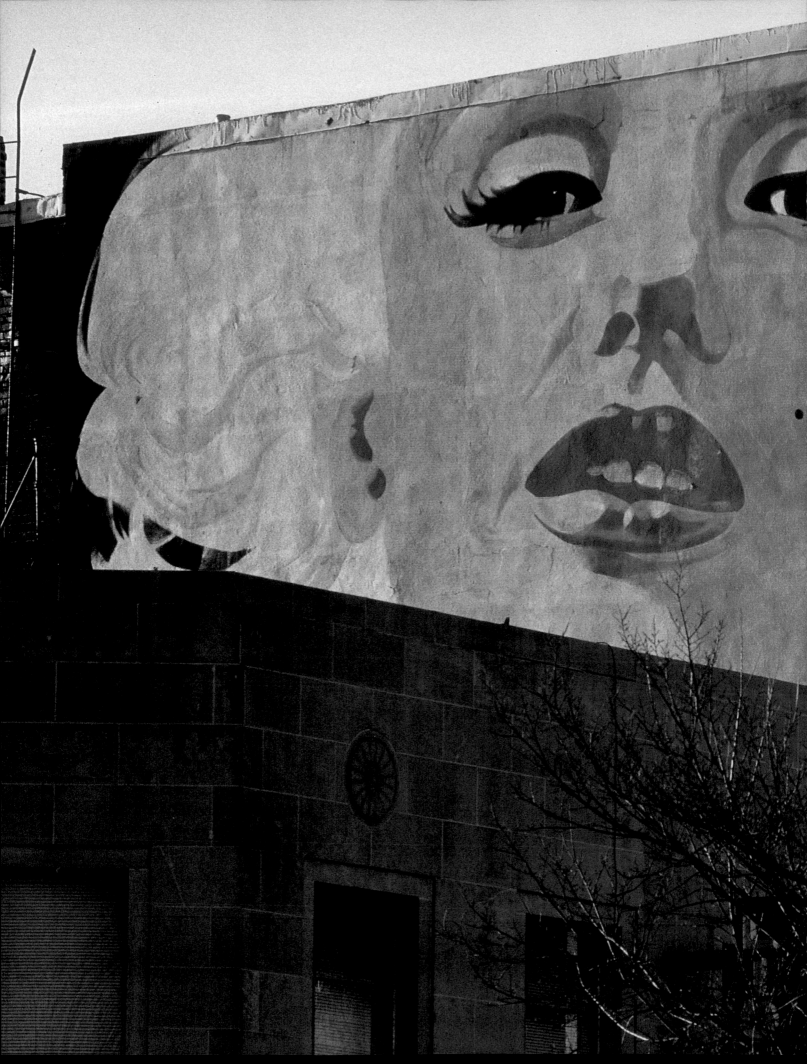

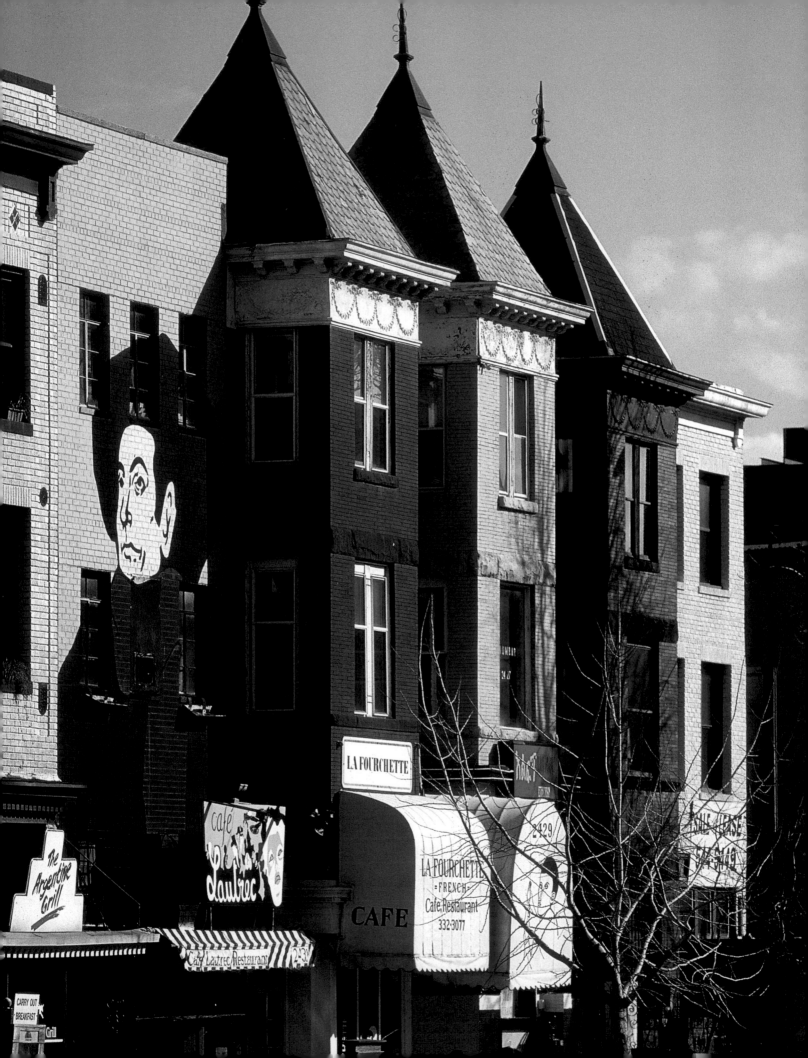

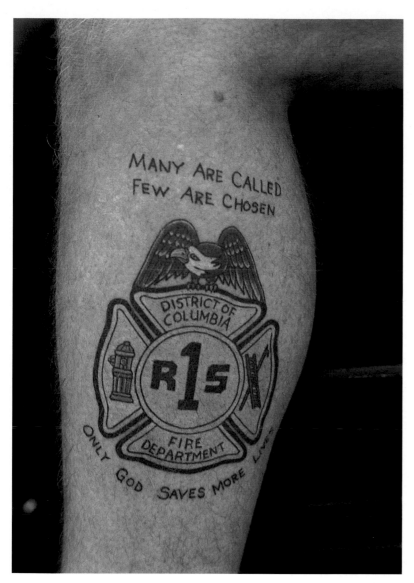

ABOVE: *A Washington D.C. fireman's tattoo*
LEFT: *Café Lautrec, Adams-Morgan*

OVERLEAF: *18th Street, Adams-Morgan*
SECOND OVERLEAF: *Ethiopian cuisine at Fasika's, Adams-Morgan*

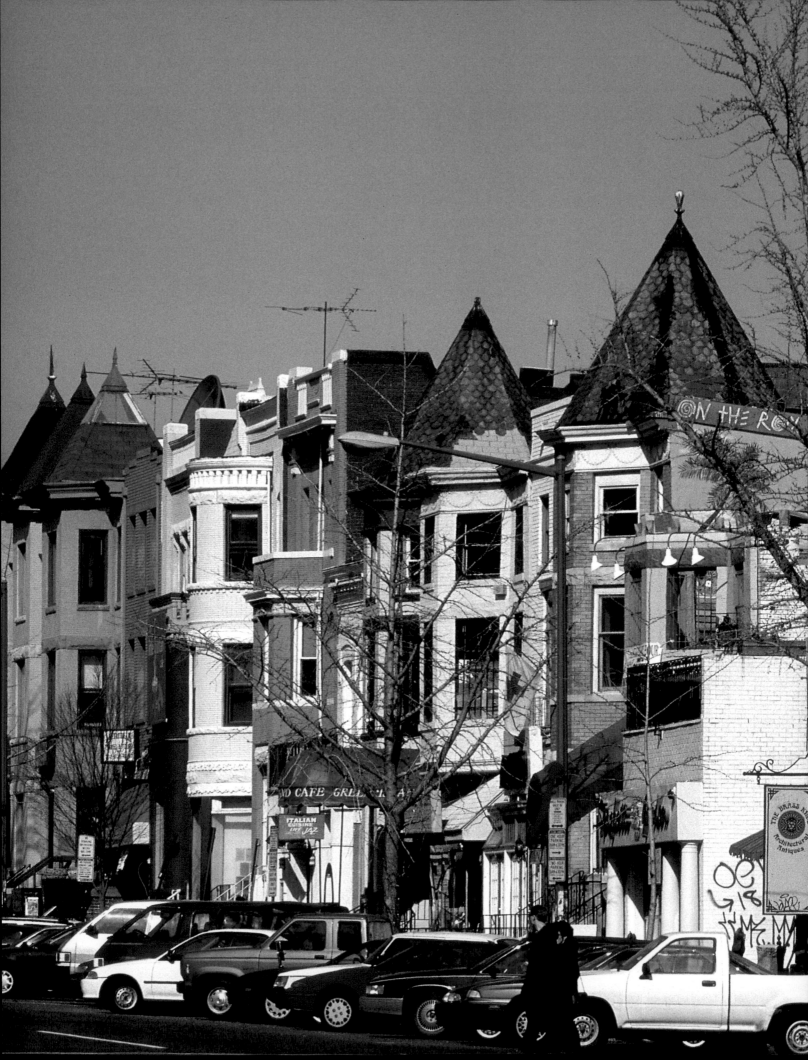

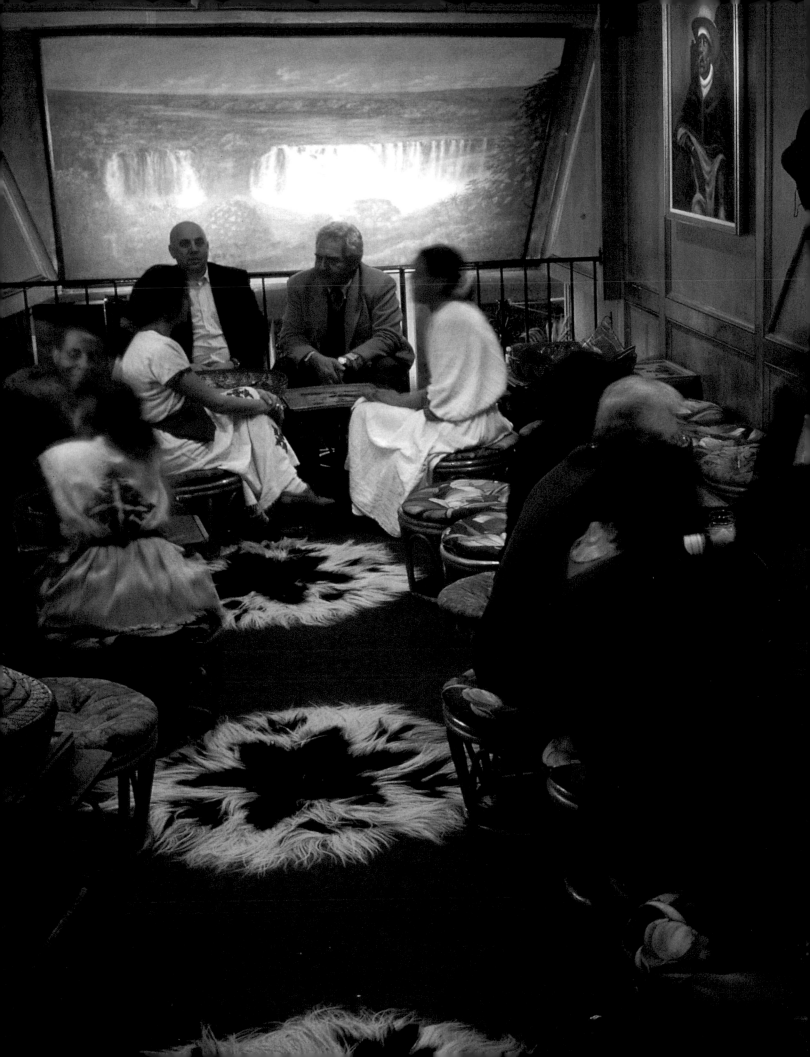

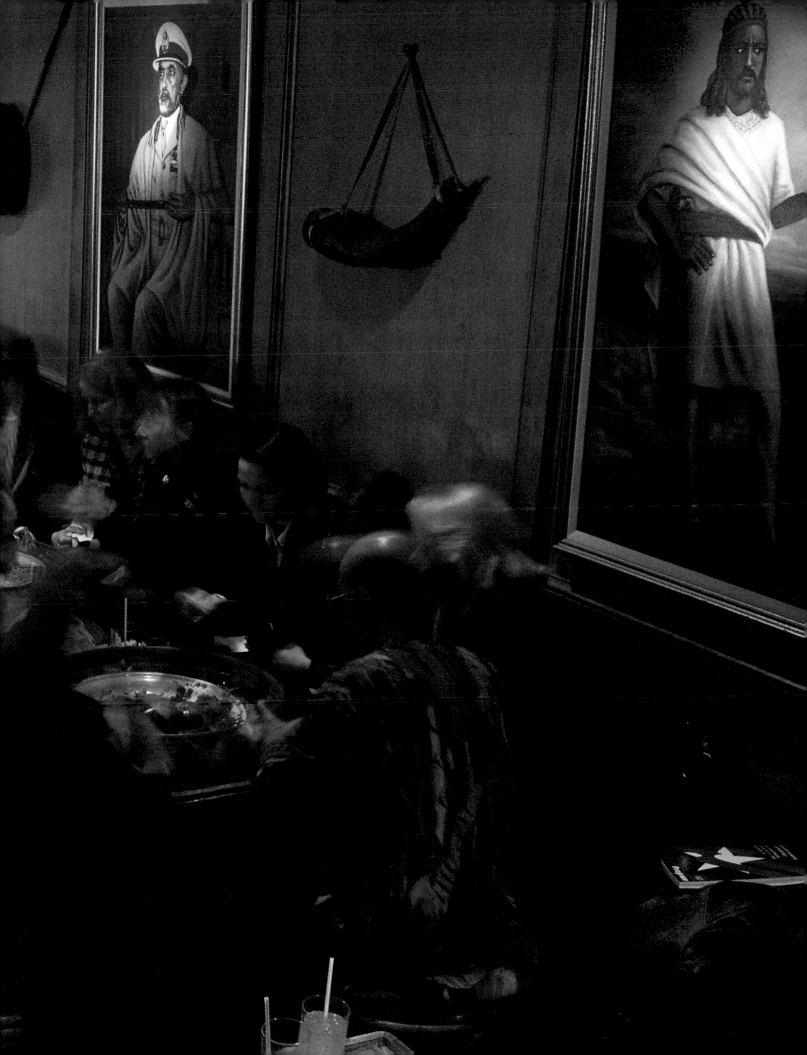

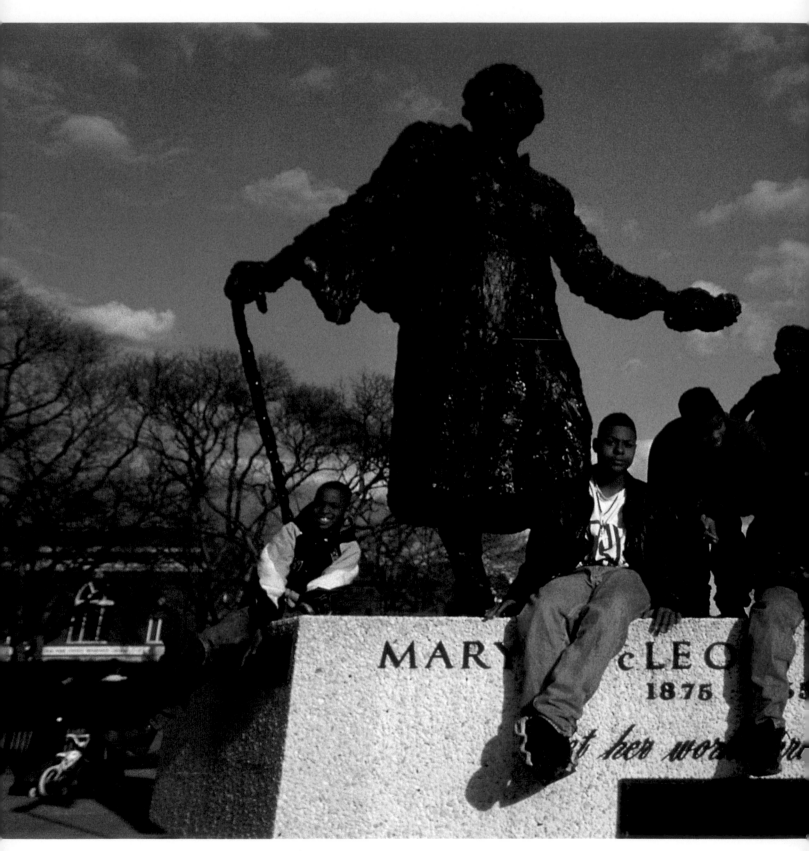

Monument to Mary McLeod Bethune, Lincoln Park

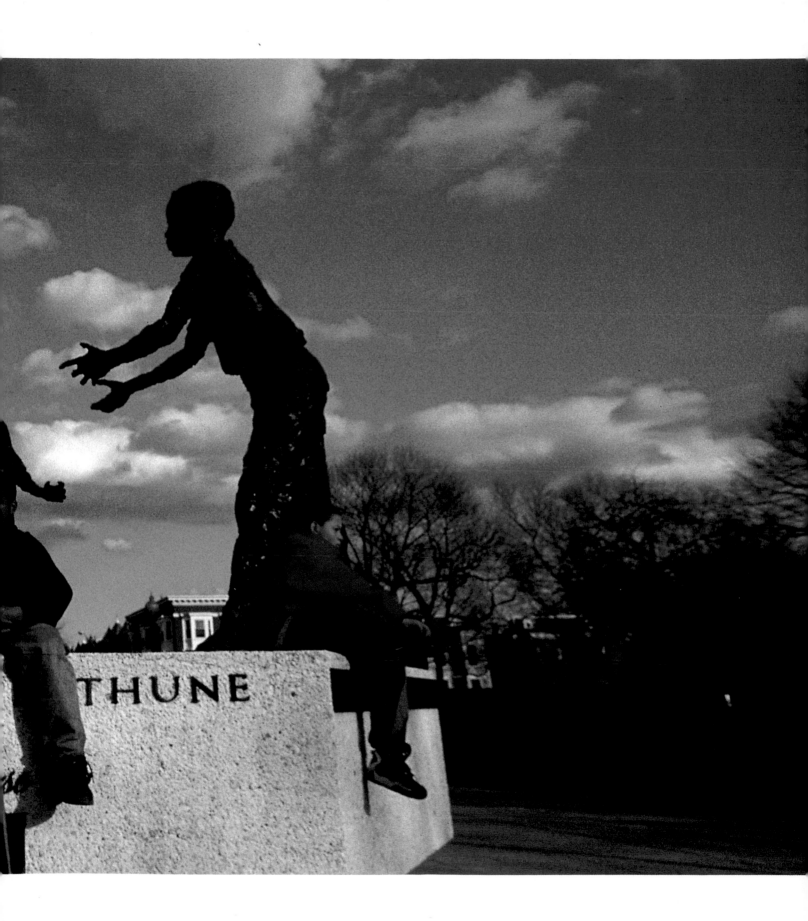

OVERLEAF: *U Street, Washington, D.C.*

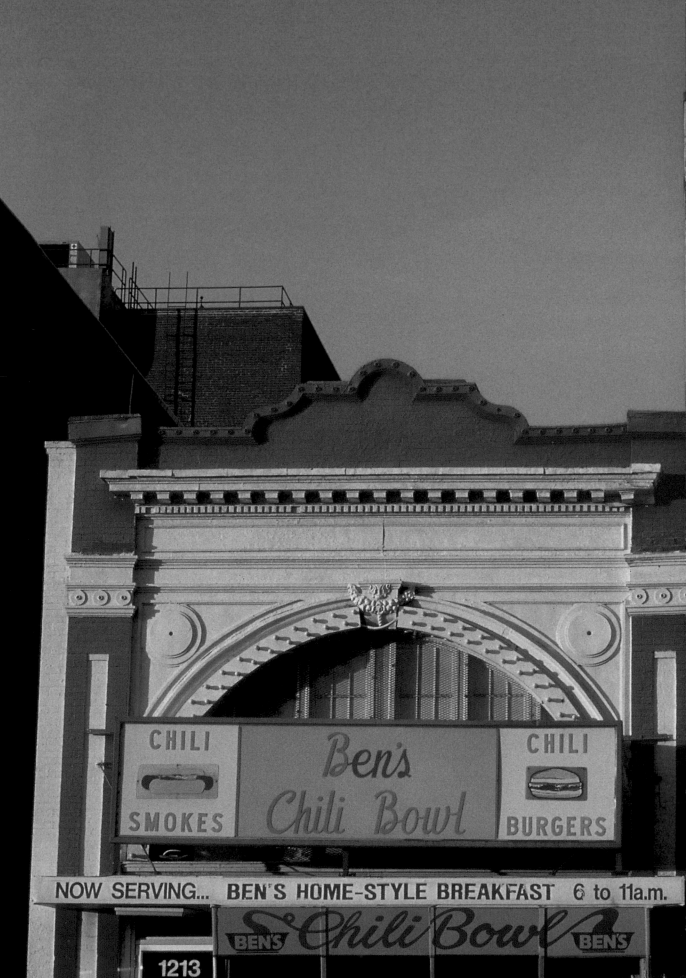

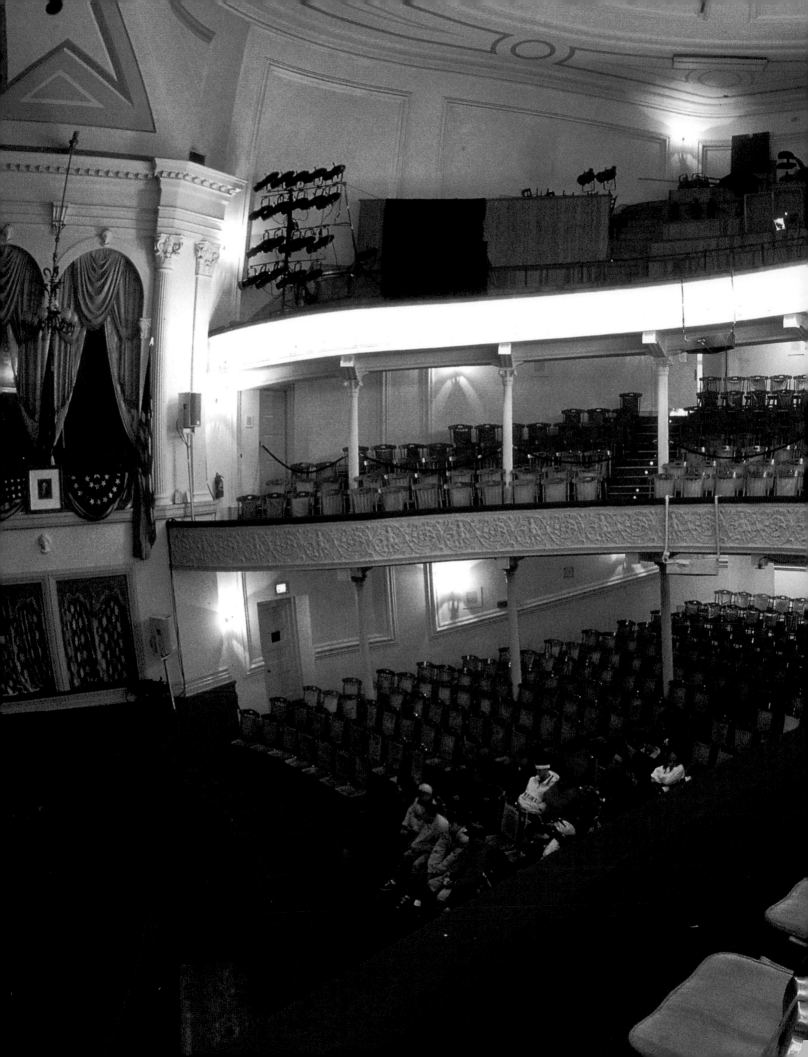

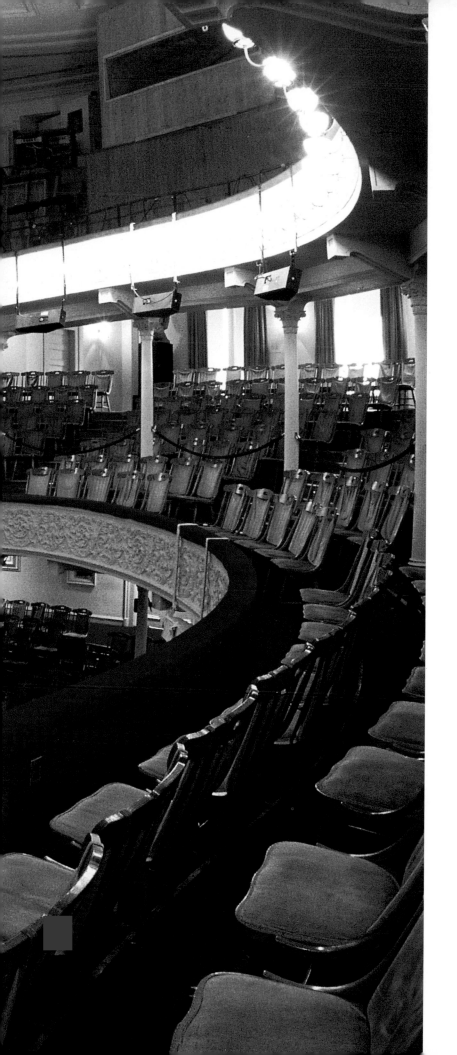

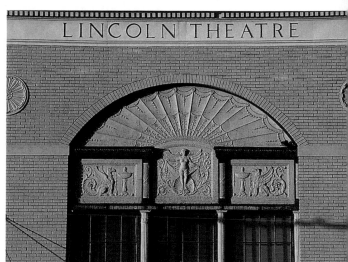

ABOVE: *The restored Lincoln Theatre on U Street*
LEFT: *The Ford Theater, site of President Abraham Lincoln's assassination*

OVERLEAF: *The John F. Kennedy Center for the Performing Arts, on the Potomac*
SECOND OVERLEAF: *Street signs en route to Great Falls National Park*

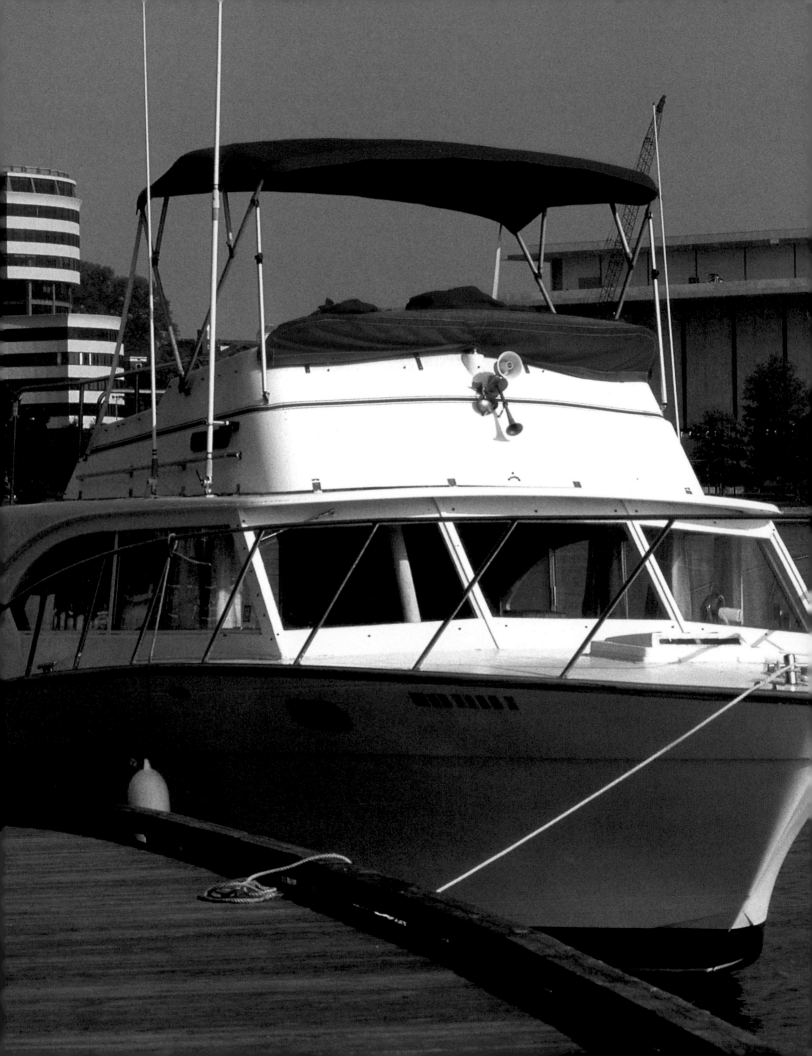

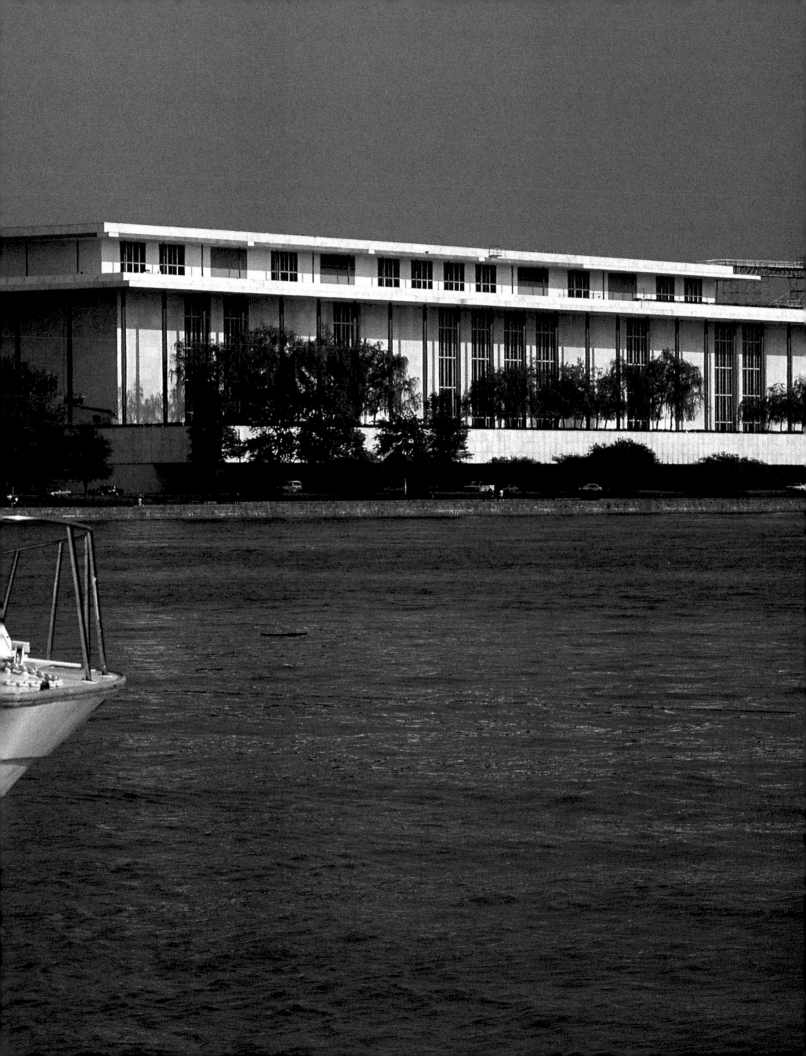

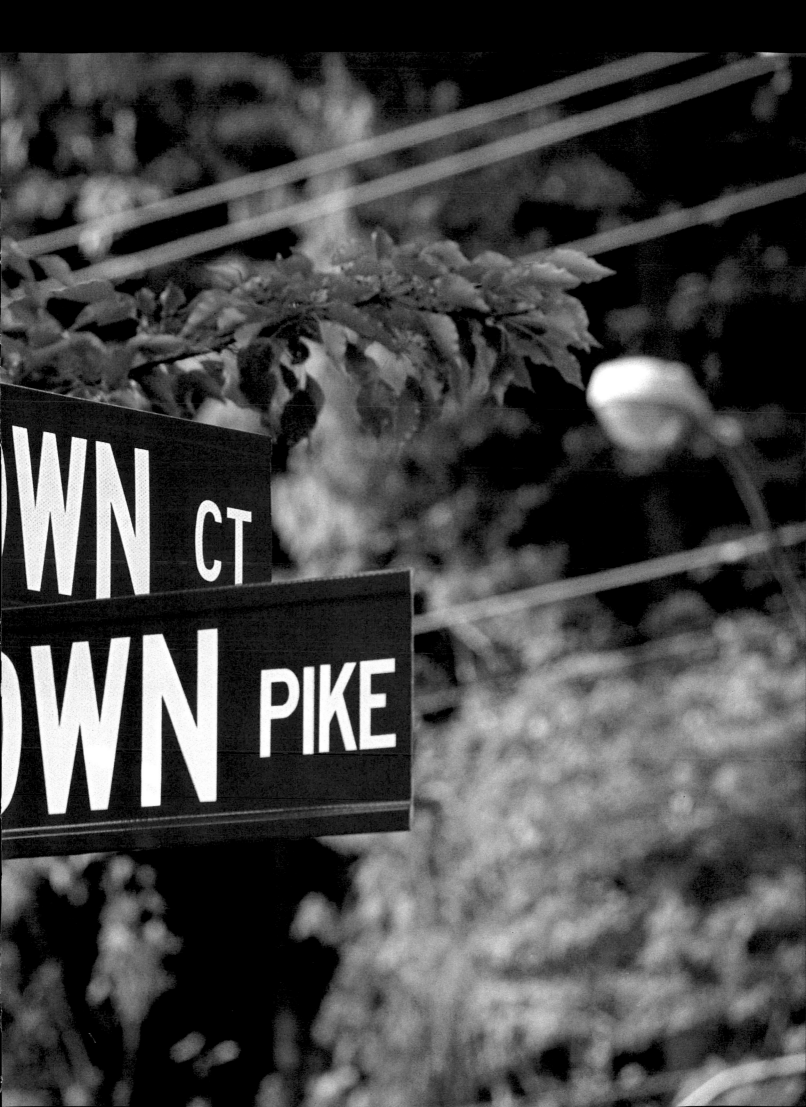

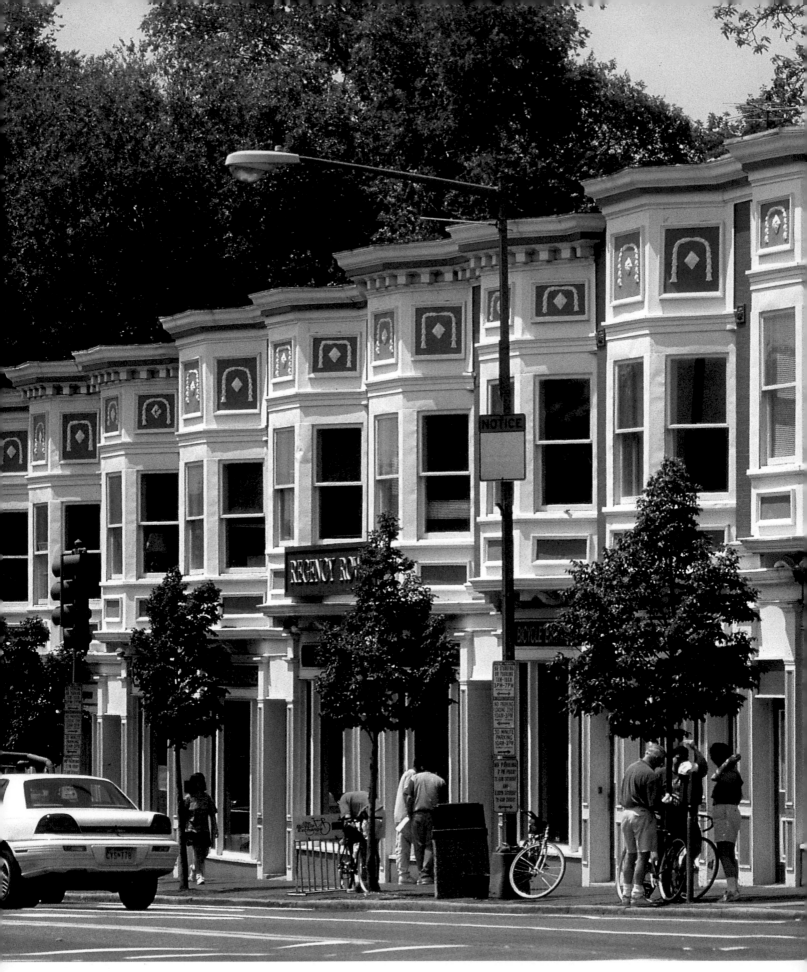

Shops on M Street

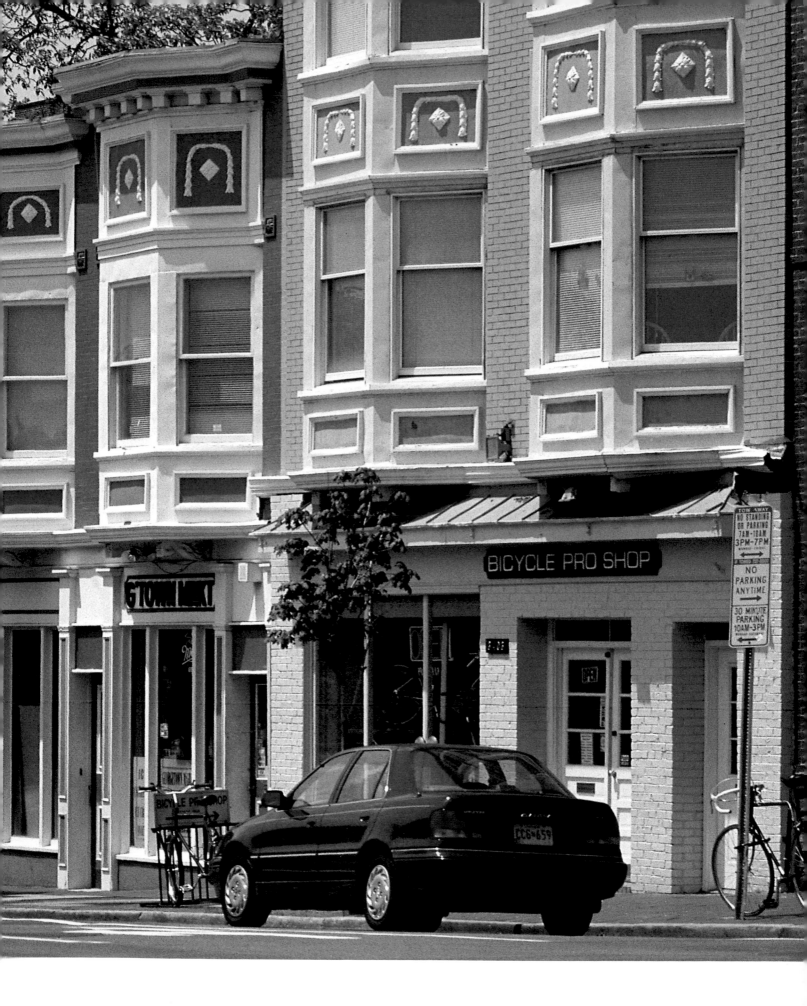

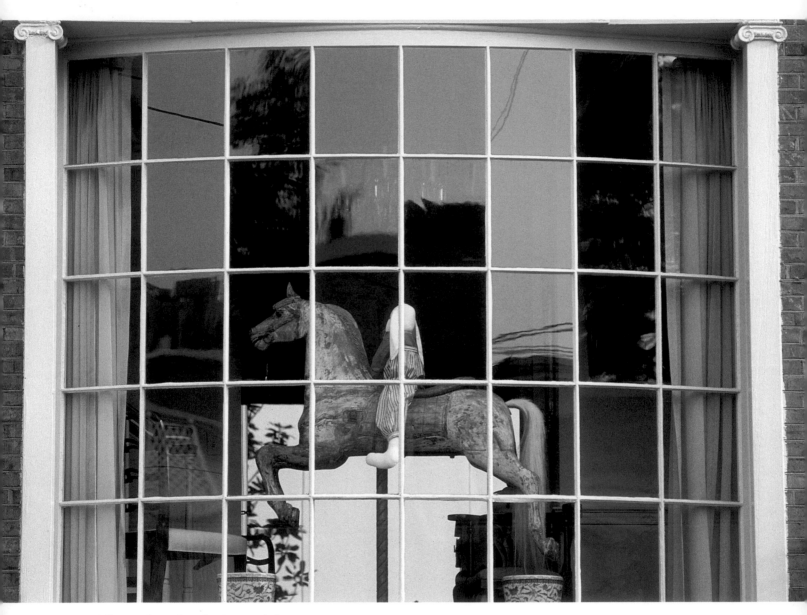

Folk art sculpture in a Georgetown window

Windows of colonial homes in Georgetown

ABOVE: *Furniture store in Georgetown* RIGHT: *Door of a Georgetown home*

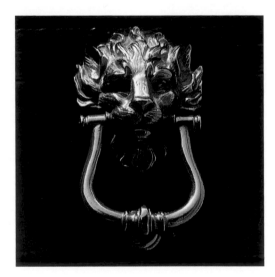

Doorknocker on a Georgetown home

OVERLEAF: *Café Milano, Georgetown*

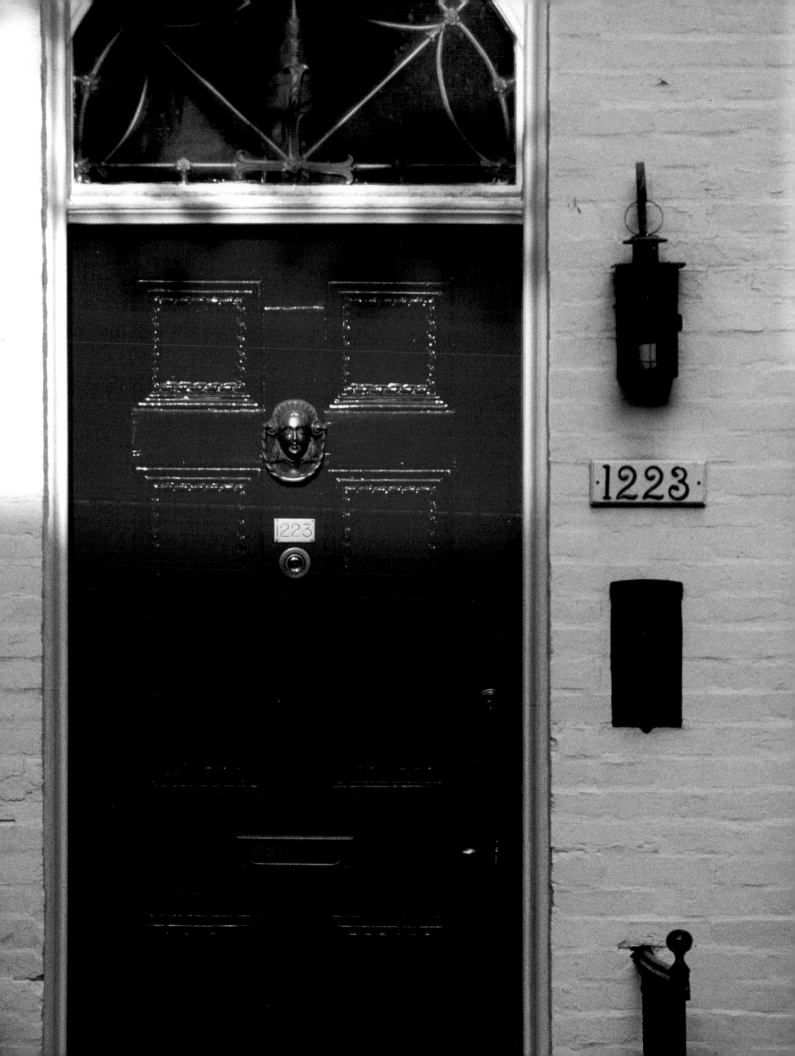

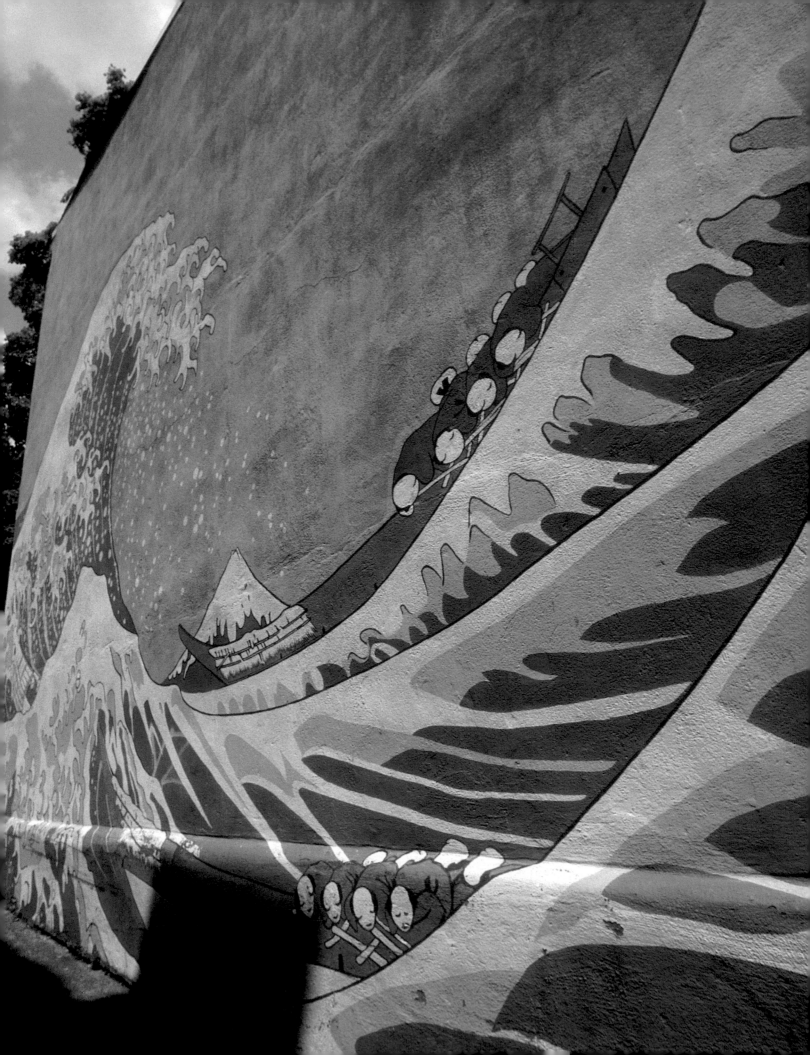

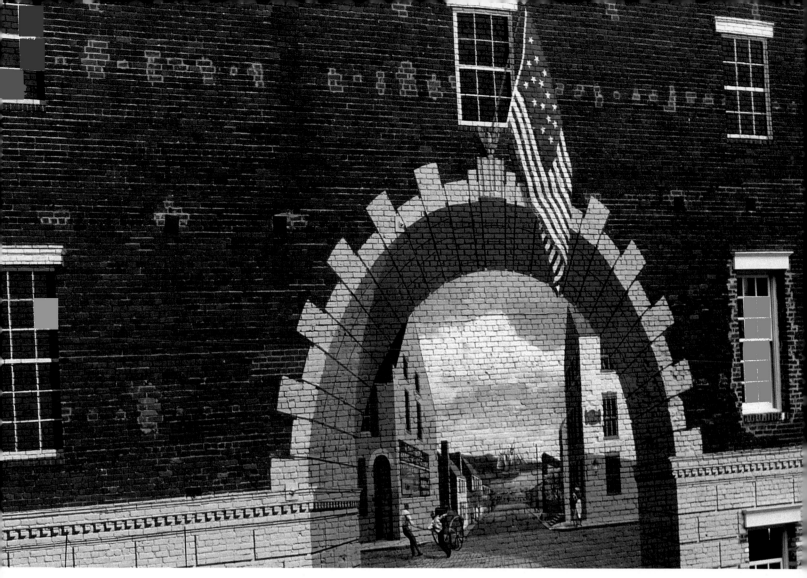

ABOVE: *Mural at the Old Glory Restaurant on M Street, Georgetown*
LEFT: *"The Great Wave Off Kanagawa." A Georgetown mural inspired by the famous Japanese woodblock print*

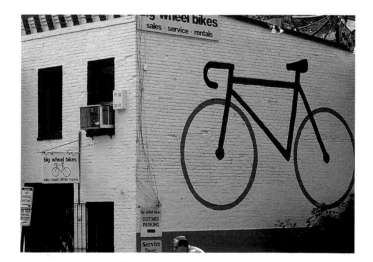

Bicycle shop, Georgetown

OVERLEAF: *The garden of Mr. & Mrs. Charles Egbert, Georgetown*

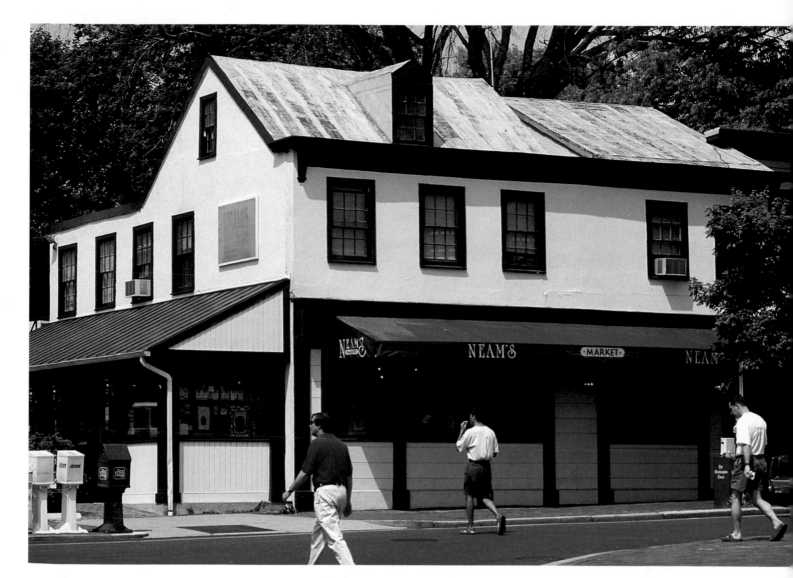

LEFT: *Georgetown restaurant* ABOVE: *Neam's, a Georgetown landmark*

OVERLEAF: *Georgetown*

Door detail, private residence, Georgetown

Old fire box, Georgetown

Fence in Georgetown

OVERLEAF: *Shops, Georgetown*

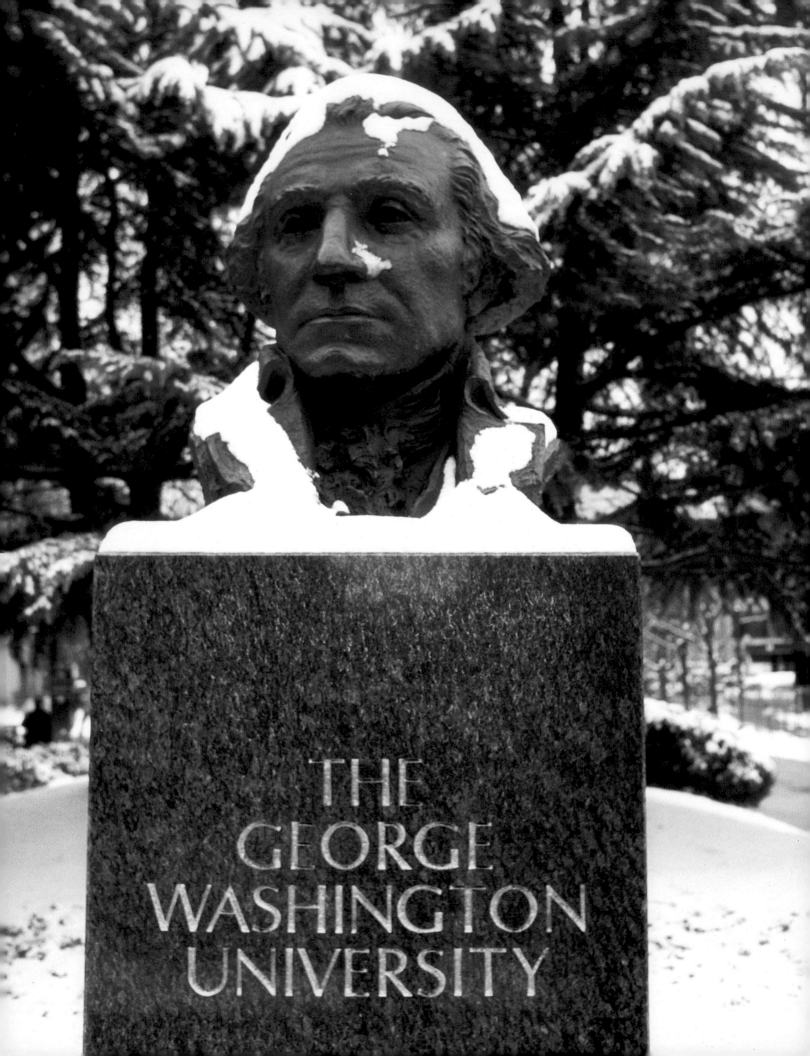

THE
GEORGE
WASHINGTON
UNIVERSITY

LEFT· *Bust of George Washington at George Washington University* ABOVE: *Campus of George Washington University*

OVERLEAF: *Campus of George Washington University*
SECOND OVERLEAF: *The Washington Monument in the springtime*

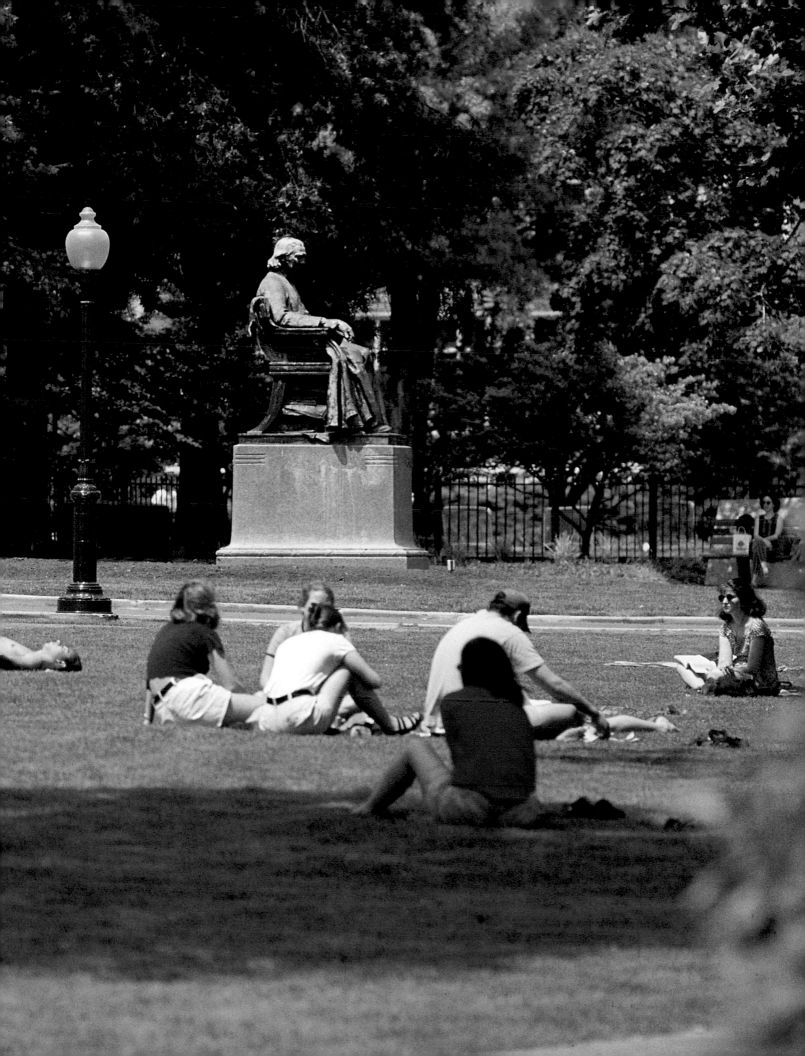

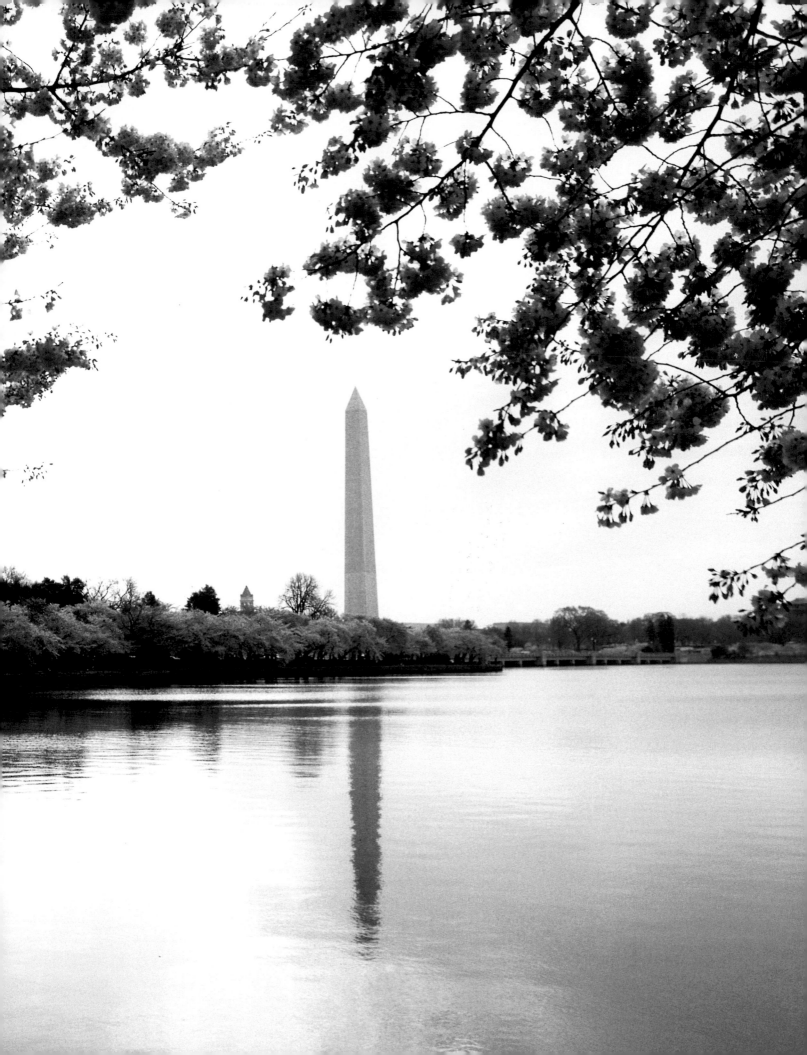

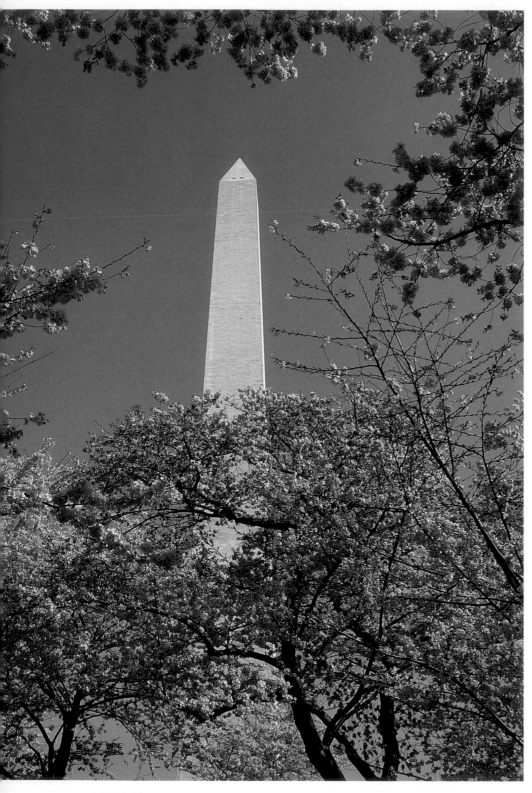

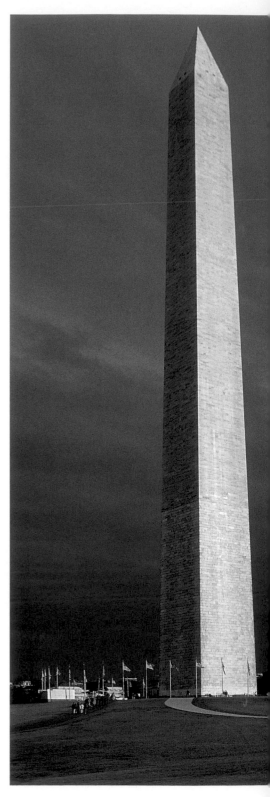

The Washington Monument

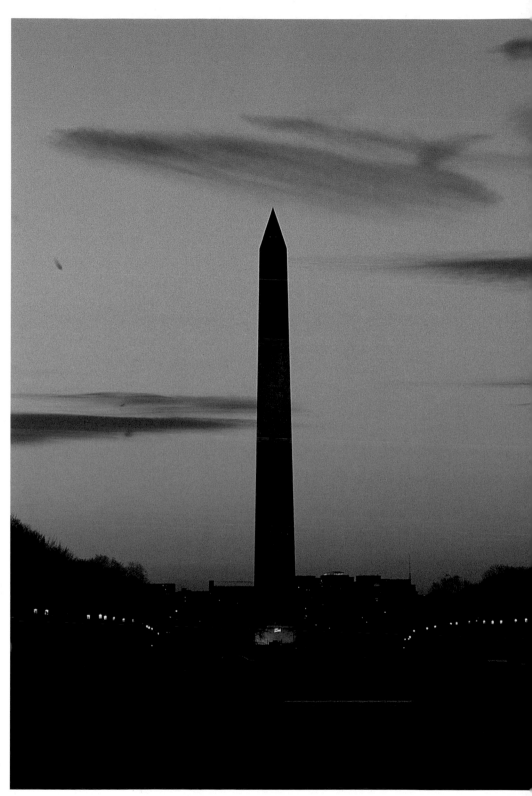

OVERLEAF: *A night view of the Lincoln Memorial, the Washington Monument, and the Capitol*

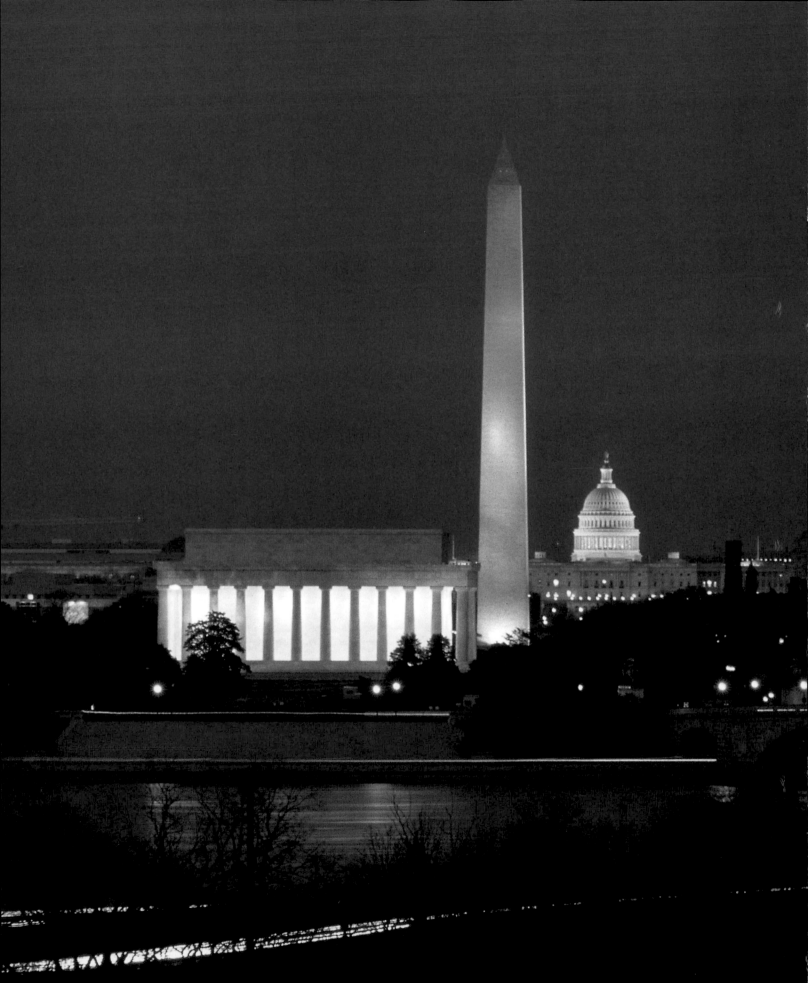

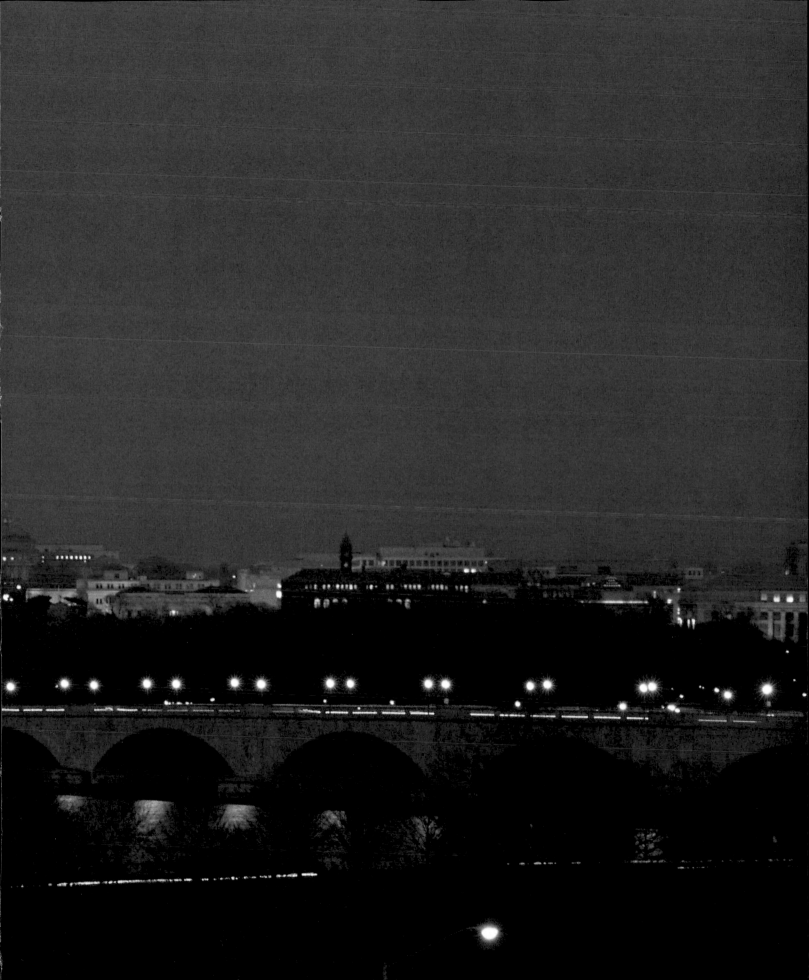

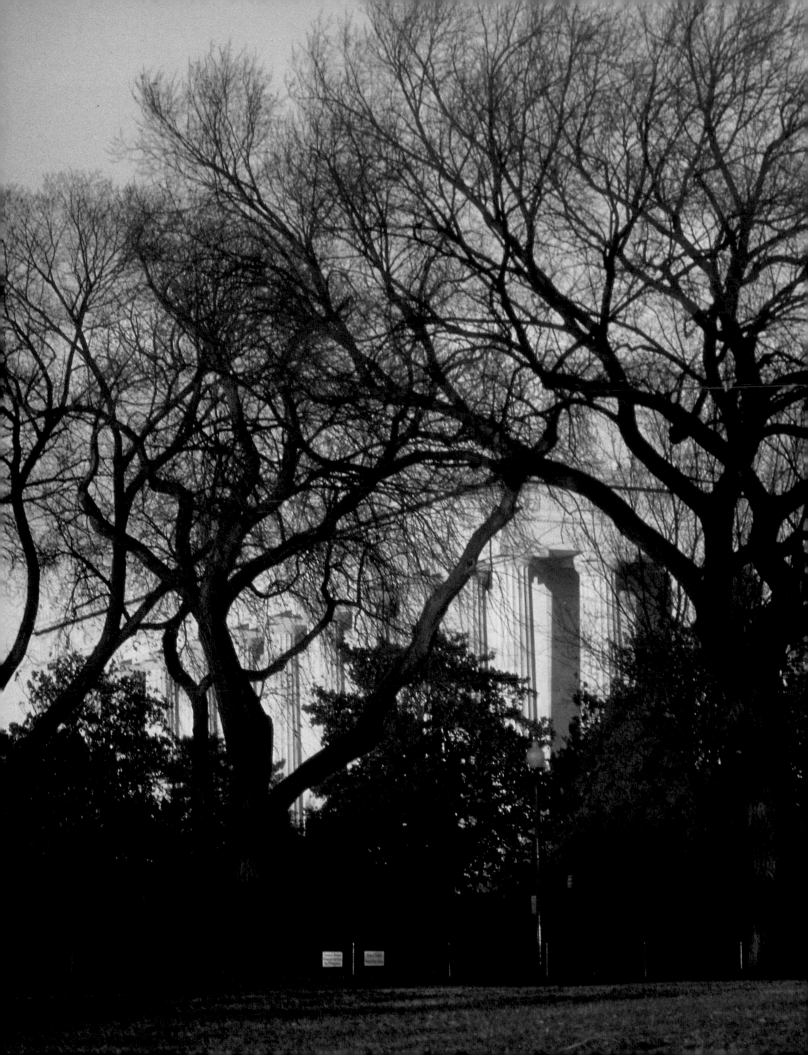

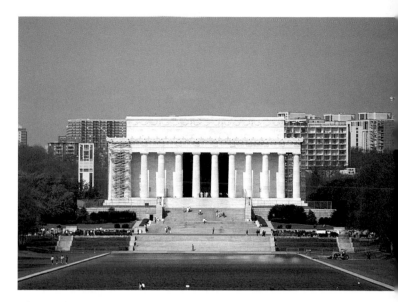

The Lincoln Memorial

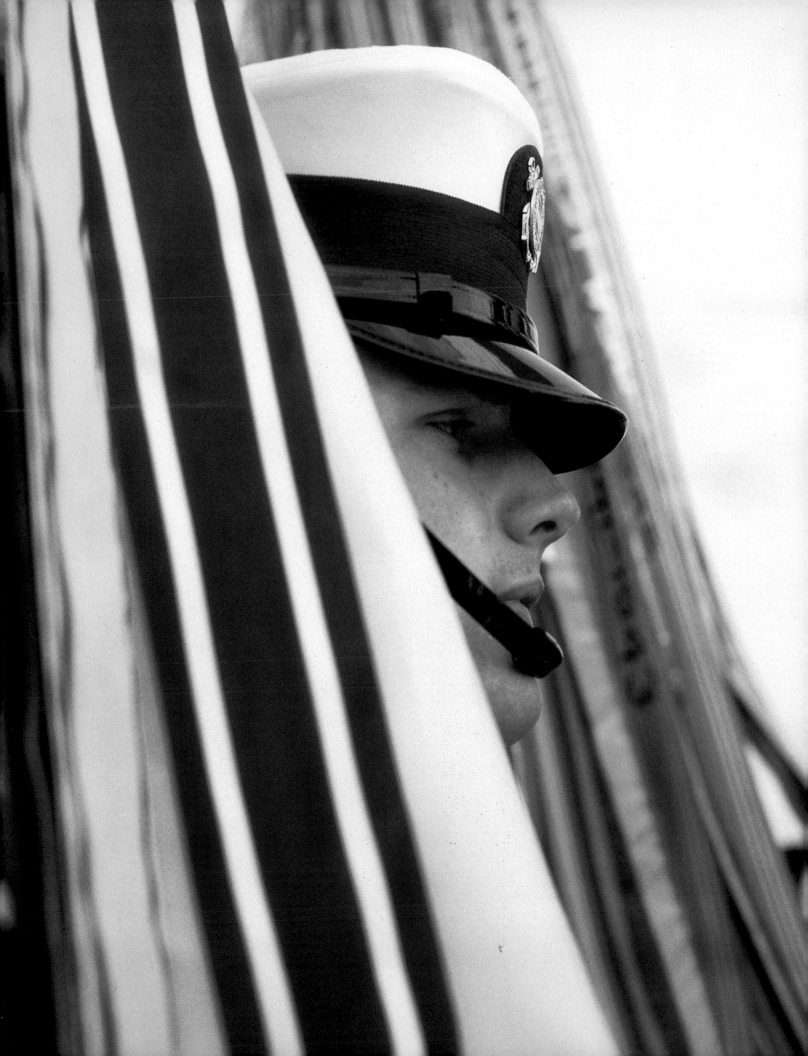

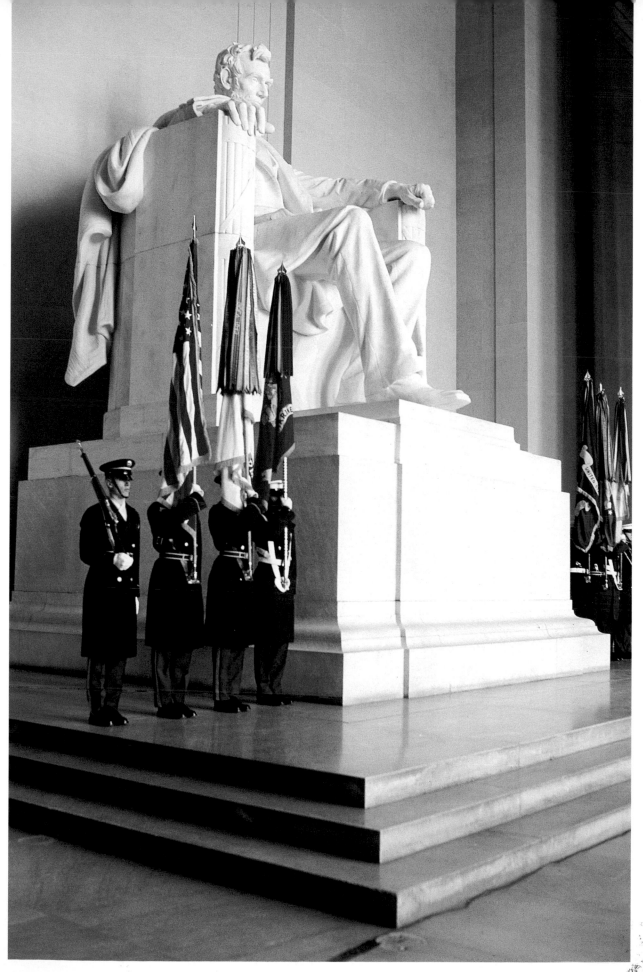

LEFT, ABOVE, AND OVERLEAF: *Ceremony commemorating Abraham Lincoln's birthday at the Lincoln Memorial*

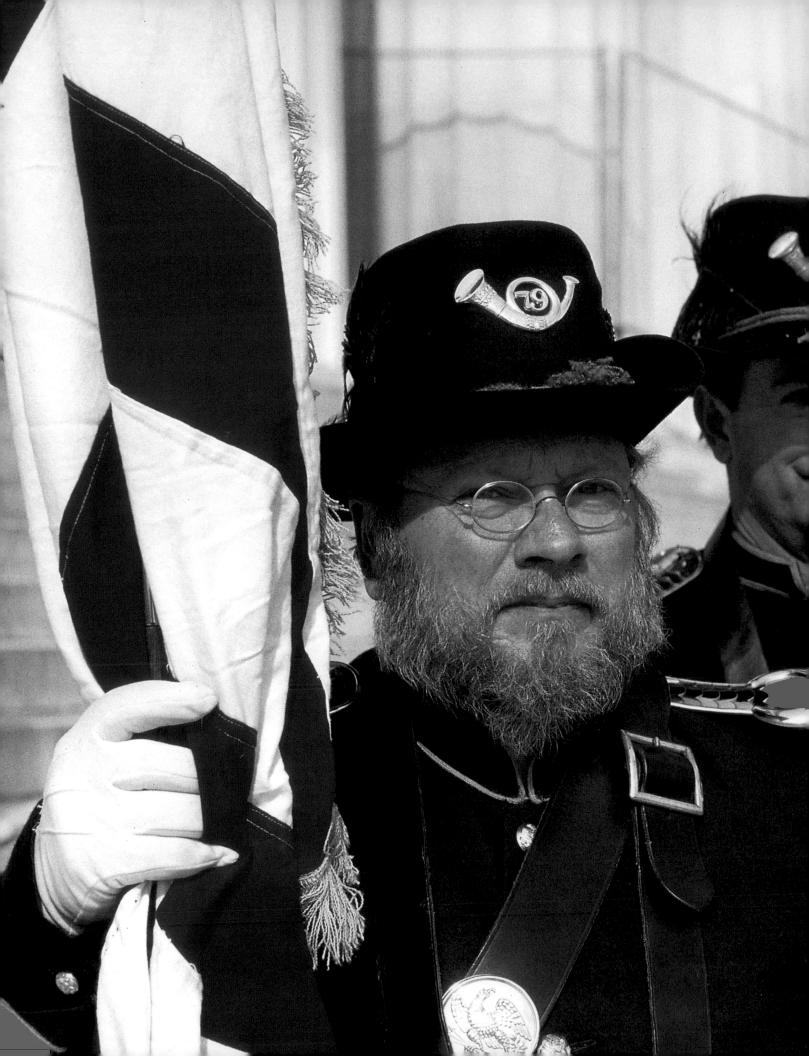

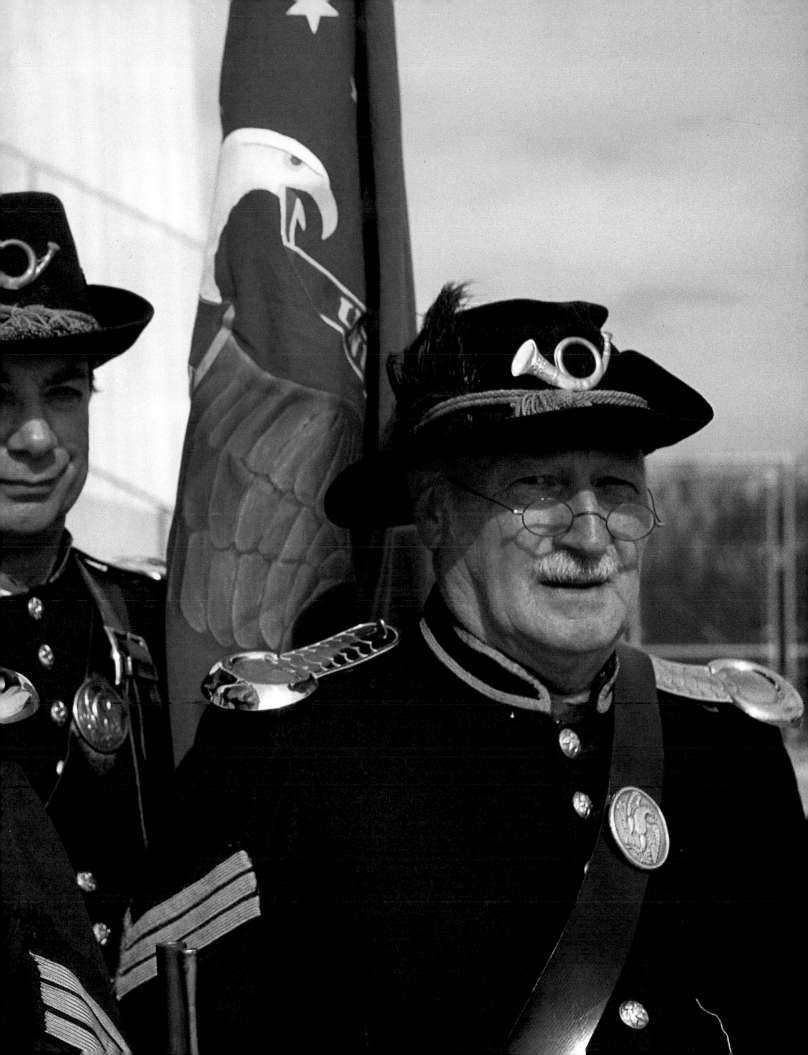

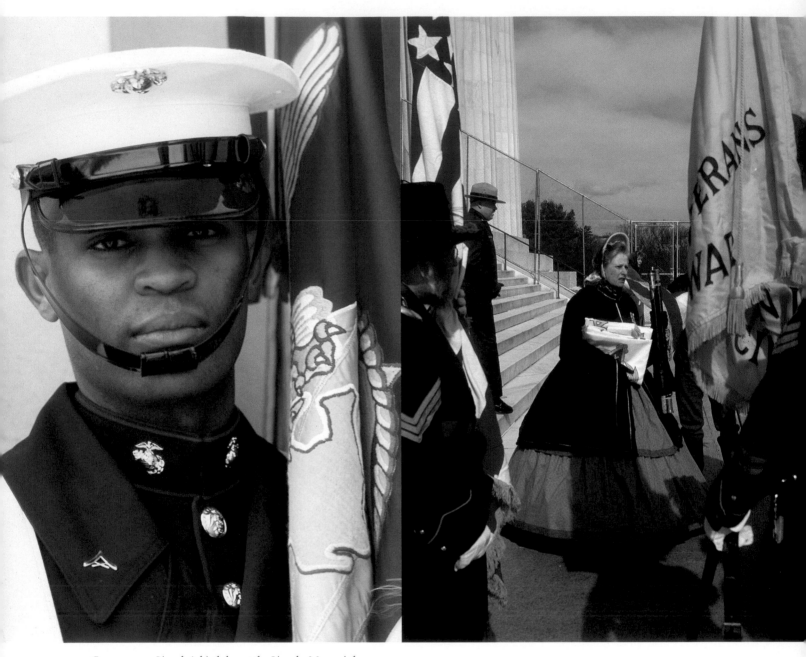

Ceremony on Lincoln's birthday at the Lincoln Memorial

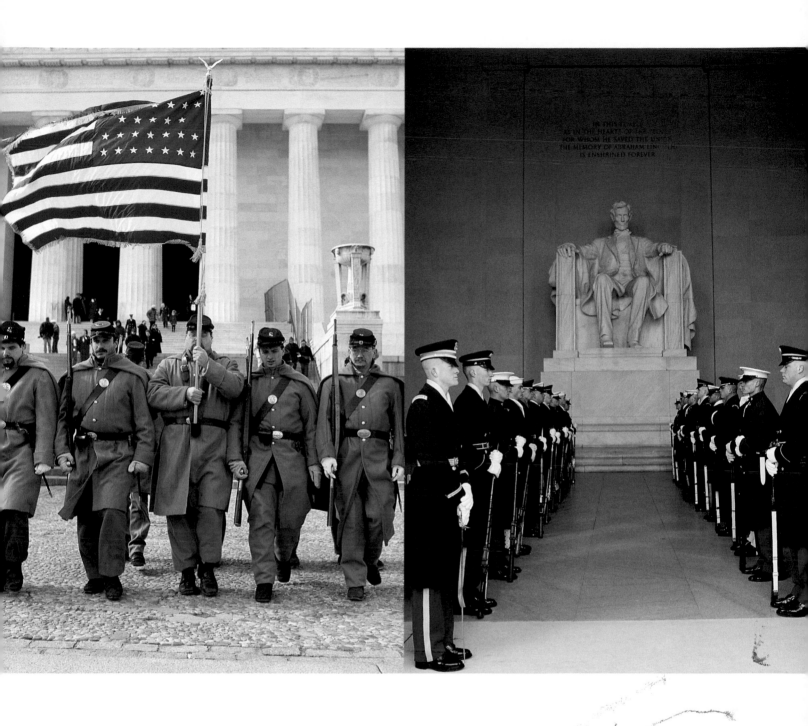

OVERLEAF: *View of the Jefferson Memorial through cherry blossoms*

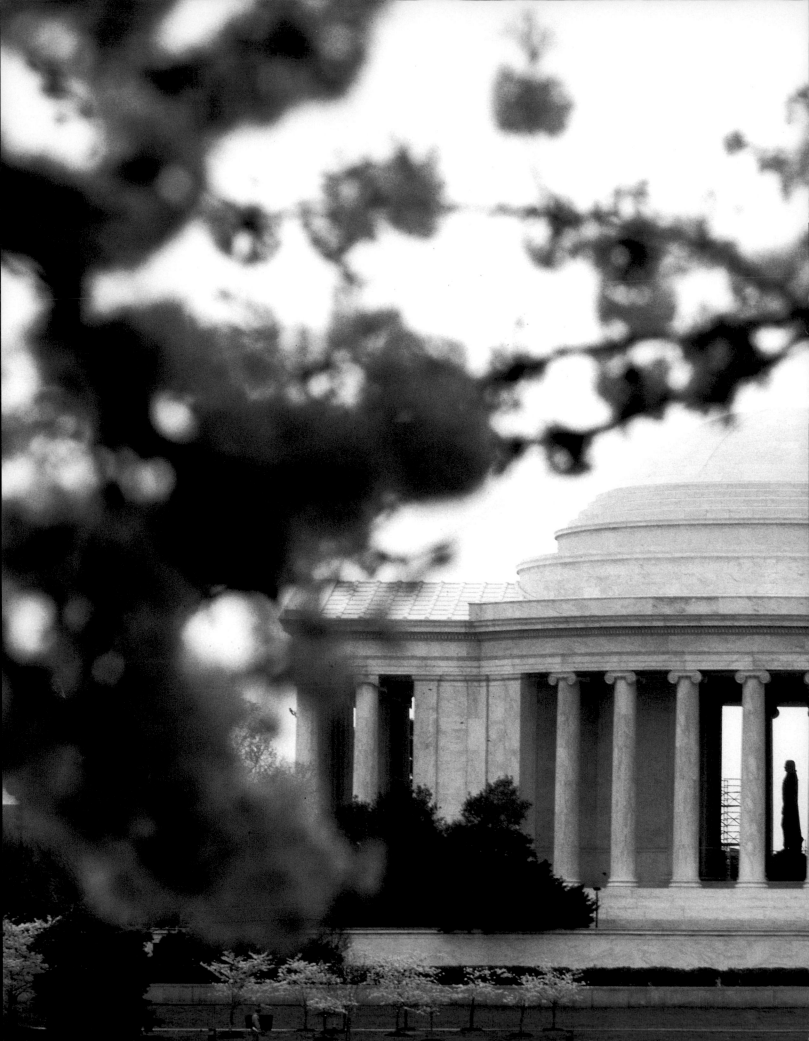

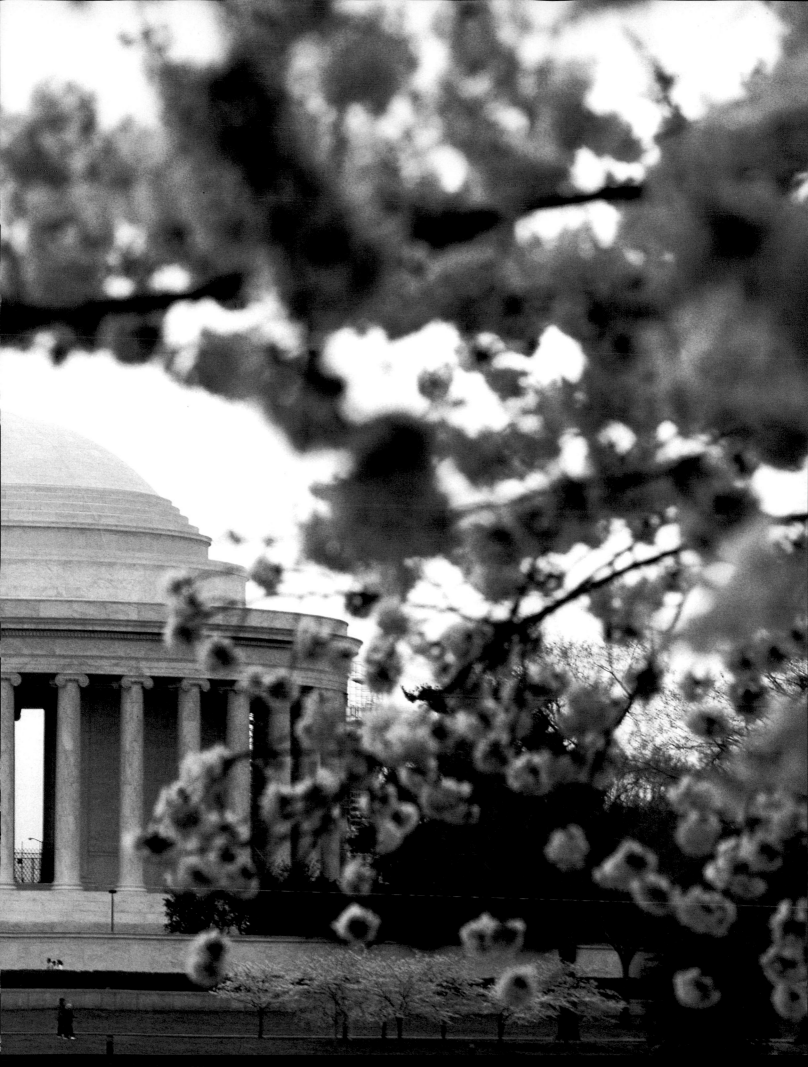

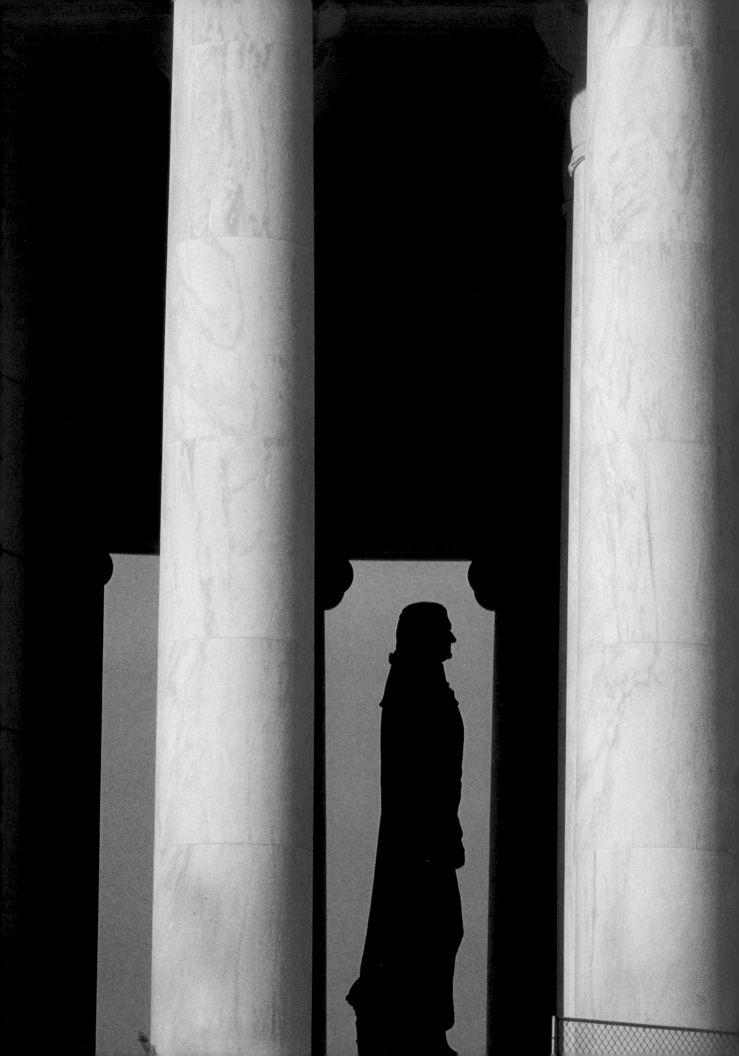

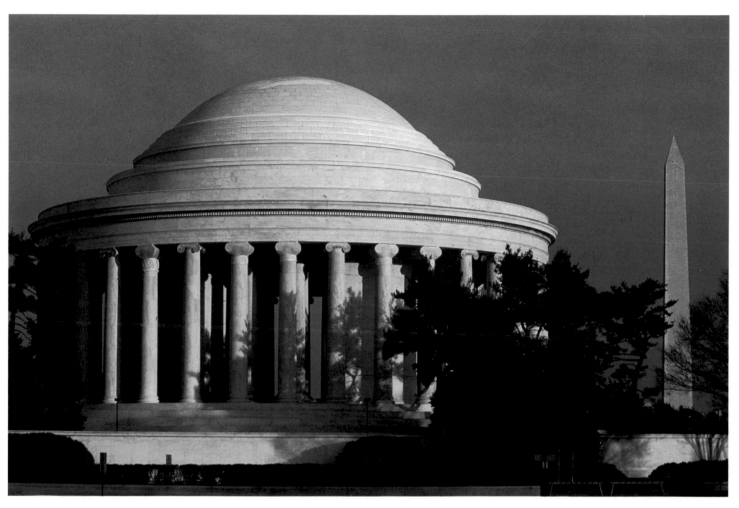

LEFT: *Silhouette of Thomas Jefferson in the Jefferson Memorial* ABOVE: *The Jefferson Memorial and the Washington Monument in the distance*

OVEROVERLEAF: *Statue of Andrew Jackson, Lafayette Square*
SECOND OVERLEAF: *The Falls of the Potomac, Great Falls National Park*

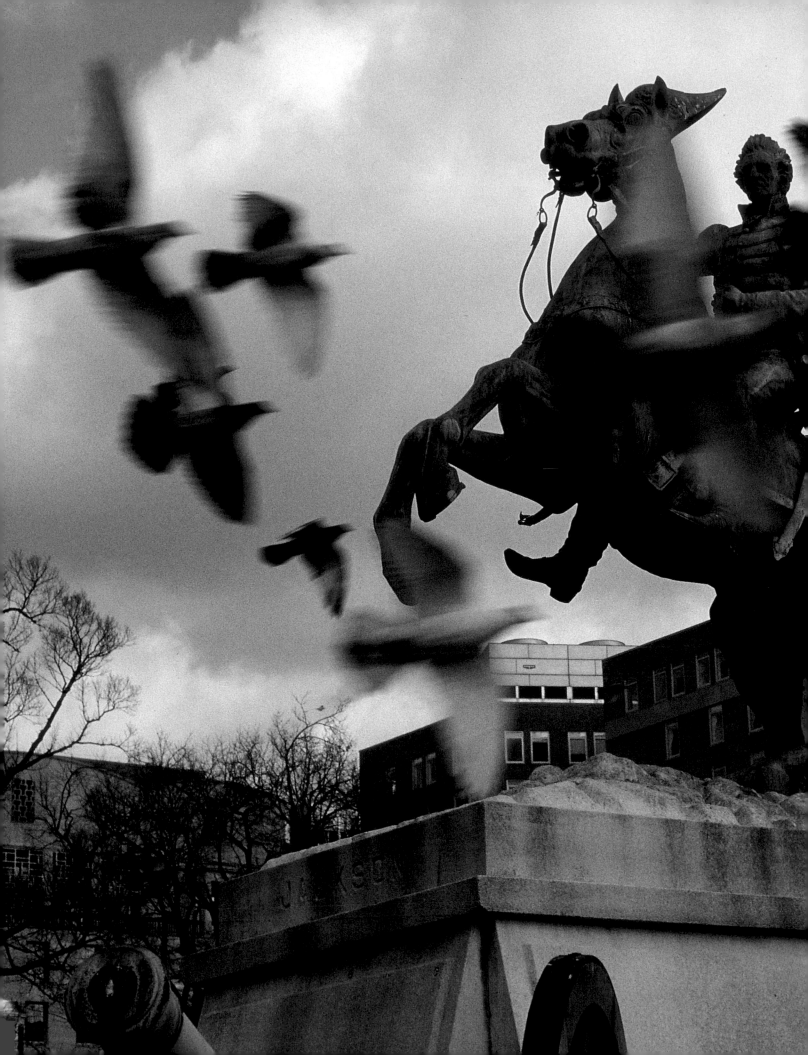

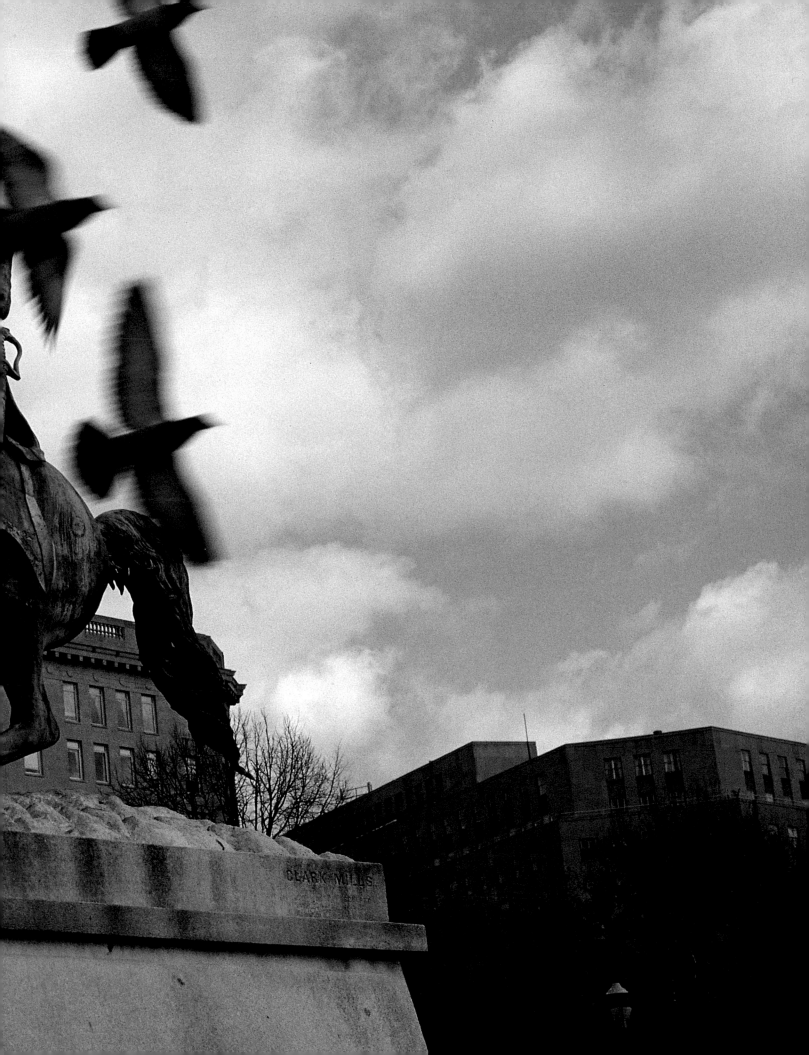

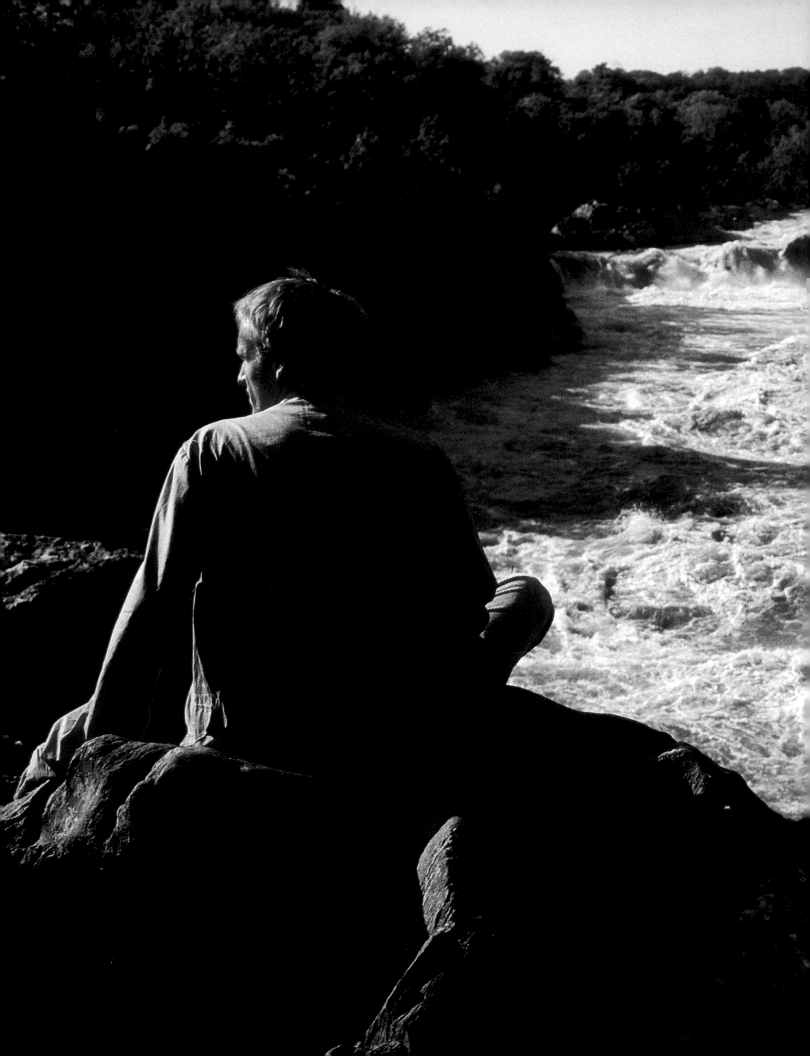

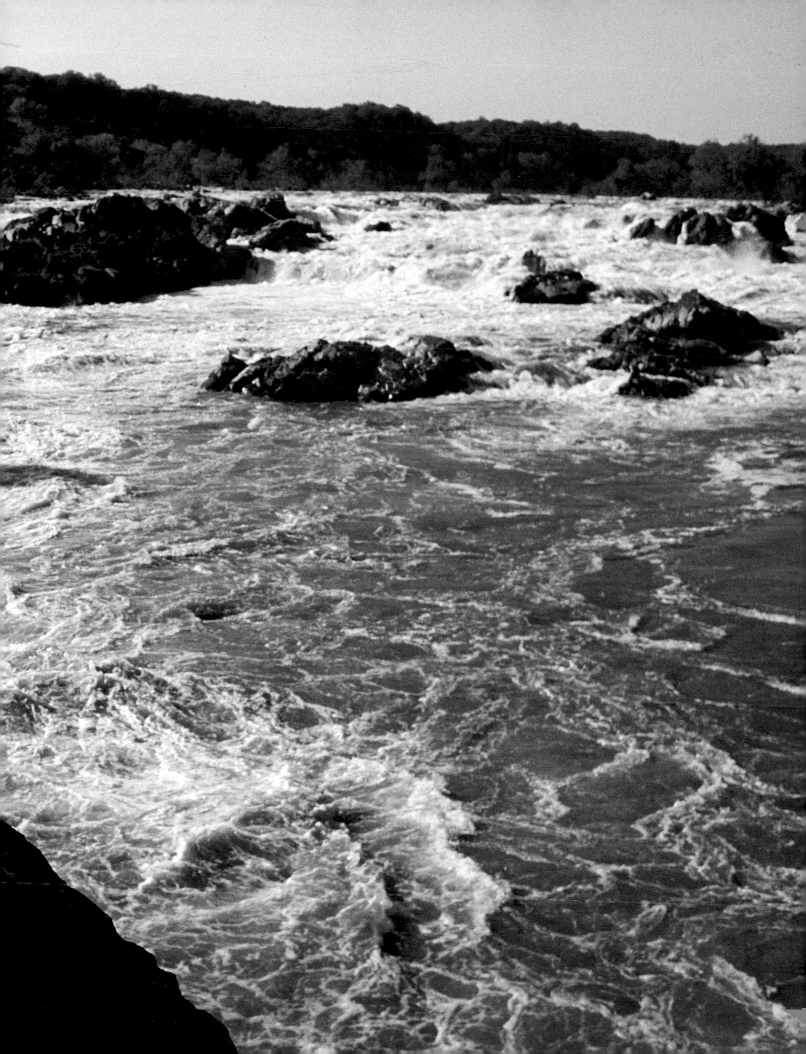

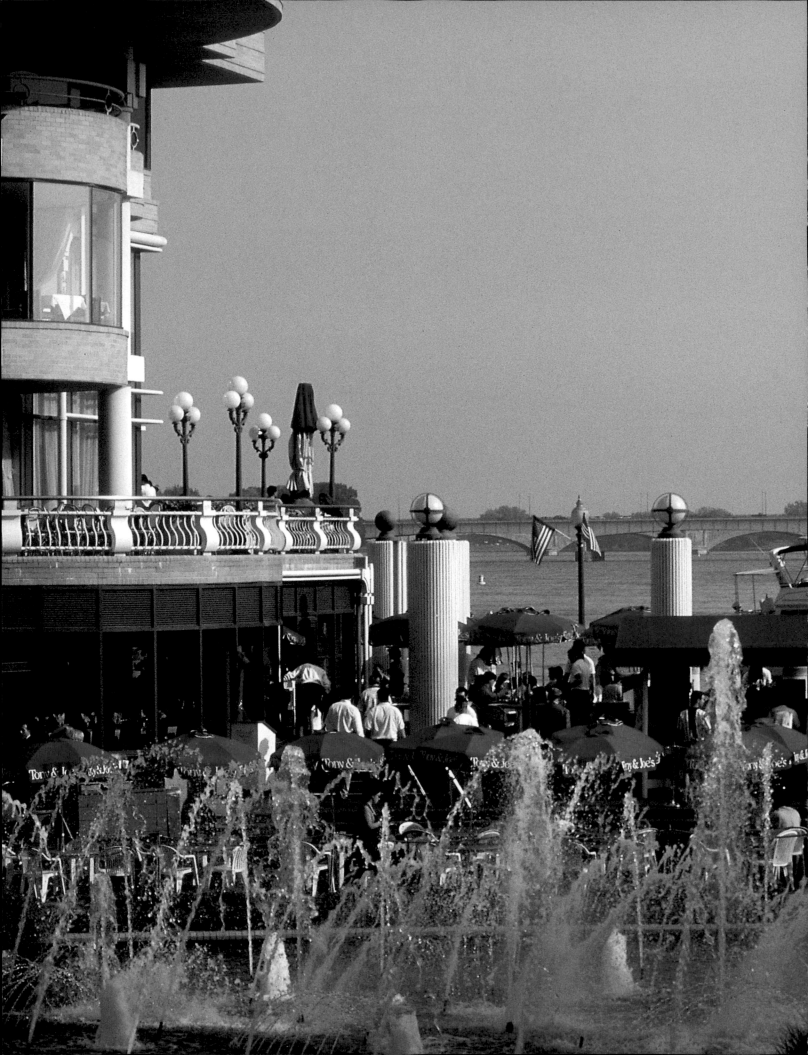

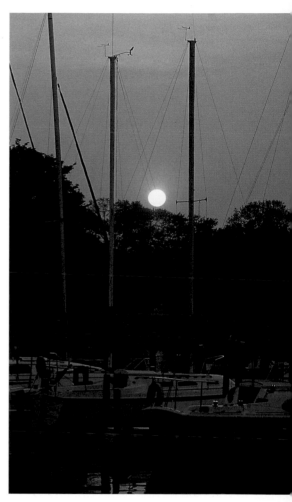

ABOVE: *Sunset over Washington Harbor*
LEFT: *A view of the Potomac from the Harbor*

OVERLEAF: *Cherry trees in bloom*
SECOND OVERLEAF: *Hsing Hsing, the panda at the National Zoological Park, a gift from the People's Republic of China; Lion guarding the entrance of The Corcoran Gallery of Art*

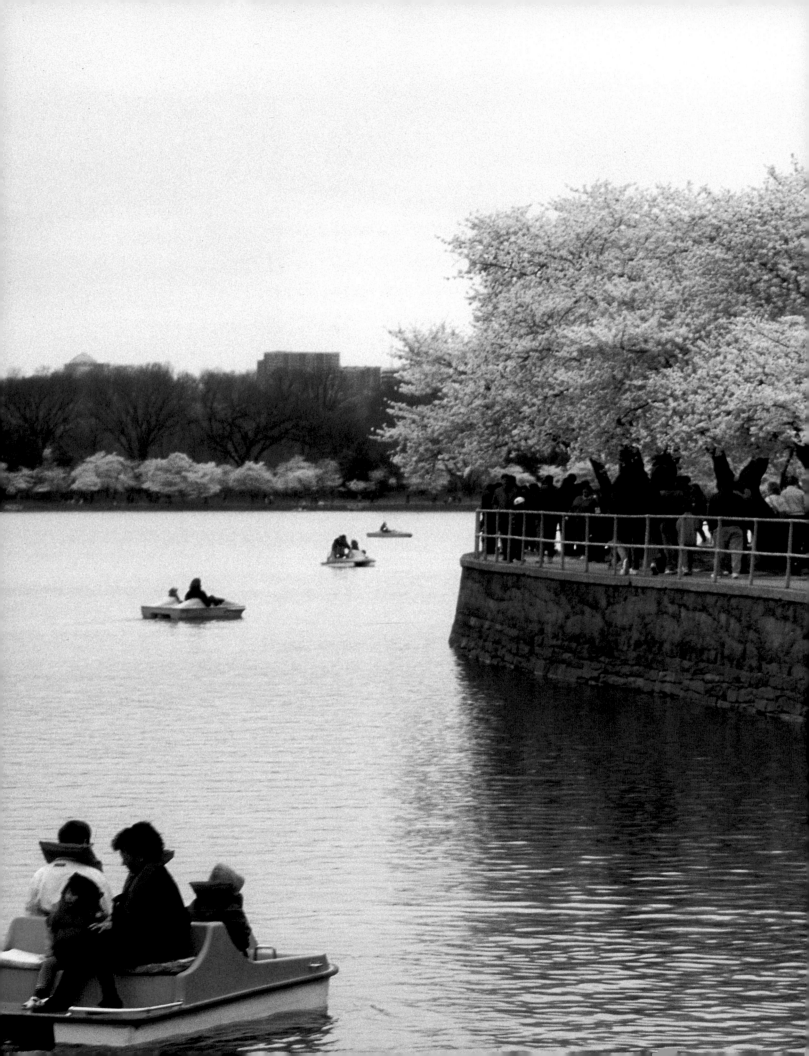

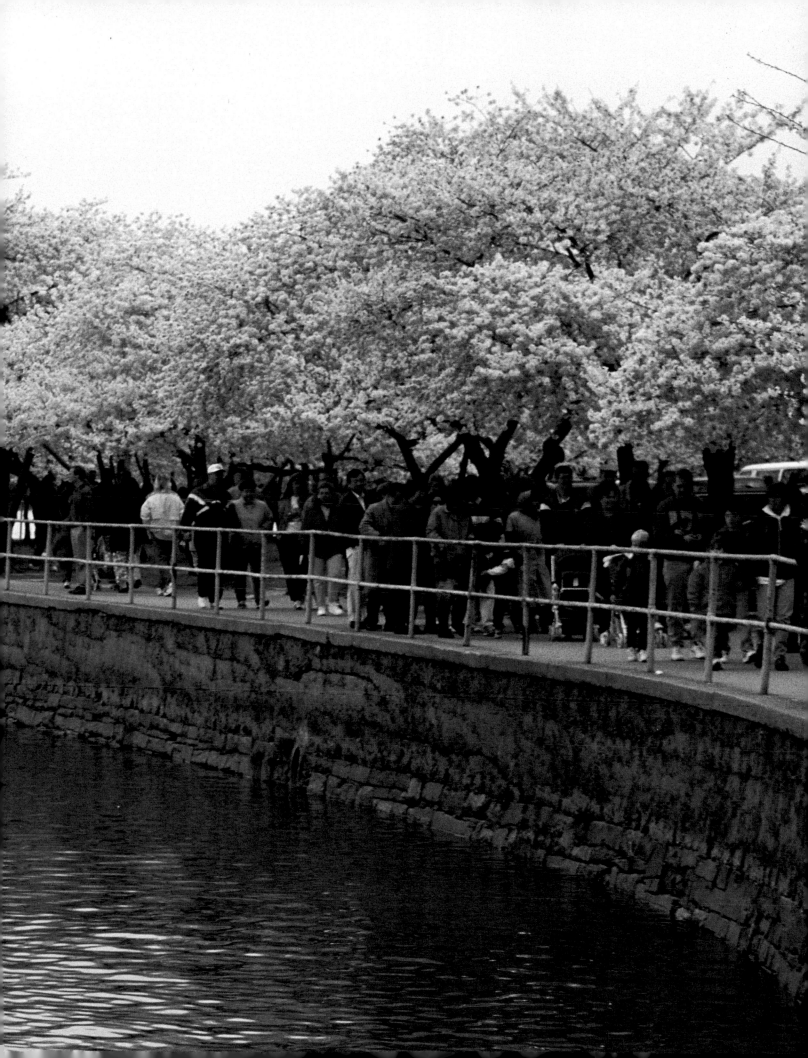

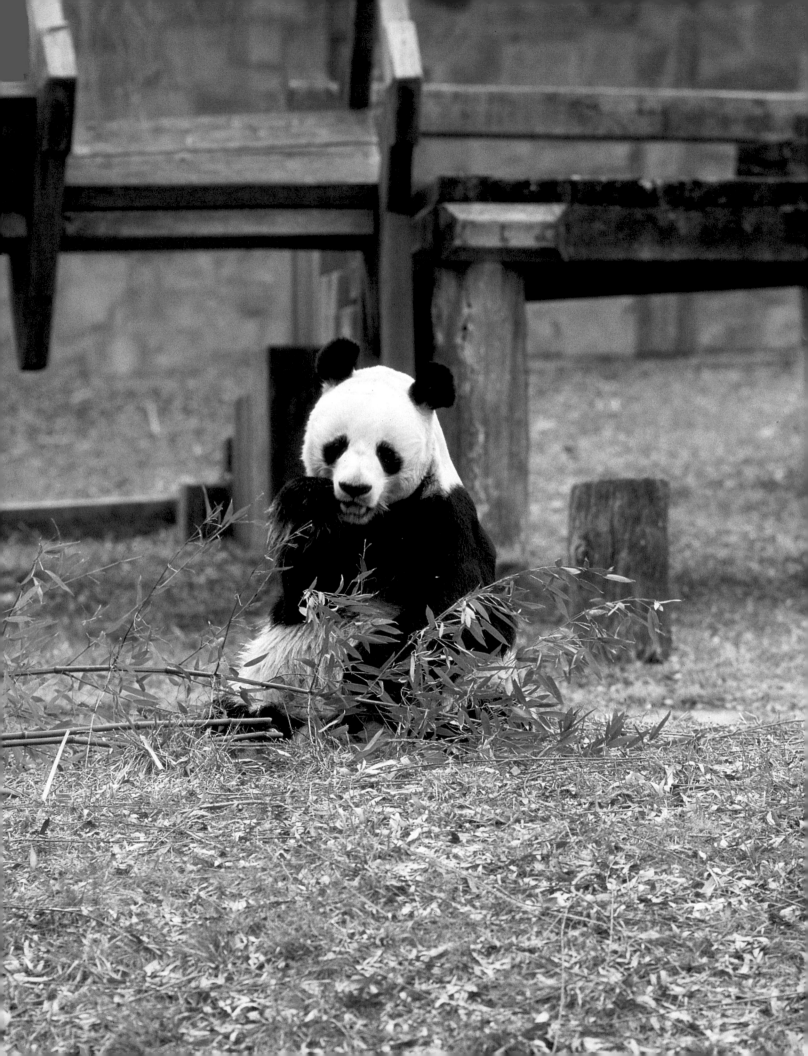

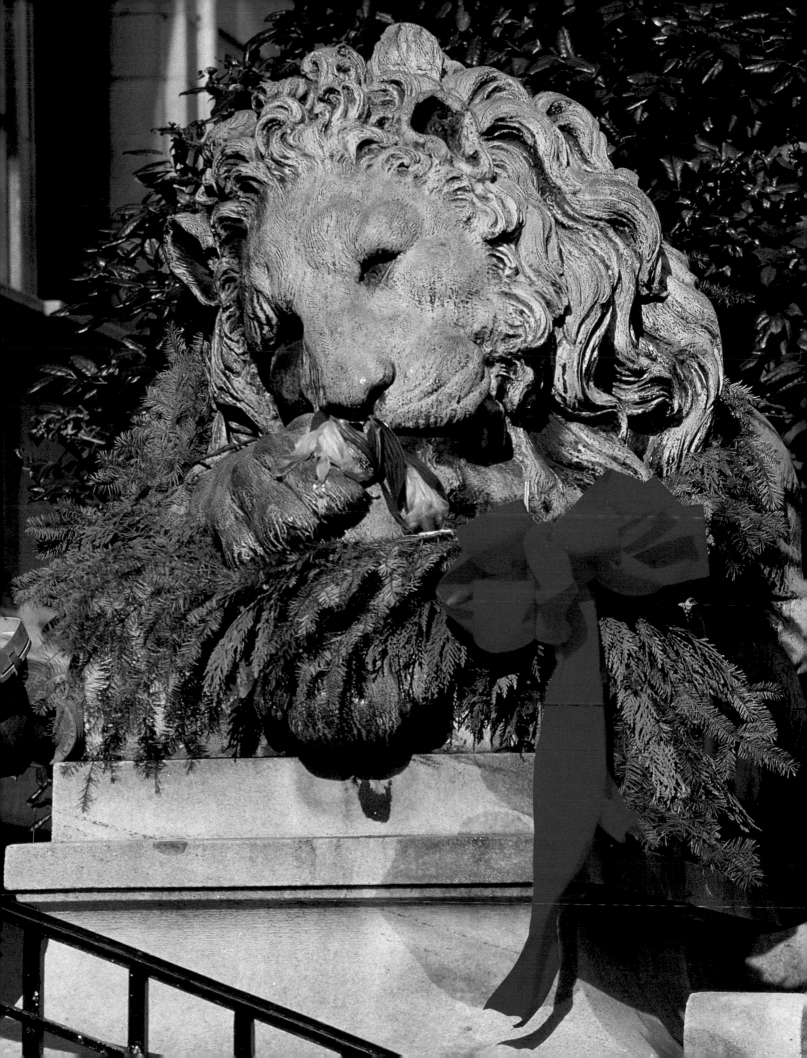

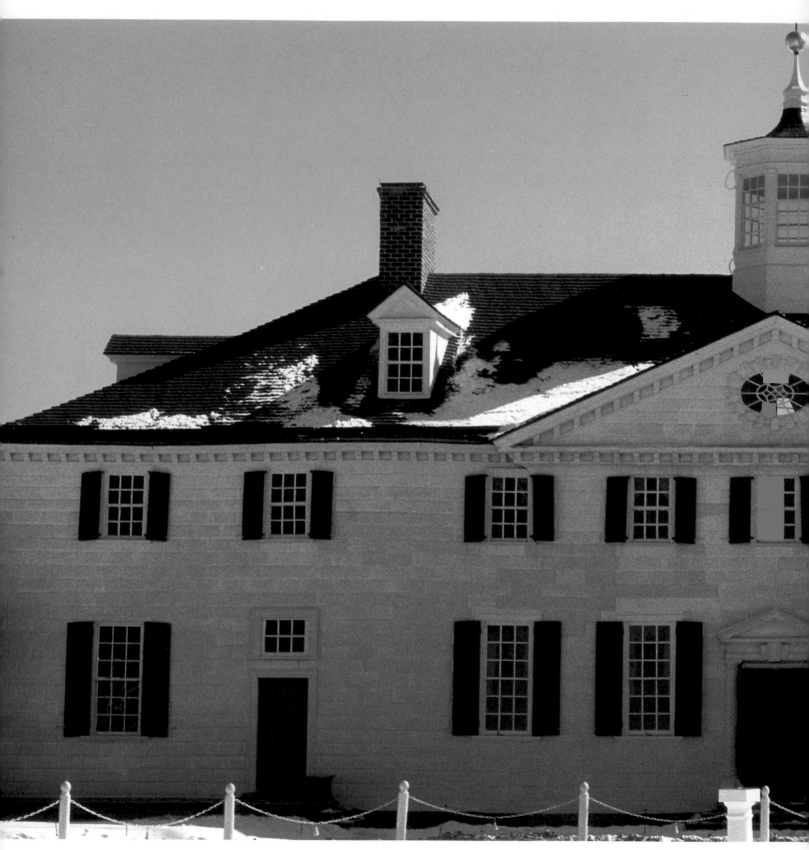

Mount Vernon

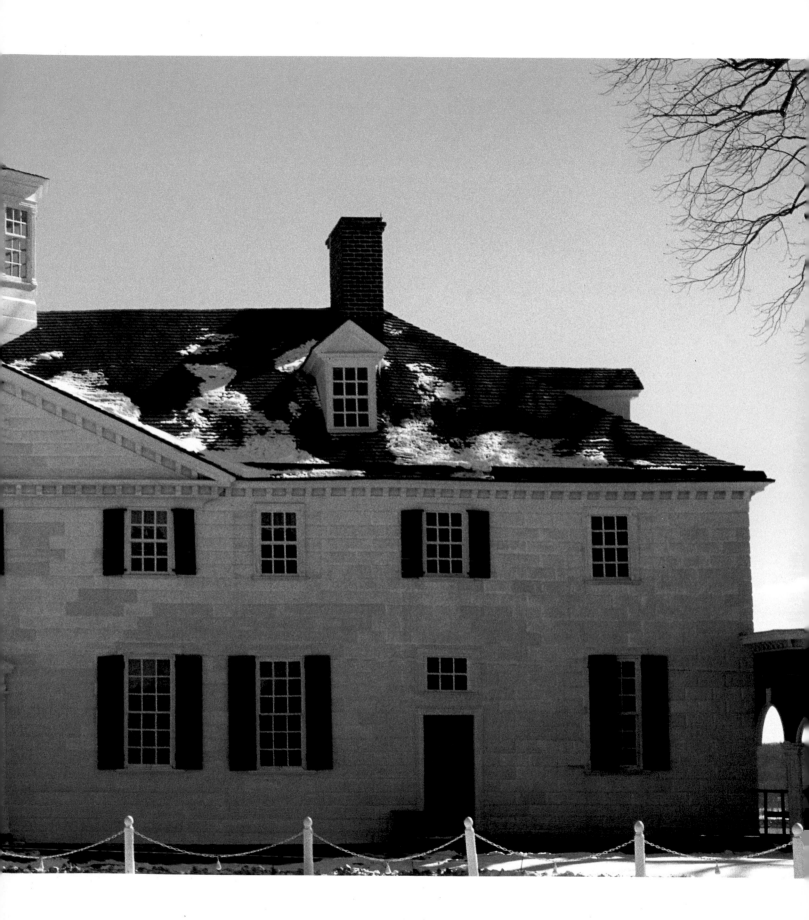

OVERLEAF: *The Garden of Dumbarton Oaks*

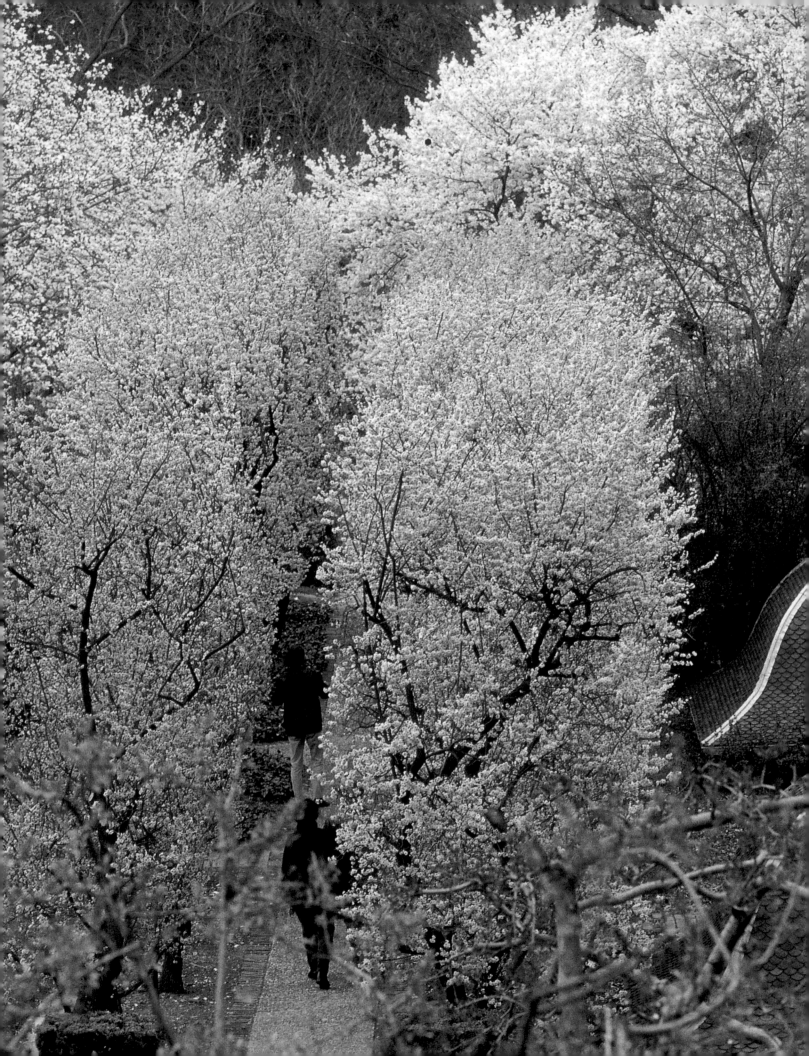

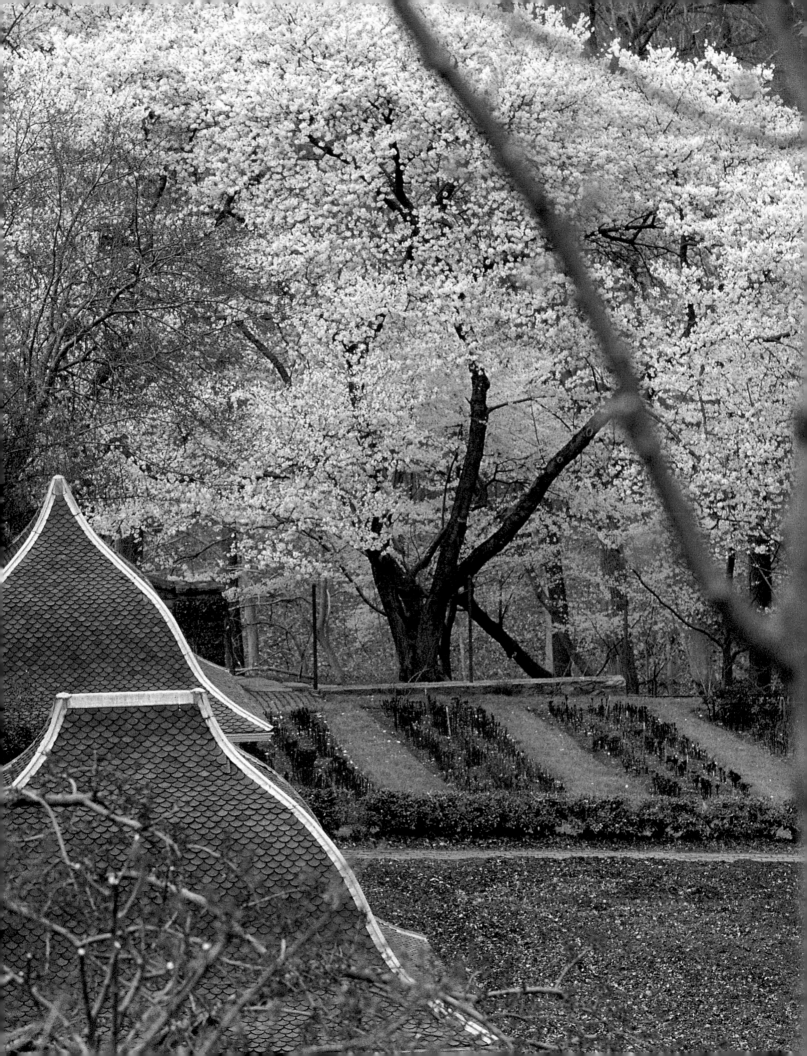

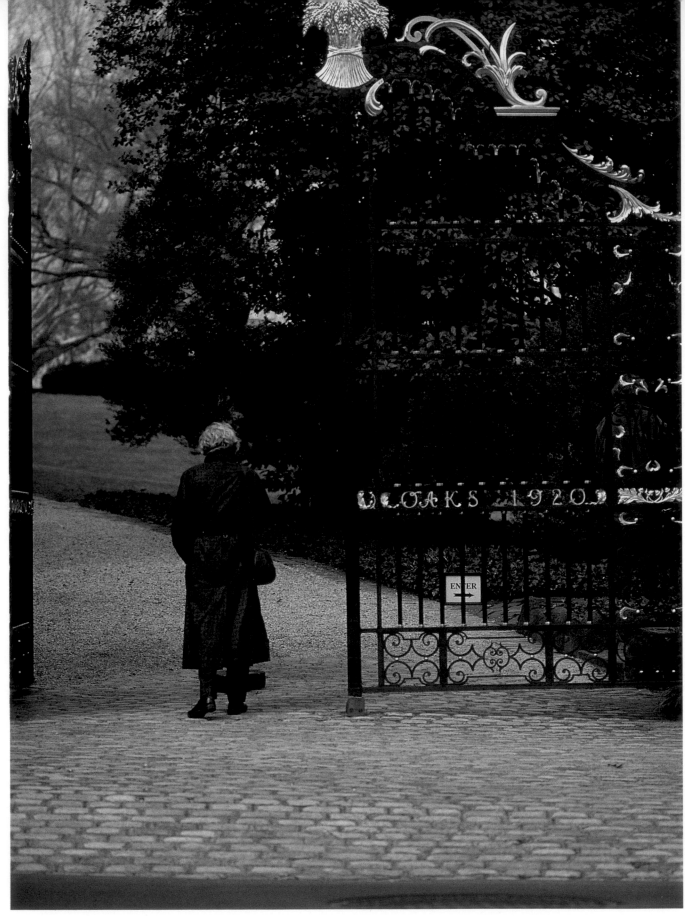

The Dumbarton Oaks gateway

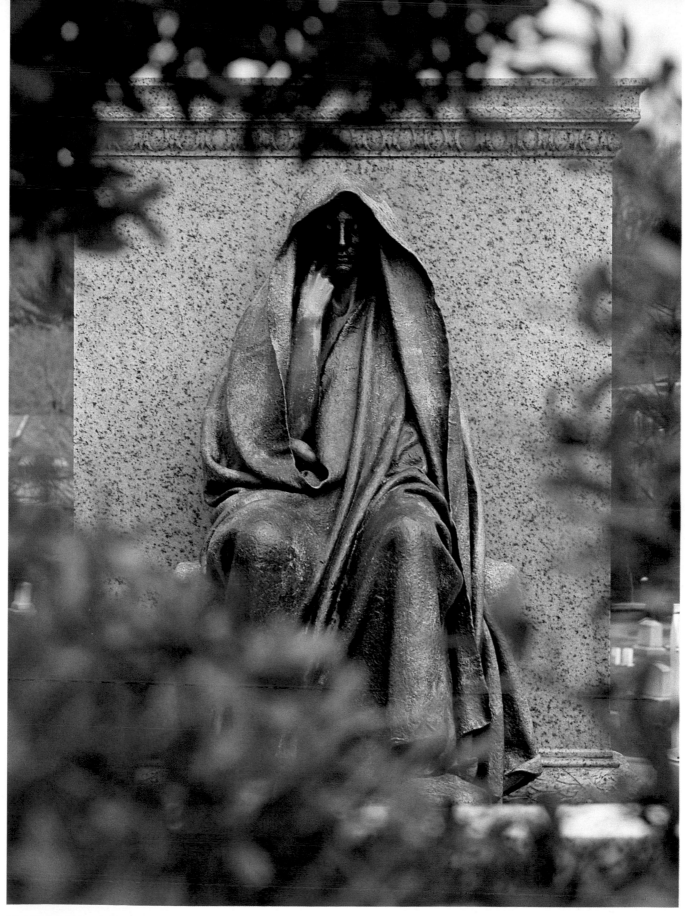

The Adams Memorial by Augustus St. Gaudens, Rock Creek Cemetery

OVERLEAF: *Rock Creek Cemetery*

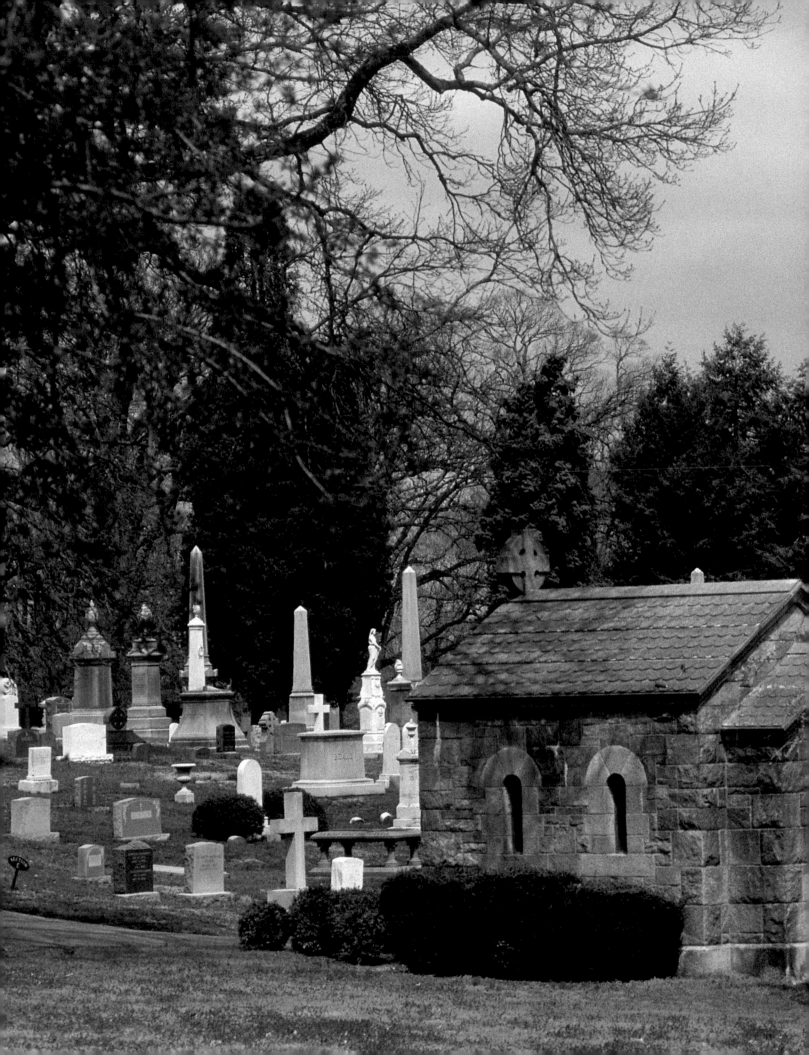

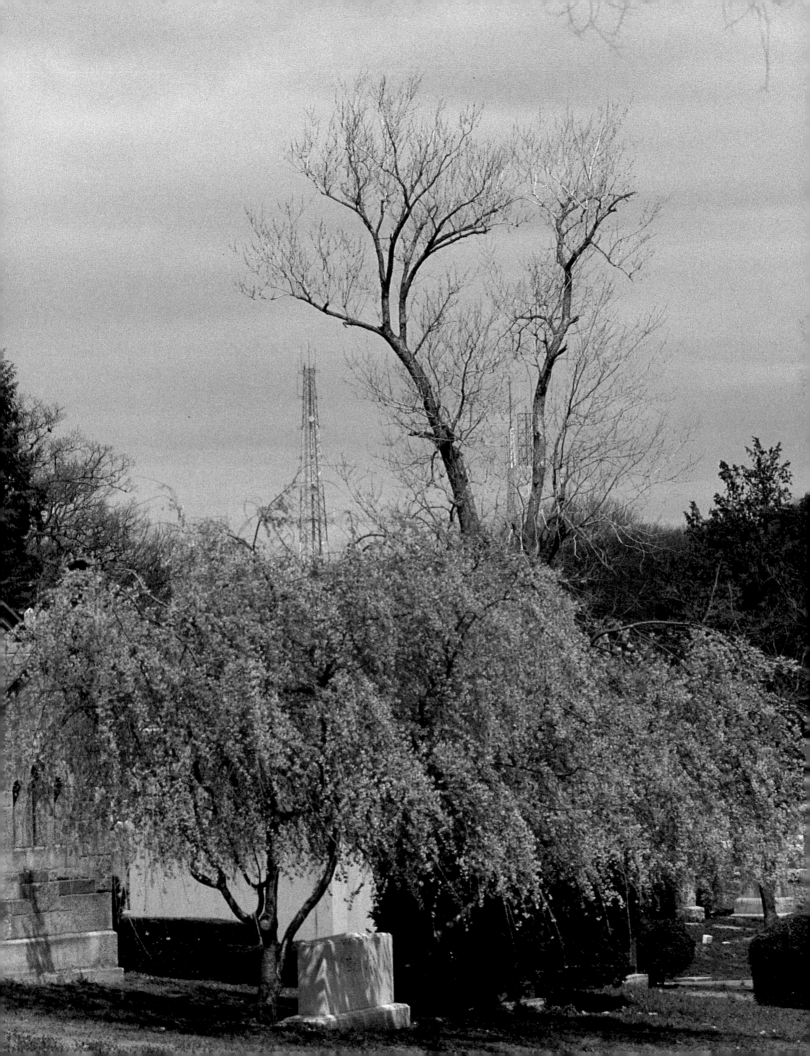

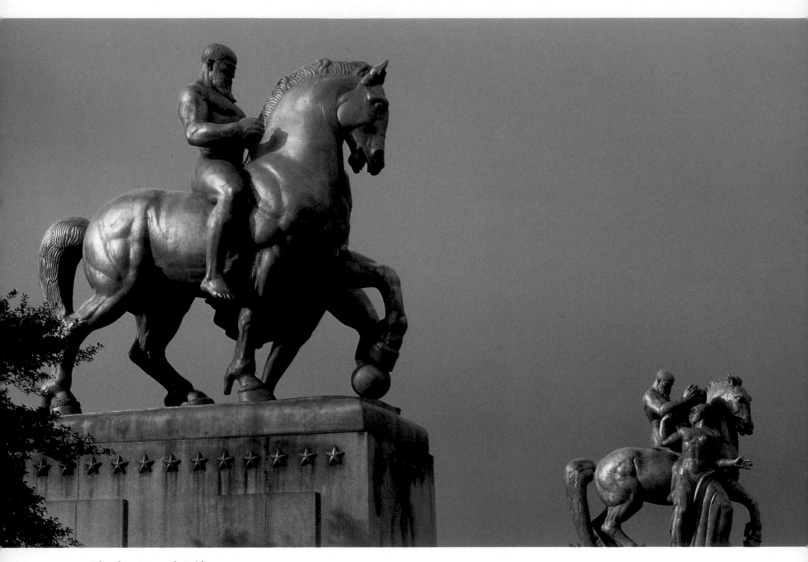

Theodore Roosevelt Bridge

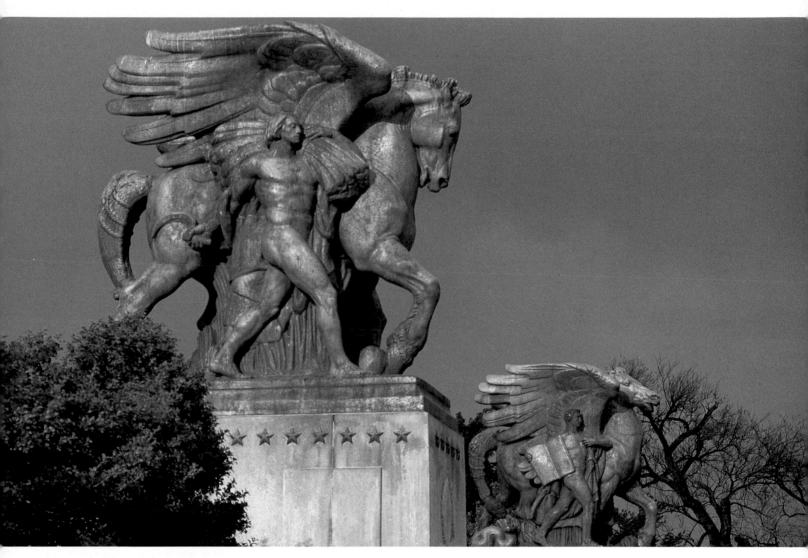

Arlington Memorial Bridge

Urn in Lafayette Square

OVERLEAF: *Sculpture on Oak Street and Wilson Boulevard*
SECOND OVERLEAF: *Robert F. Kennedy Stadium*

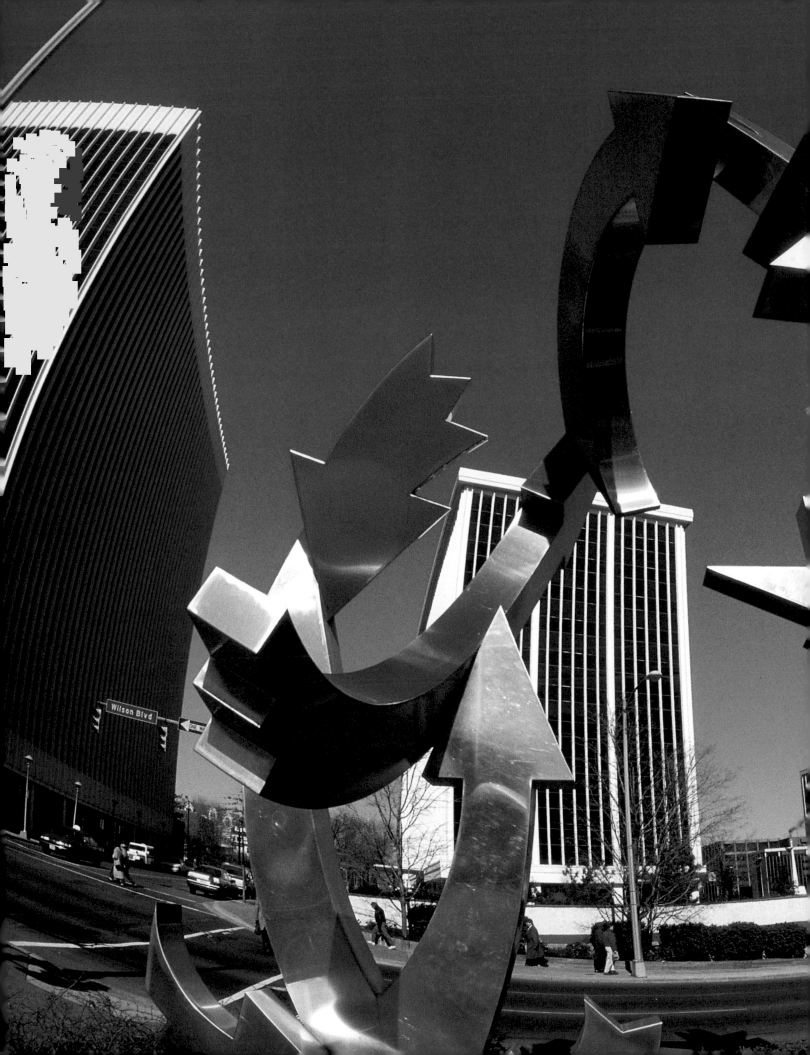

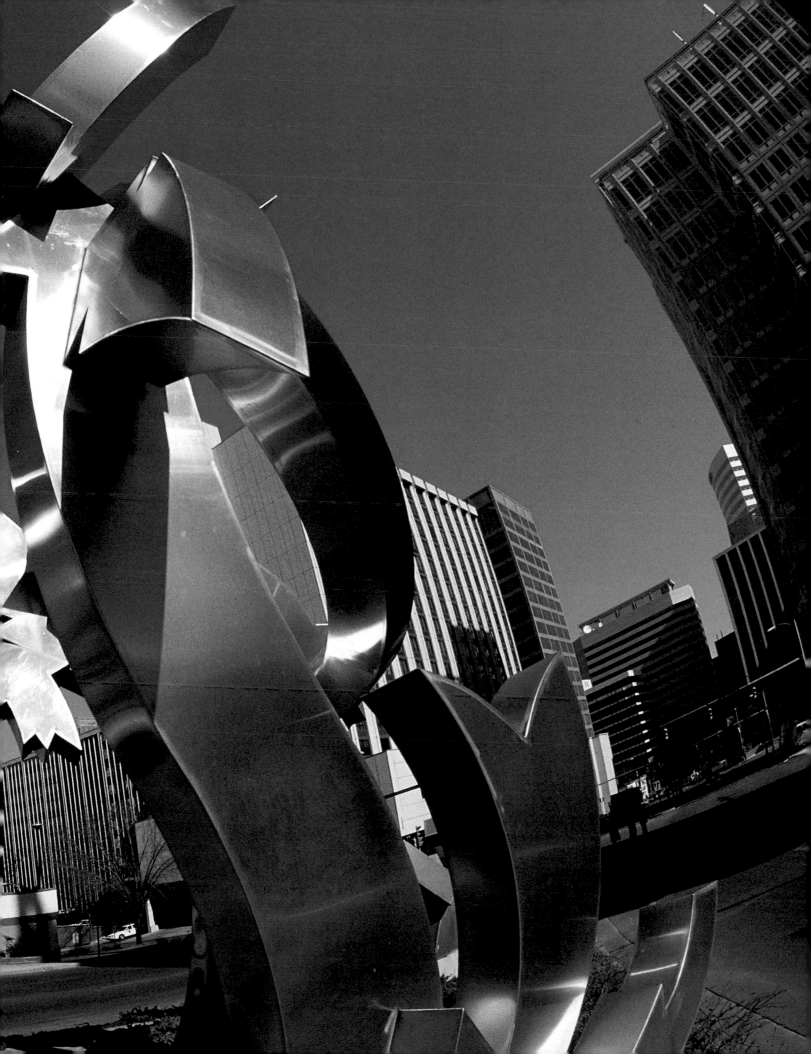

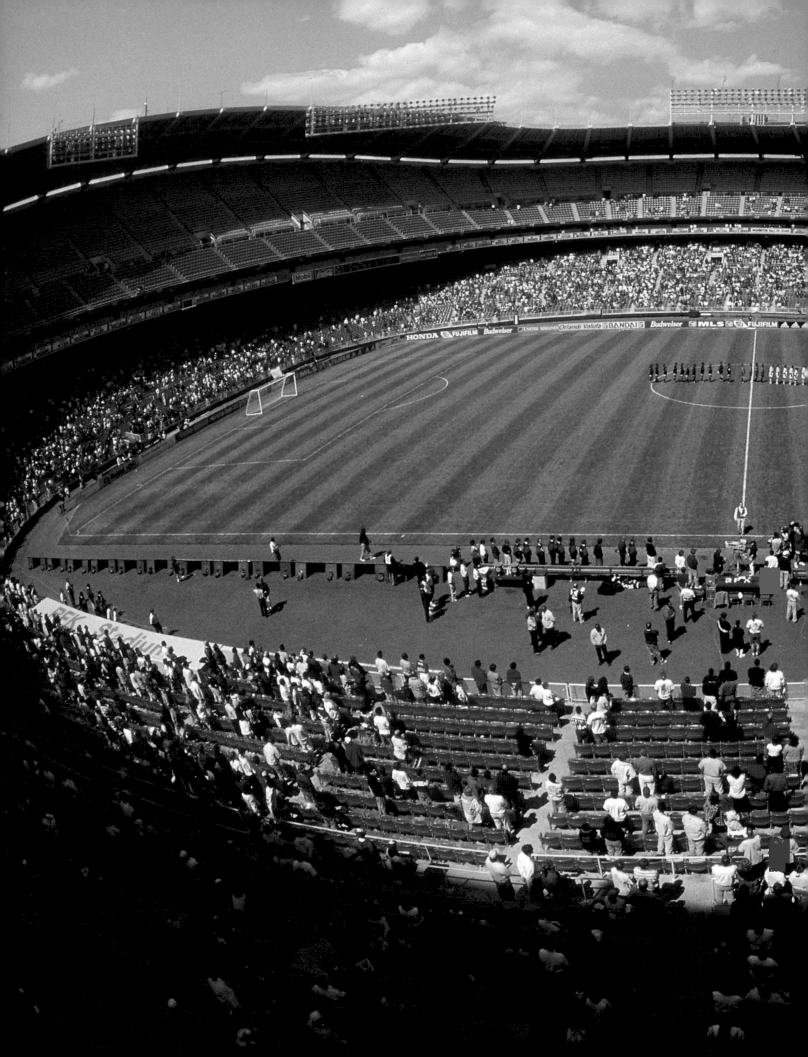

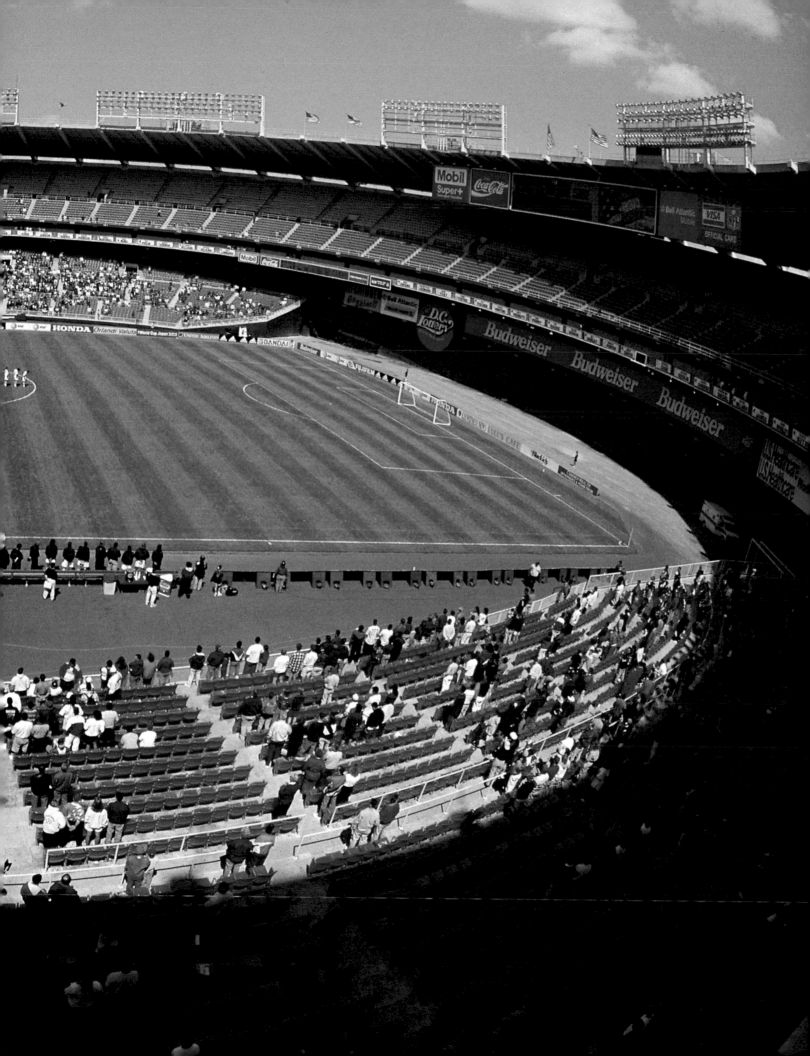

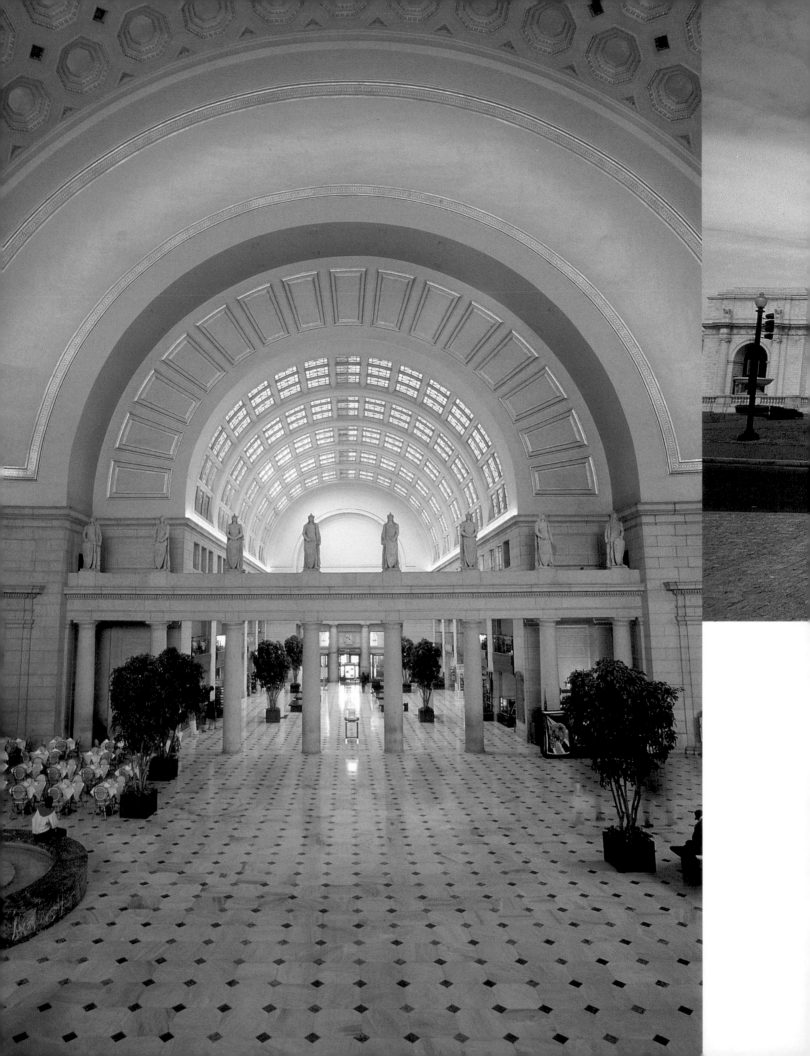

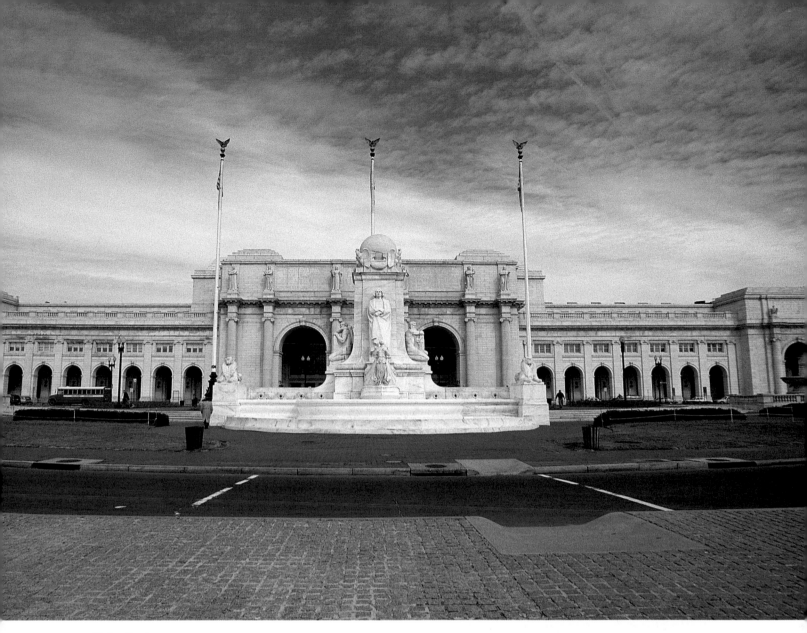

Union Station

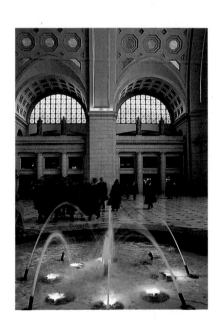

OVERLEAF: *Metro 29 Diner, Arlington*

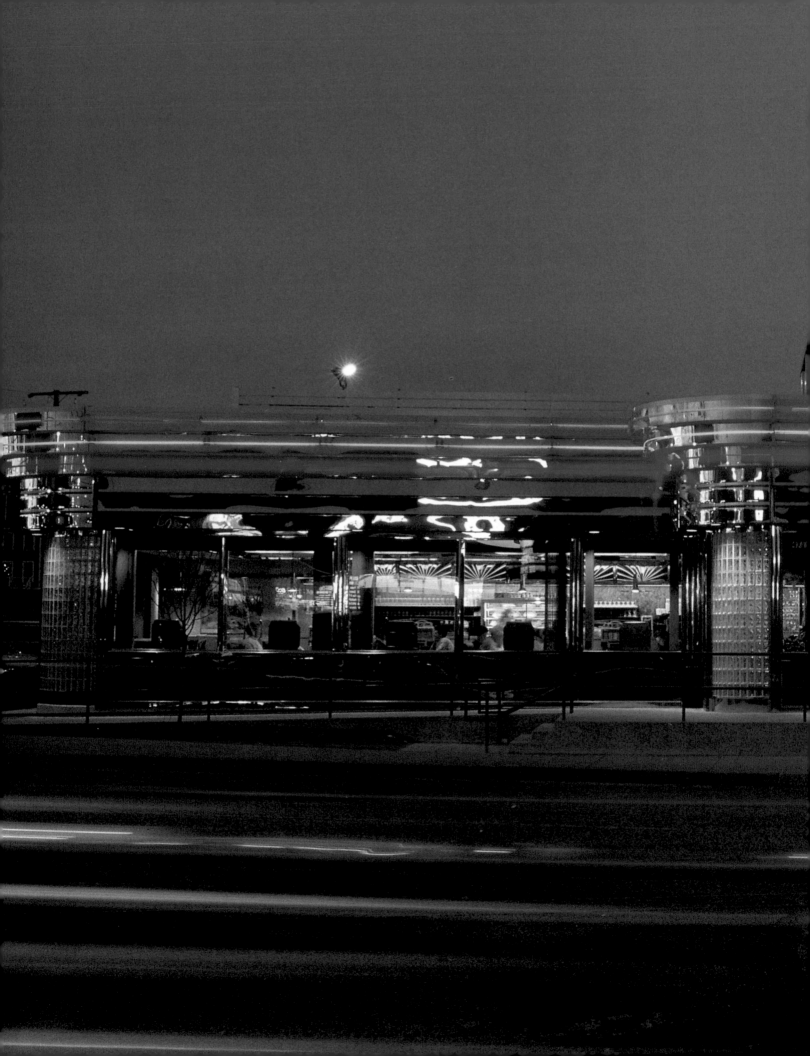

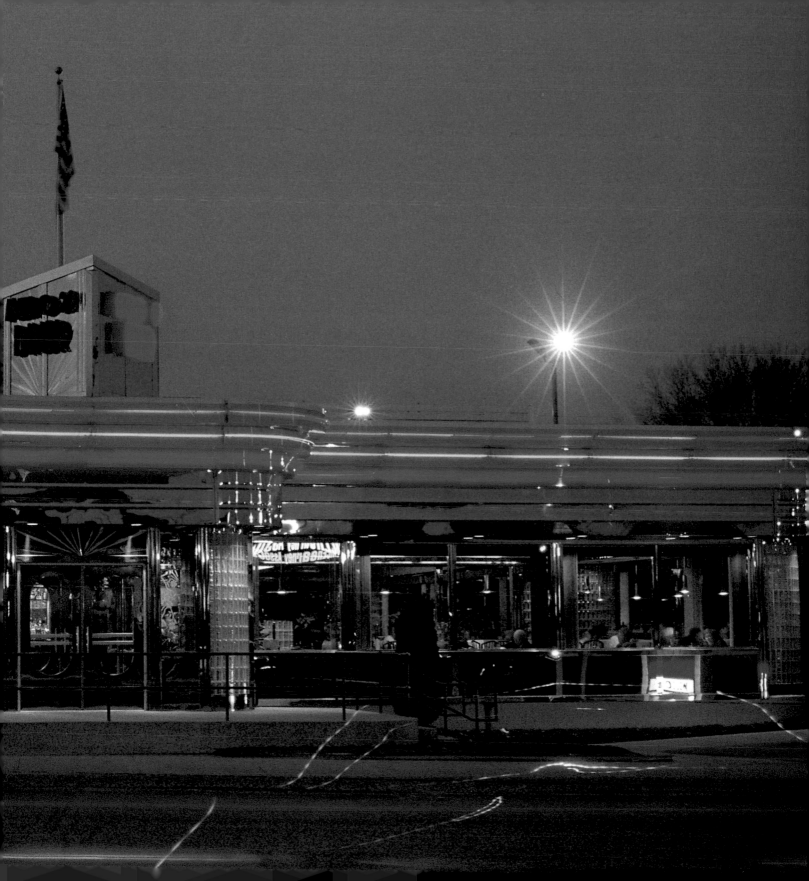

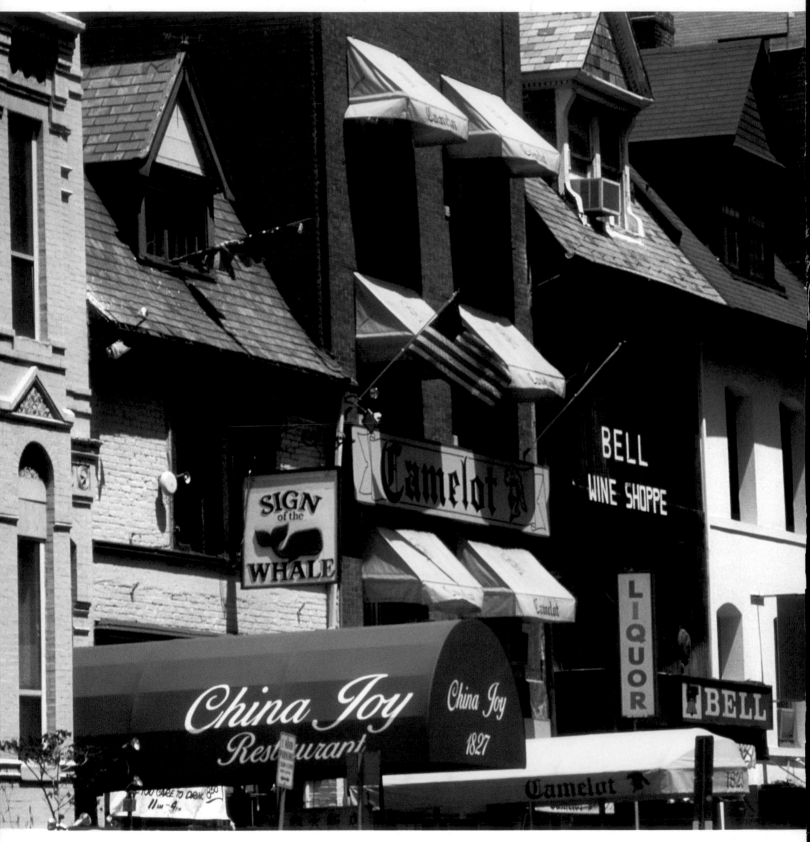

Shops and restaurants of 19th Street

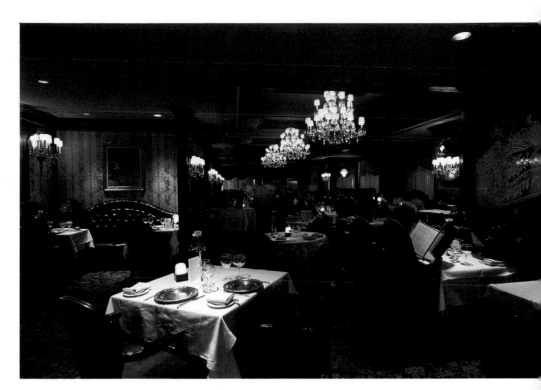

Maison Blanche, a Washington, D.C. establishment

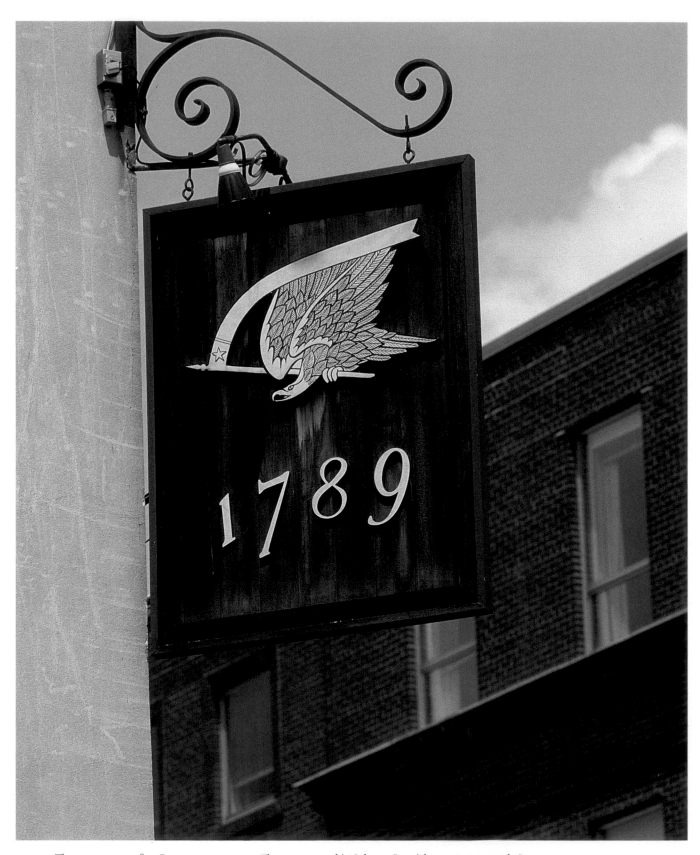

ABOVE: *The restaurant, 1789, Georgetown* RIGHT: *Flamenco mural in Jaleo, a Spanish restaurant on 7th Street*

OVERLEAF: *The Watergate Complex*
SECOND OVERLEAF: *The lobby of the Carlton Hotel*

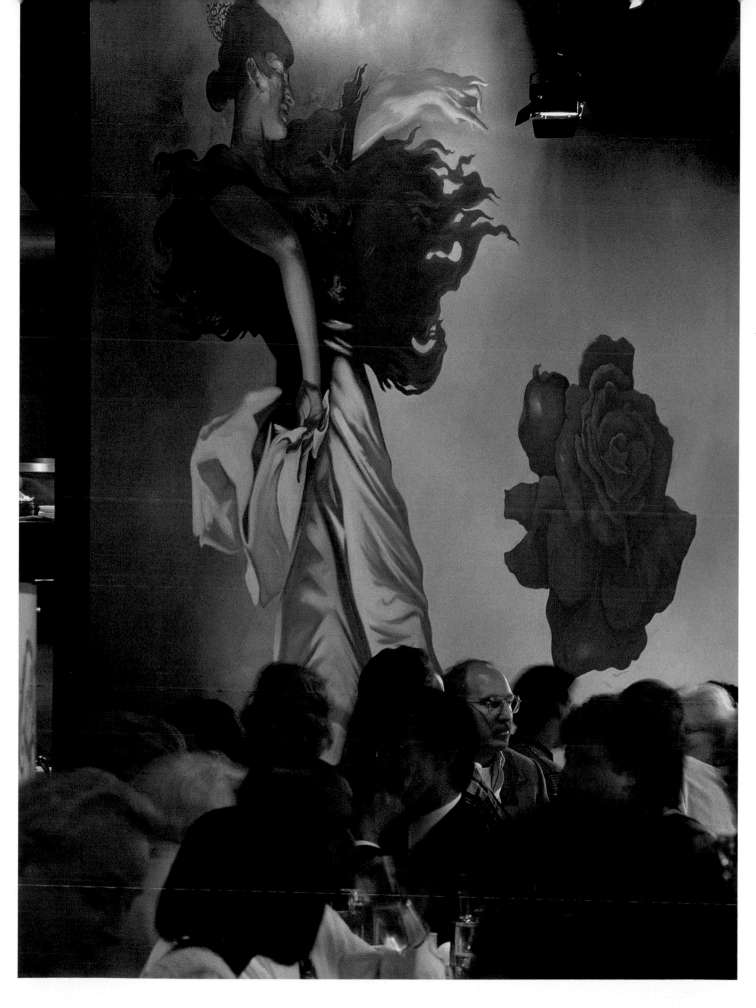

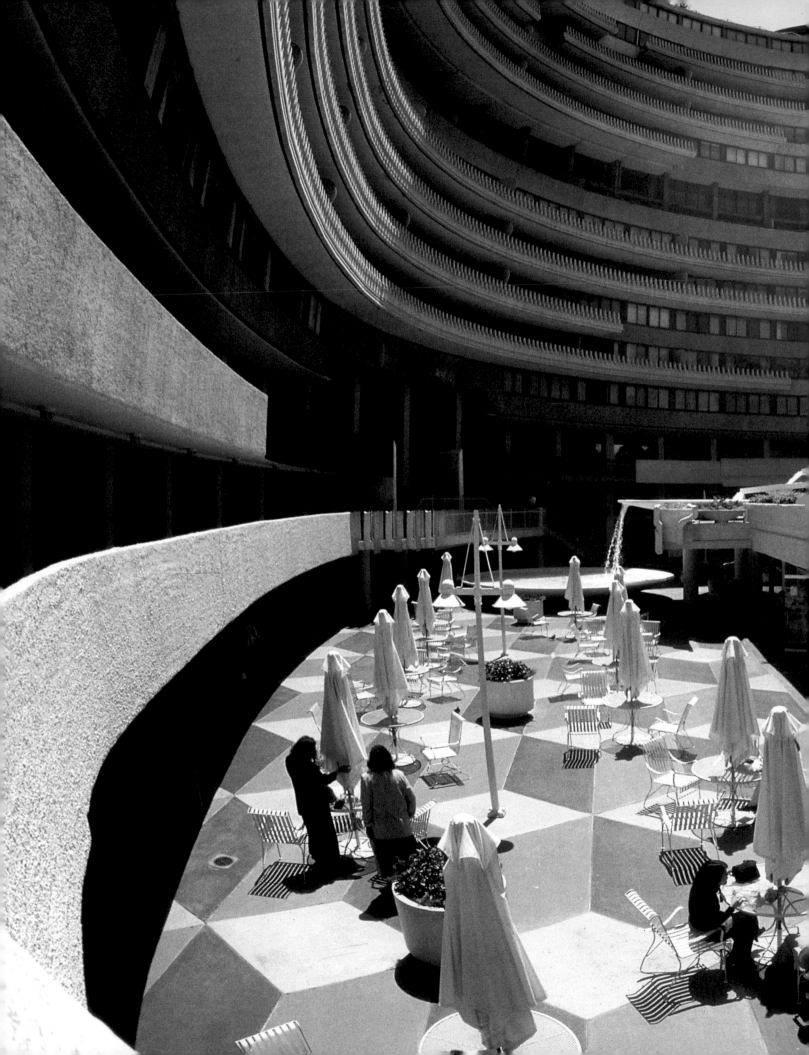

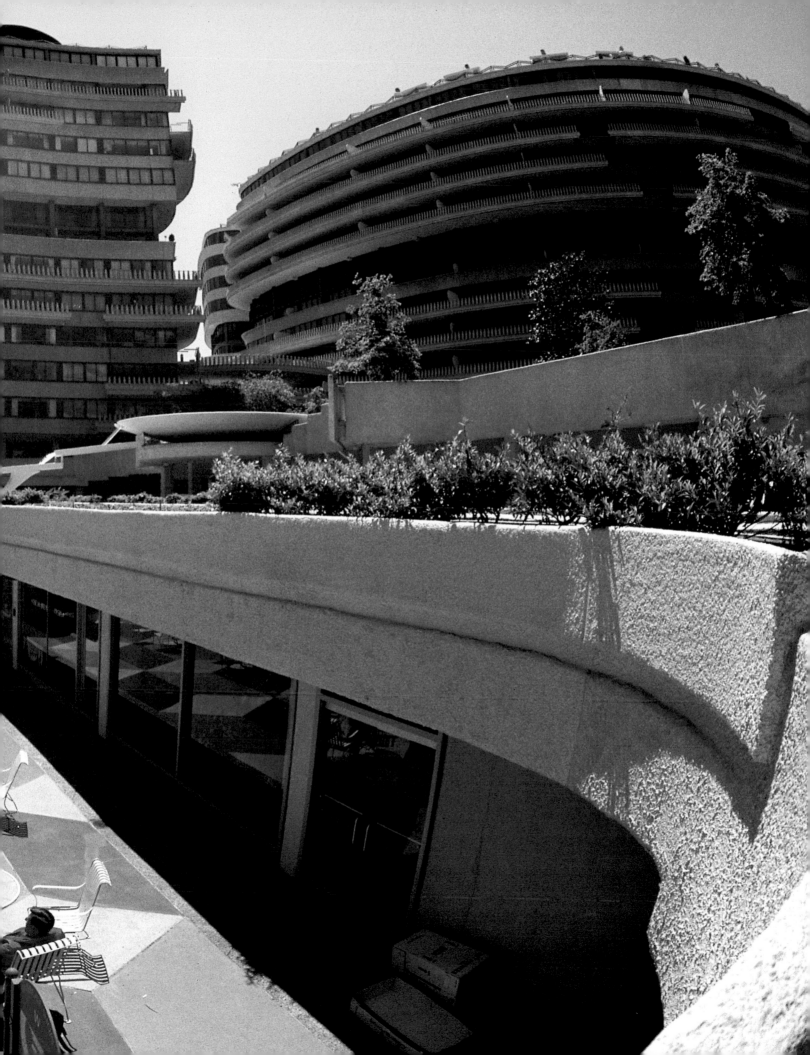

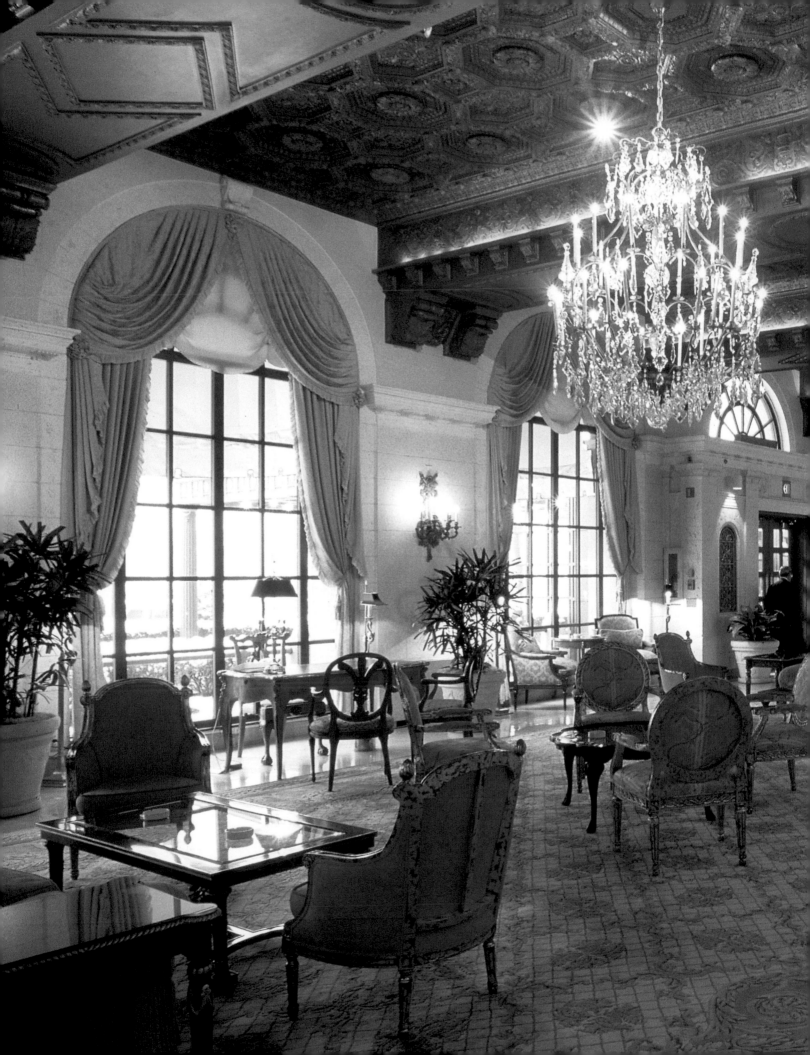

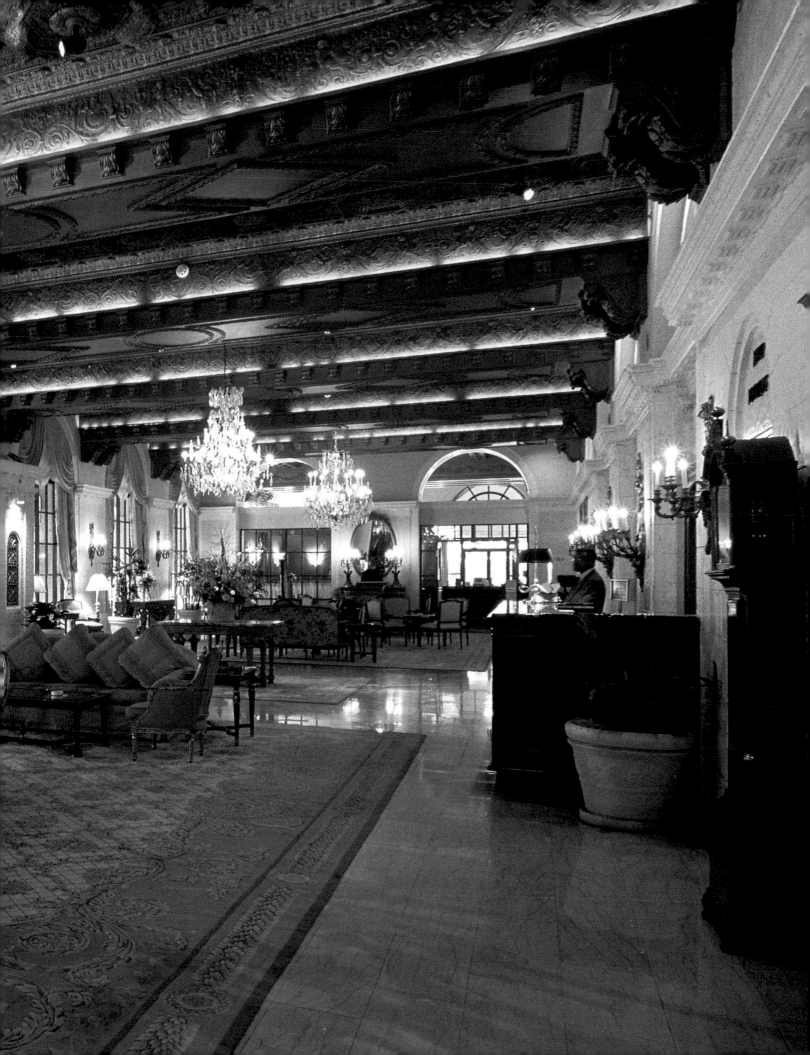

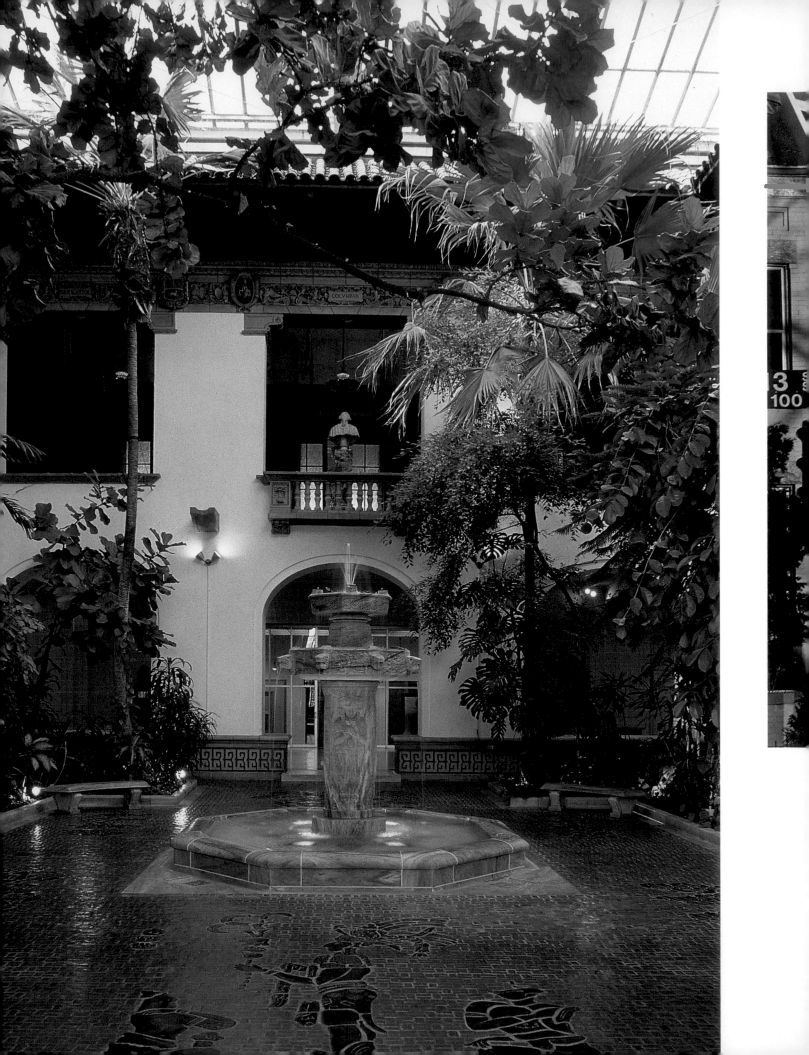

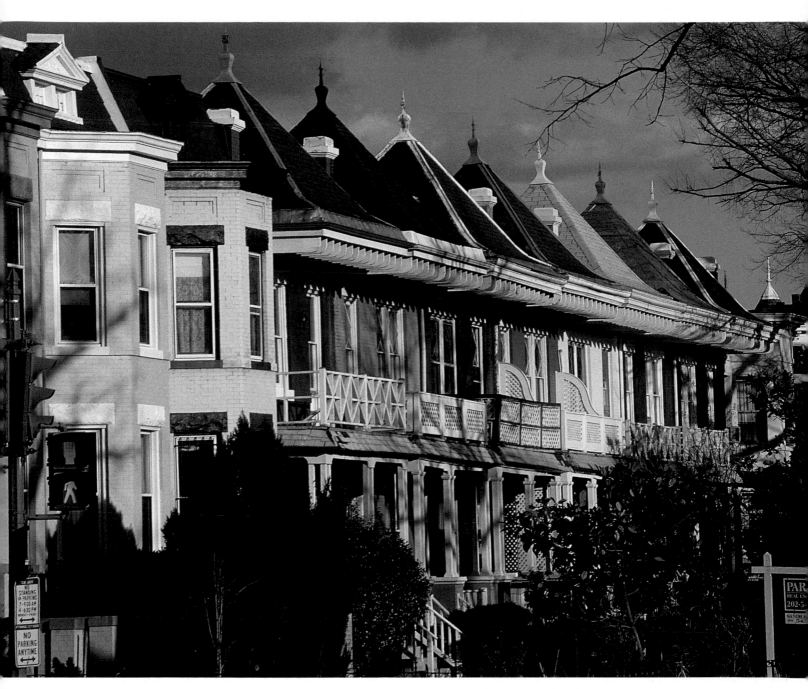

LEFT: *The patio of the Organization of American States building , built in 1910 by architects Albert Kelsey and Paul Cret*
ABOVE: *Massachusetts Avenue homes near Lincoln Park*

OVERLEAF: *Reflection of 19th Street*

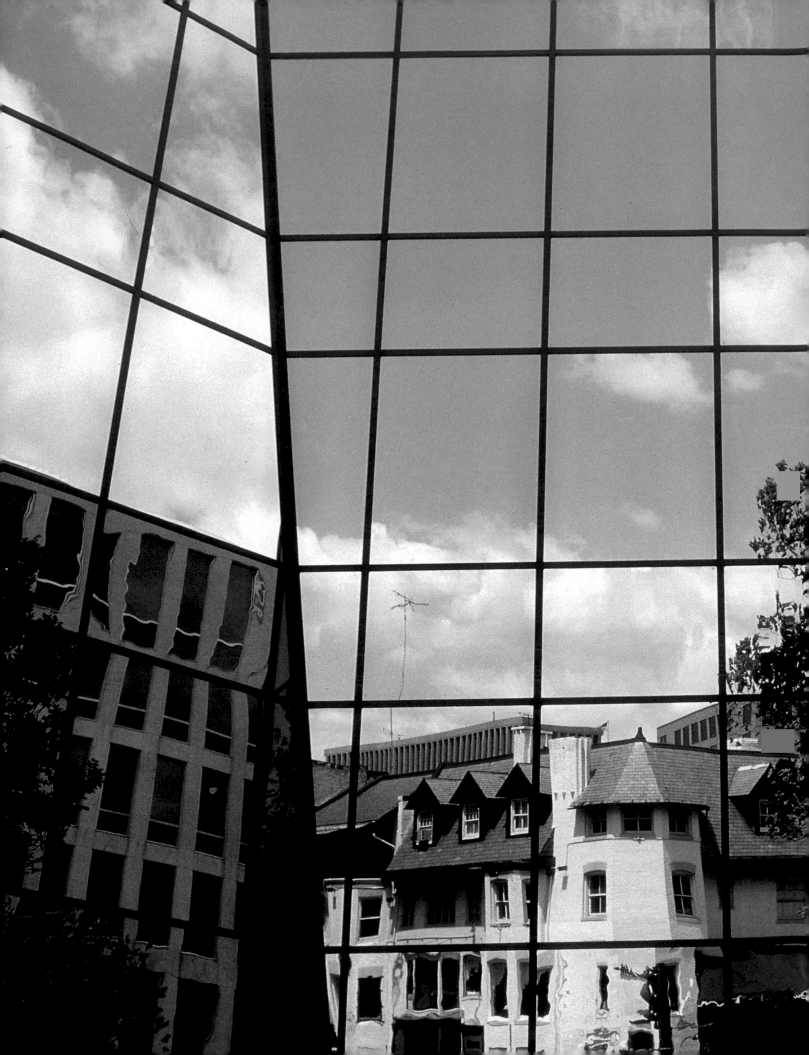

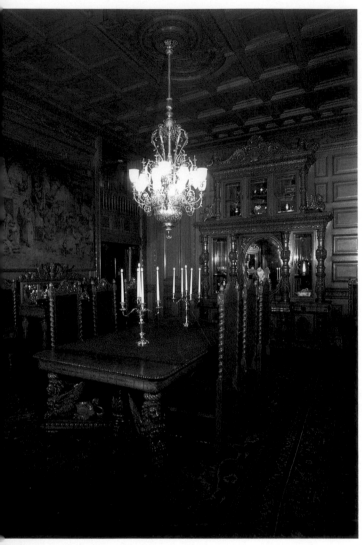

Heurich House Museum

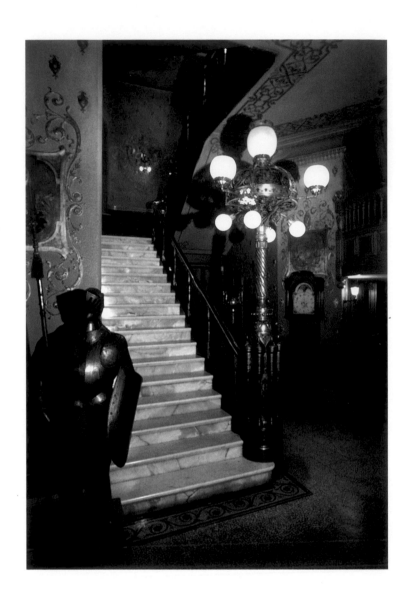

*The Blair House, built in the 1820s, is now used
to accomodate official guests of the president*

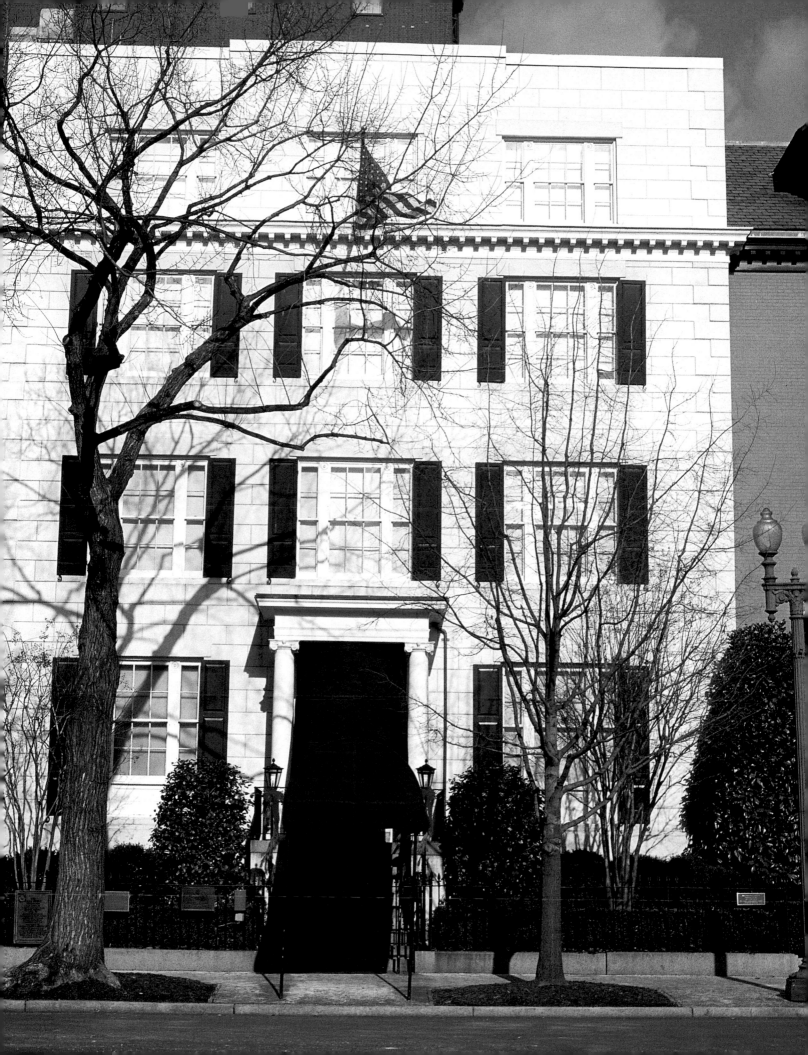

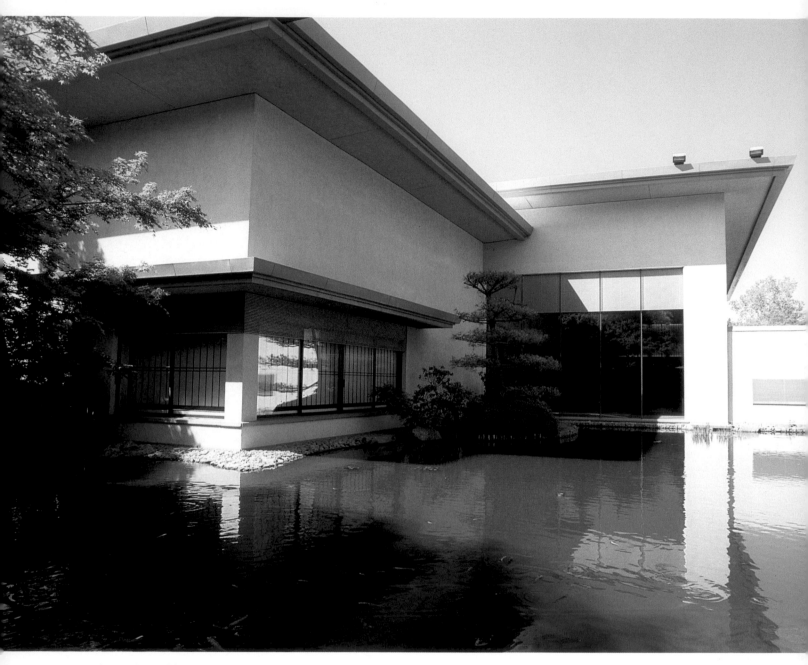

The Residence of the Ambassador of Japan

OVERLEAF: *Dutch Embassy; The Islamic Center*
SECOND OVERLEAF: *The Canadian Embassy*

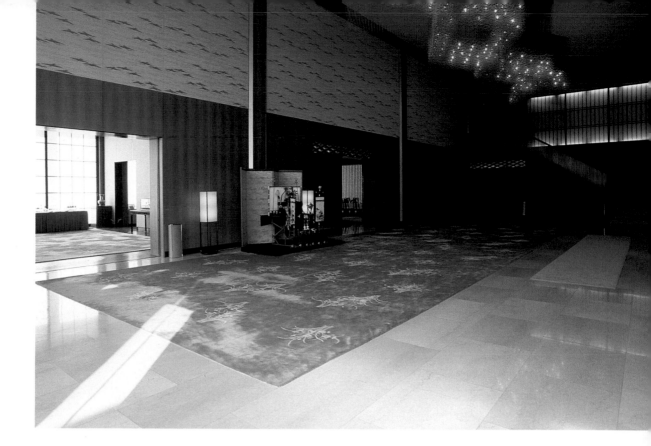

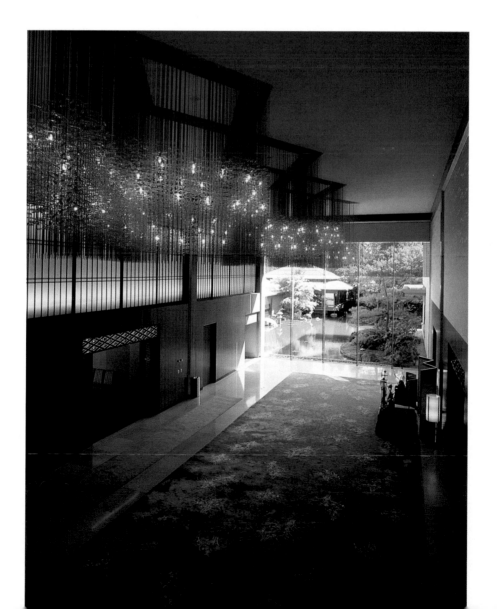

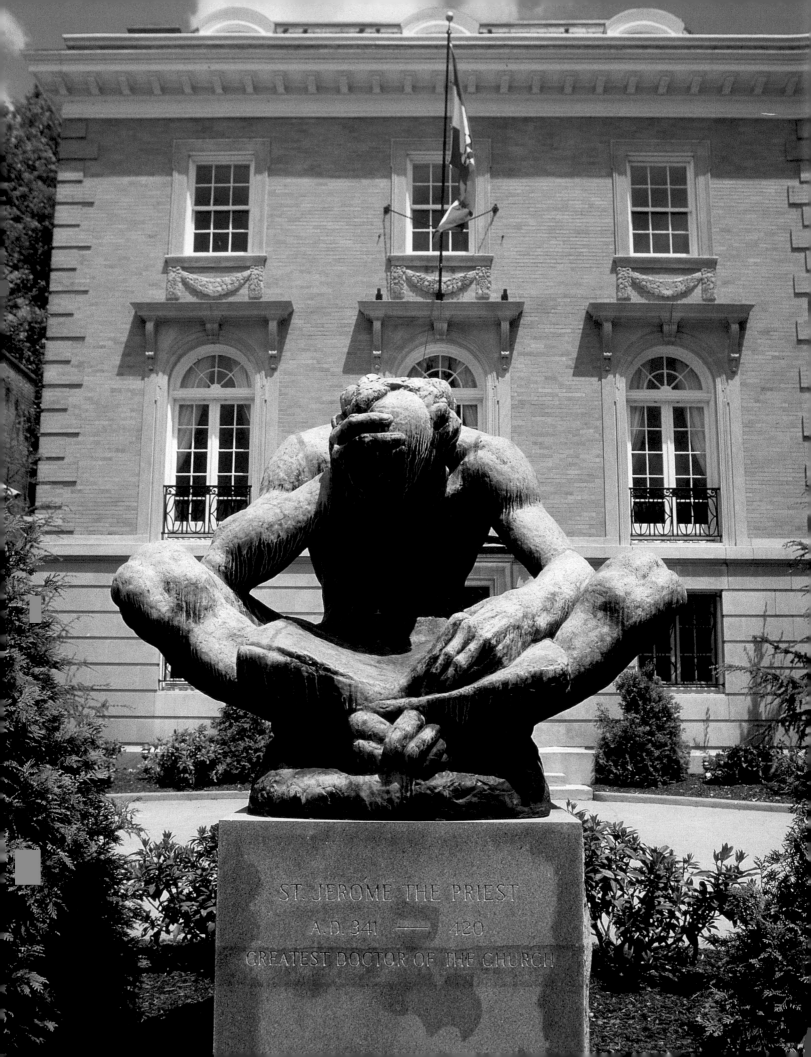

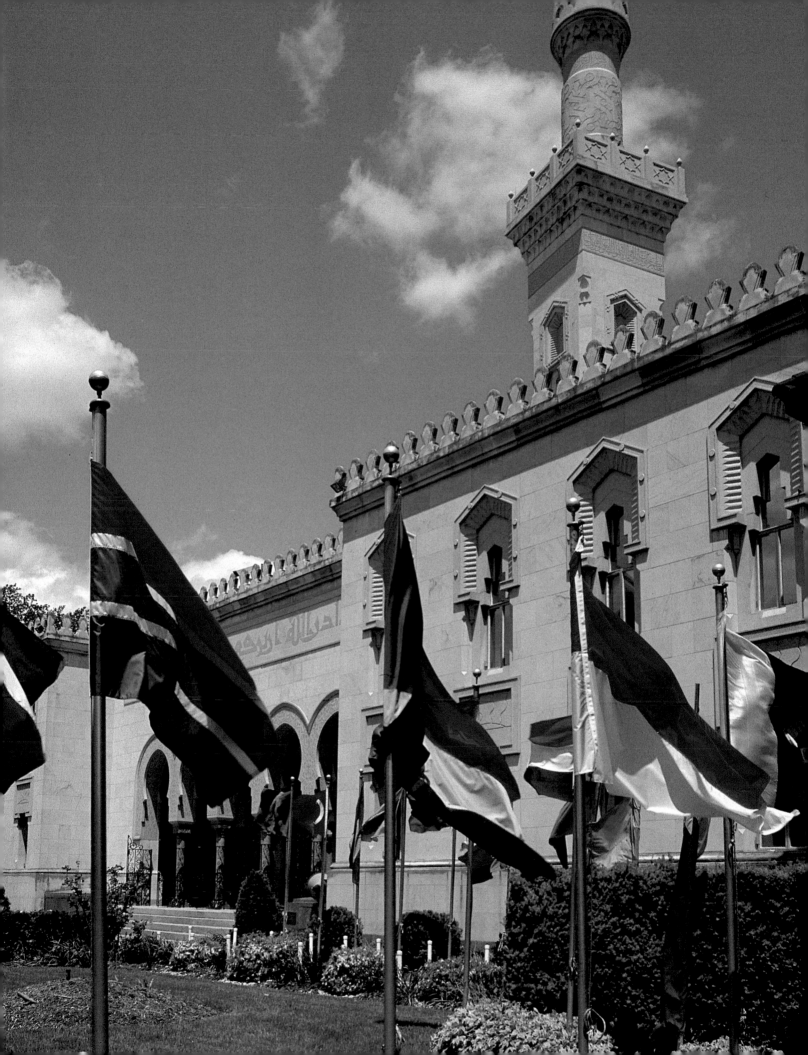

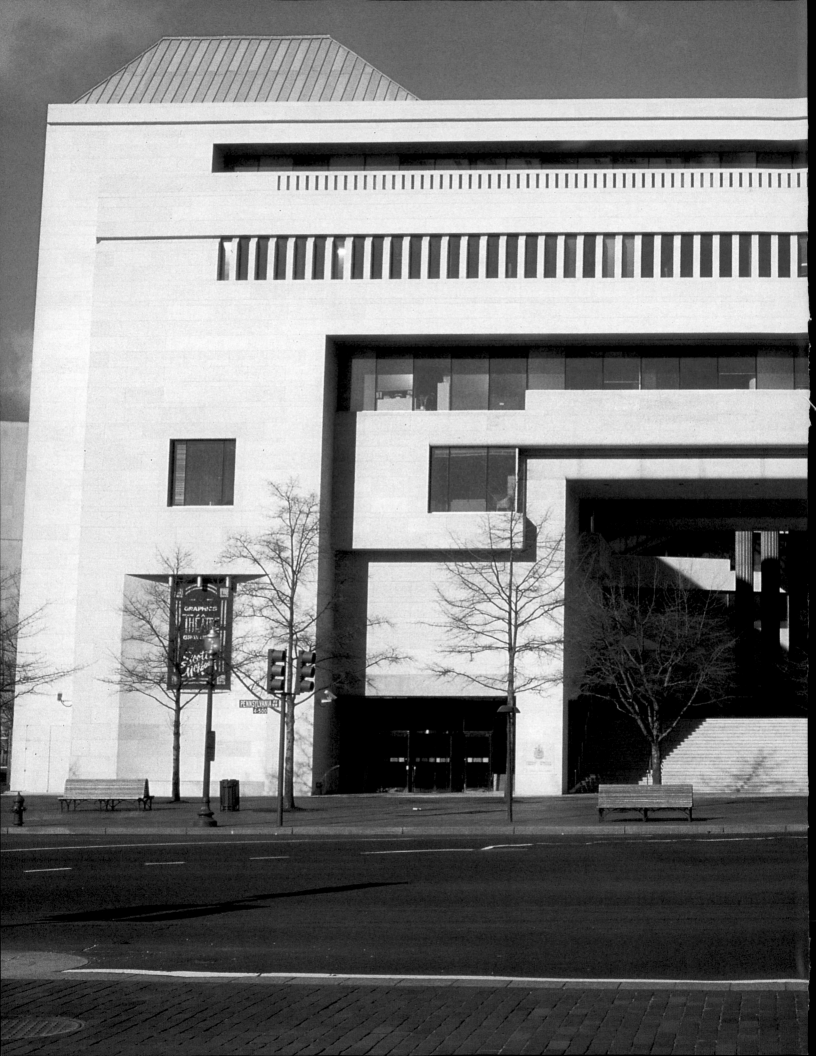

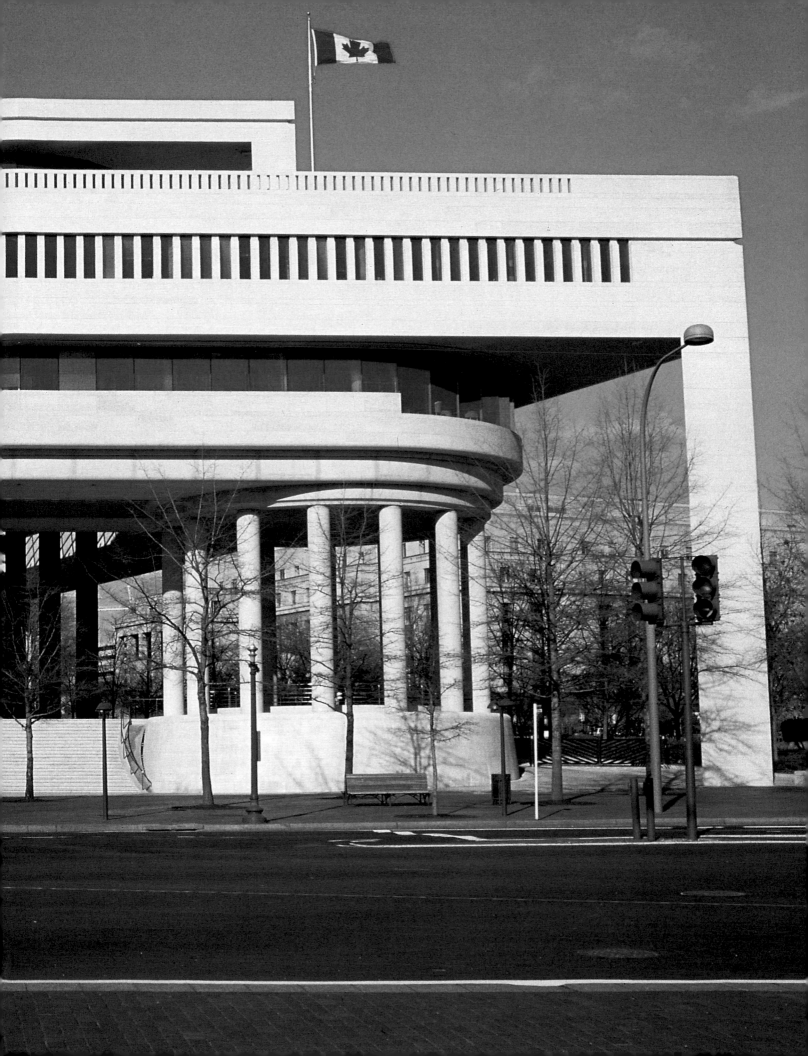

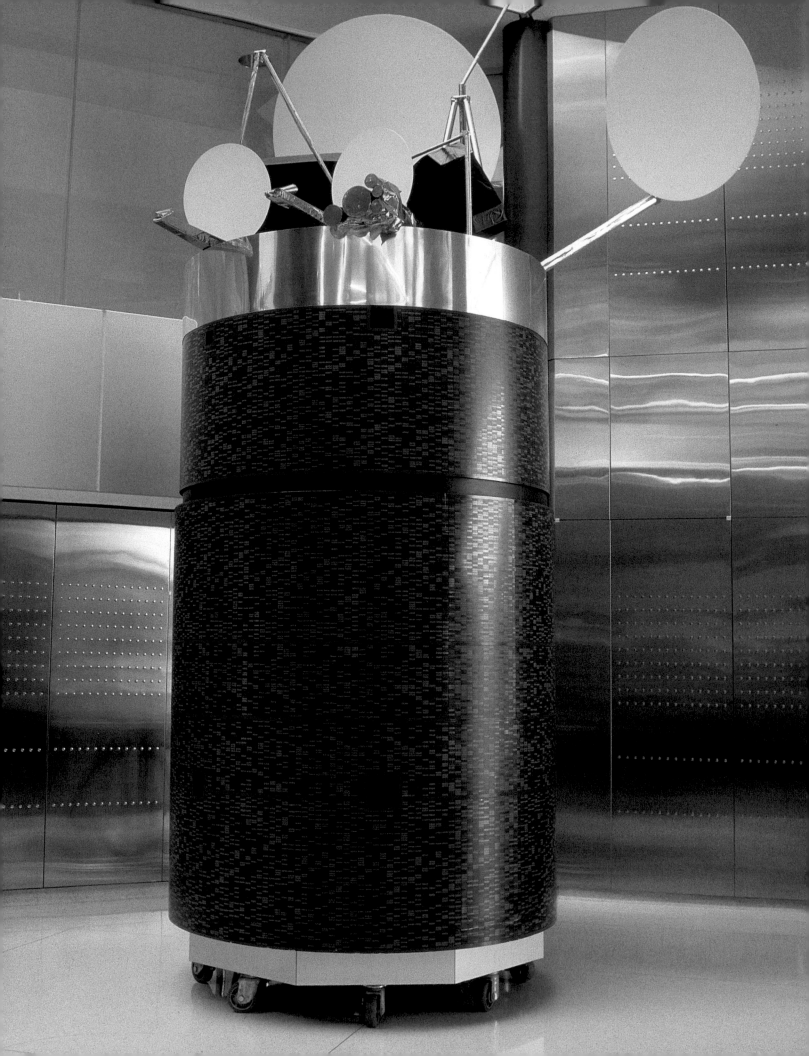

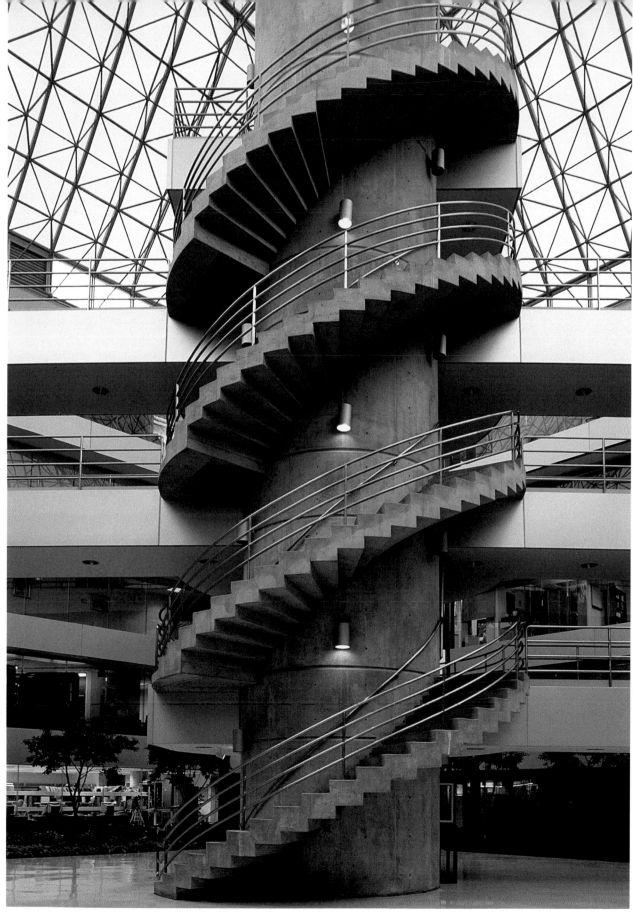

ABOVE: *Lobby of the INTELSAT building, a global satellite company. Designed by John Andrews*
LEFT: *An INTELSAT satellite on display in the lobby*

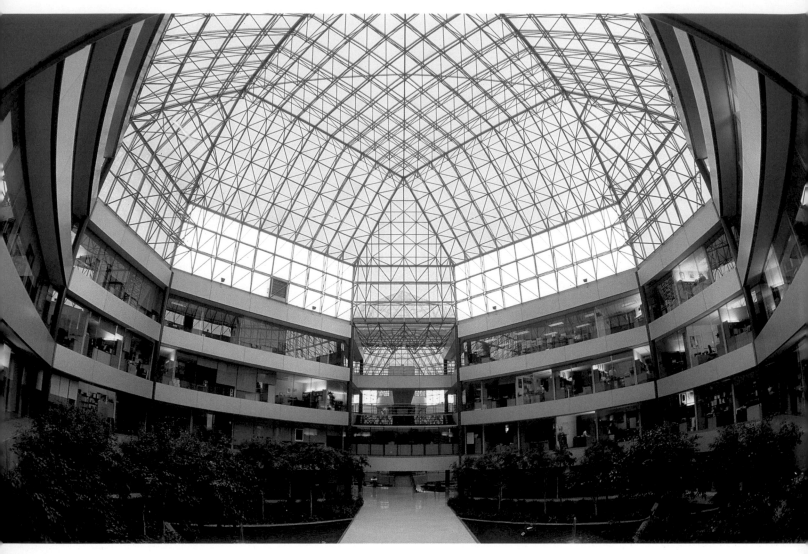

The INTELSAT's domed ceiling

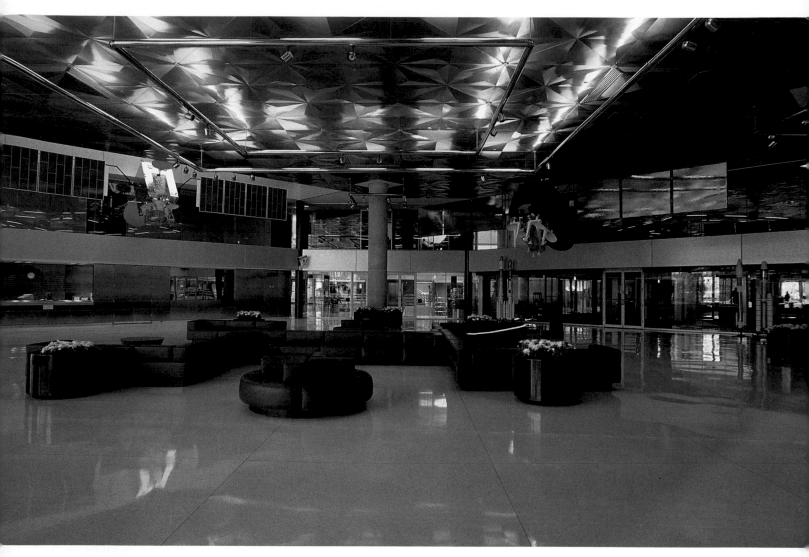

The lobby of the INTELSAT *building*

An INTELSAT *satellite*

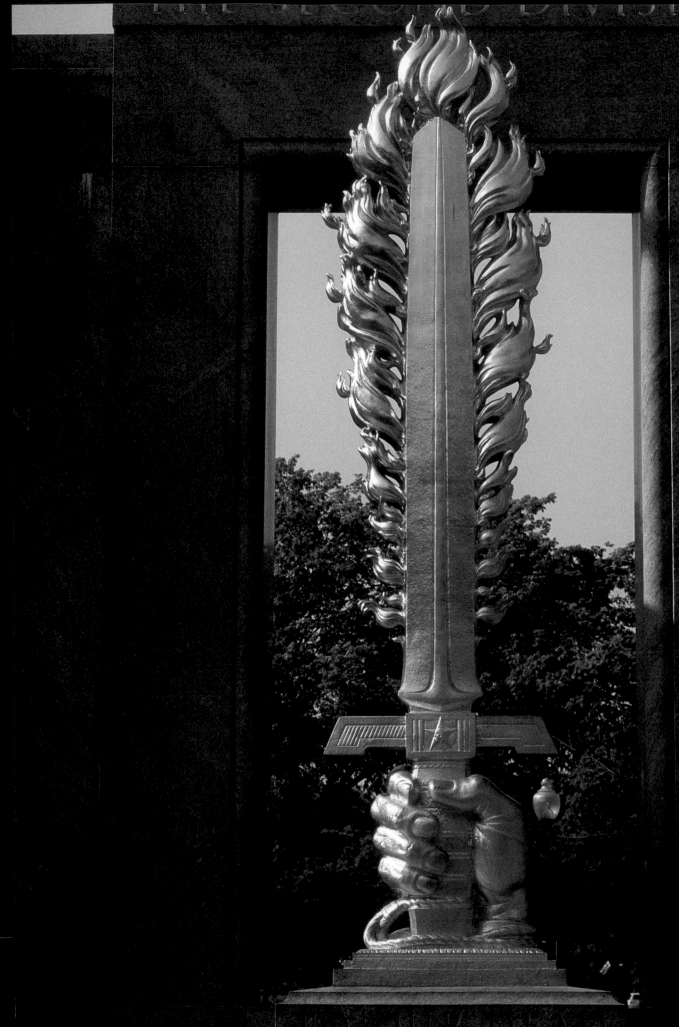

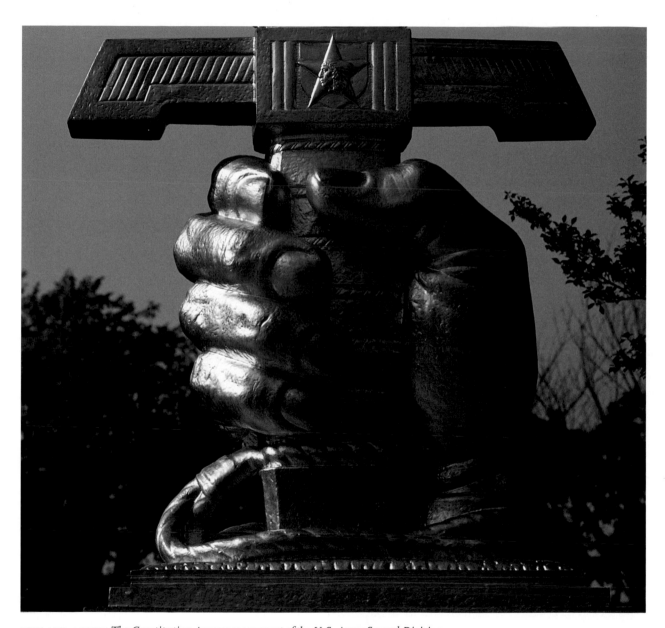

LEFT AND ABOVE: *The Constitution Avenue monument of the U.S. Army Second Division*

OVERLEAF: *Korean War Veterans Memorial*

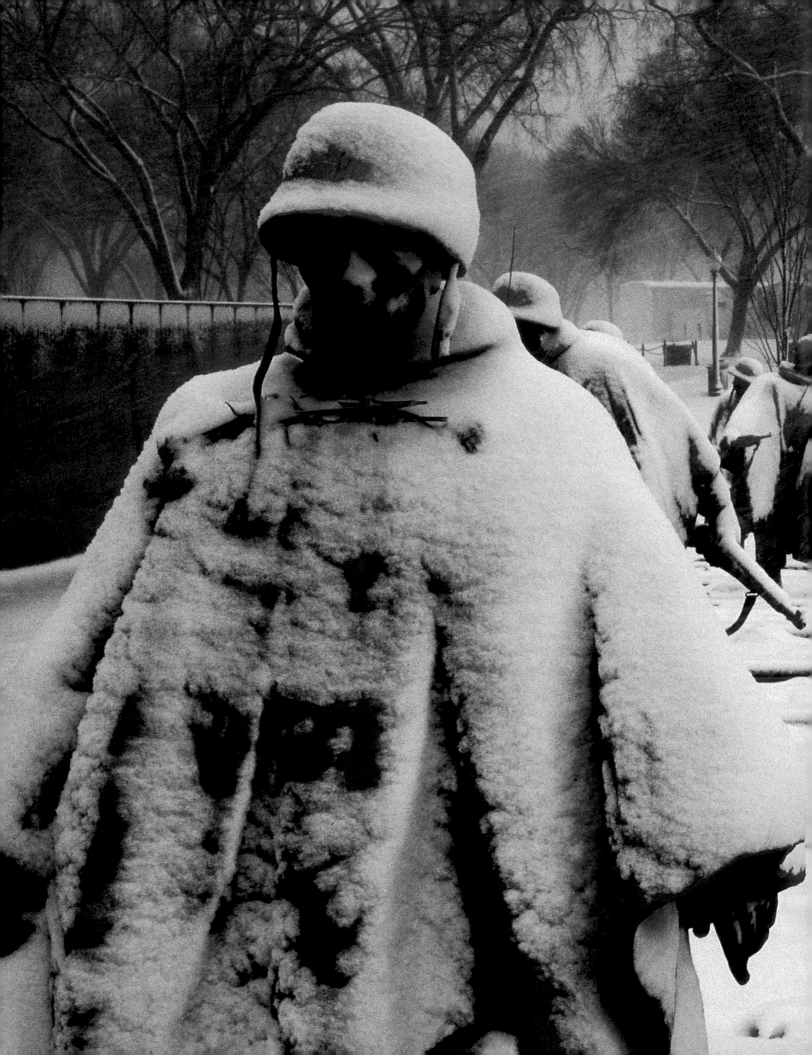

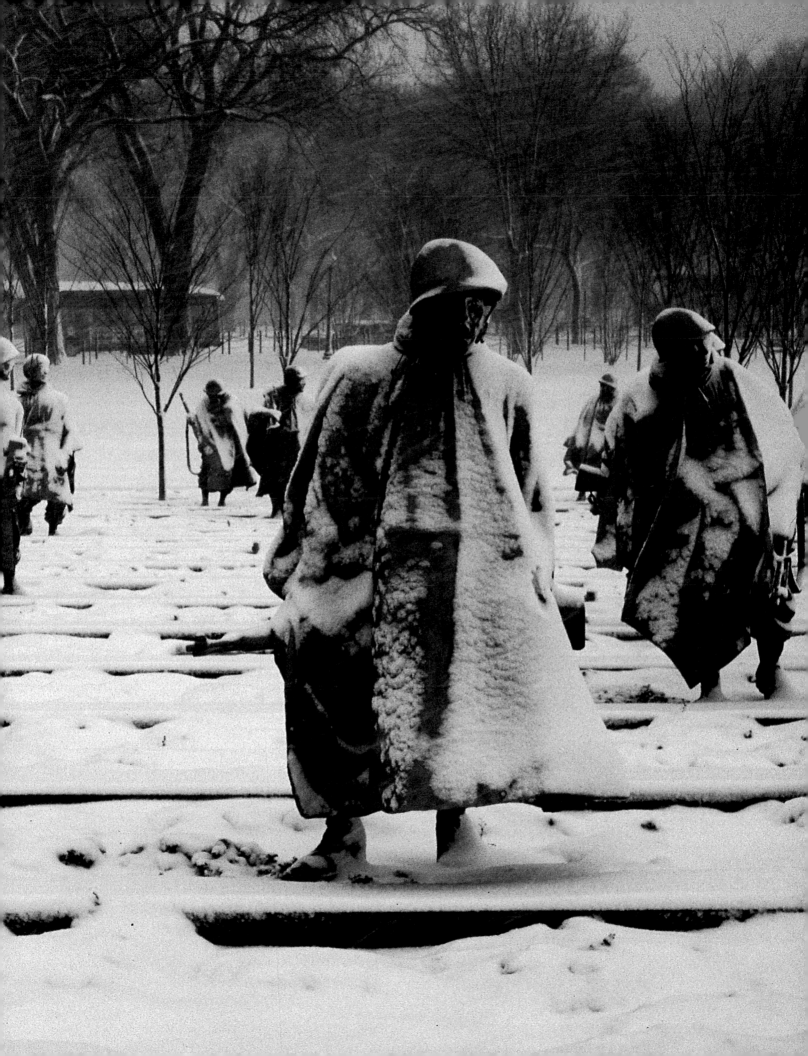

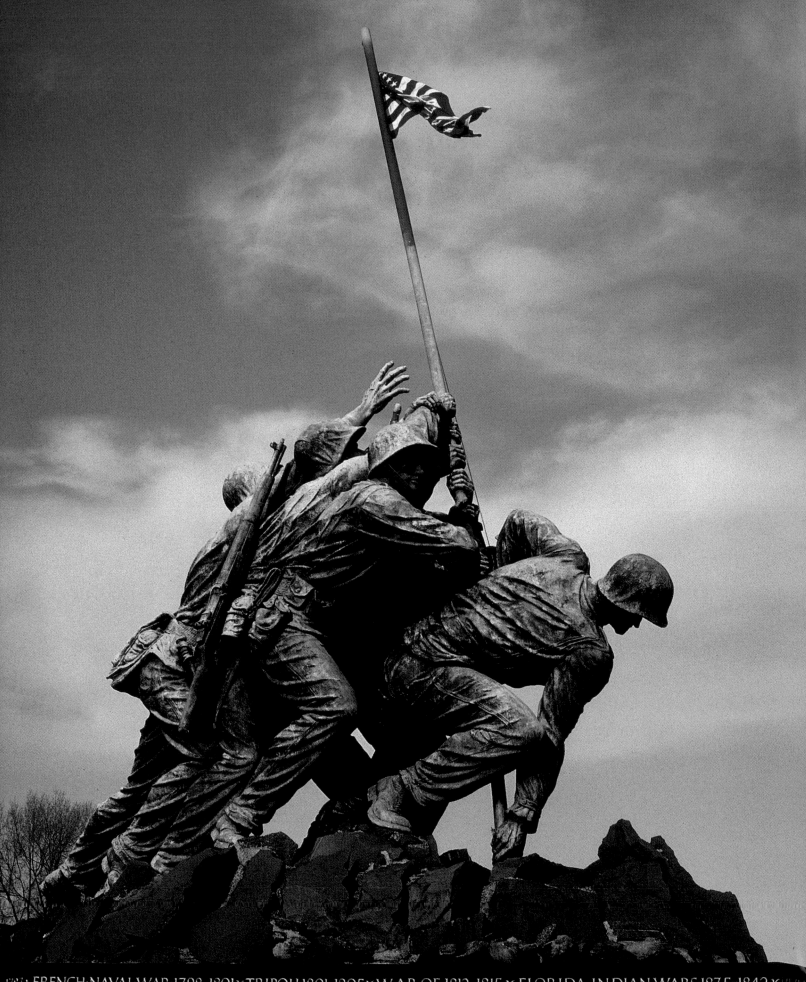

1775 FRENCH·NAVAL·WAR·1798-1801 ✕ TRIPOLI·1801-1805 ✕ WAR·OF·1812-1815 ✕ FLORIDA·INDIAN·WARS·1835-1842 ✕

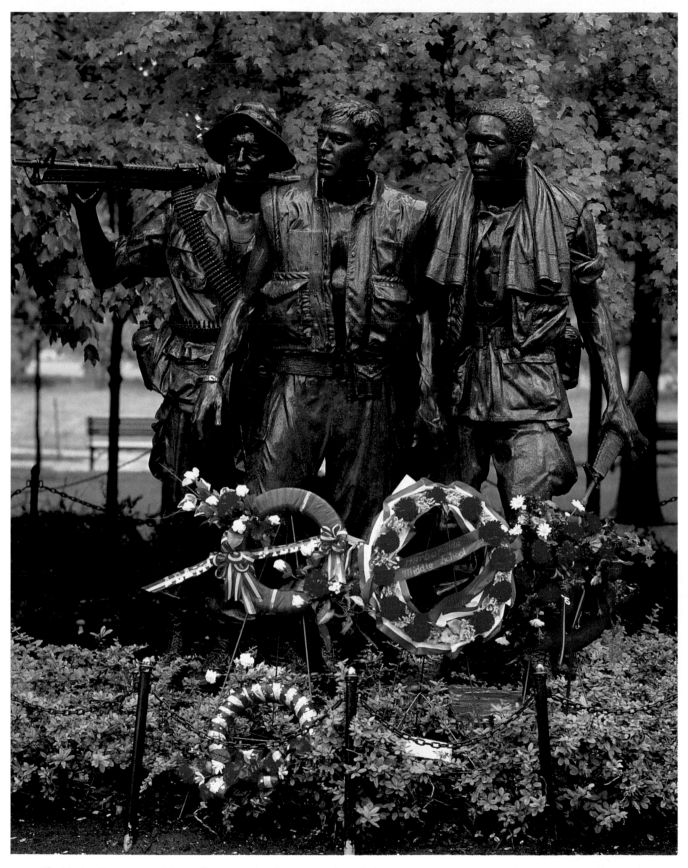

LEFT: *The Marine Corps Memorial at Arlington National Cemetery, also called Iwo Jima* ABOVE: *Statue, Vietnam Veterans Memorial*

OVERLEAF: *The graves of President John F. Kennedy and Jacqueline Kennedy Onassis, Arlington National Cemetery*

167 ～

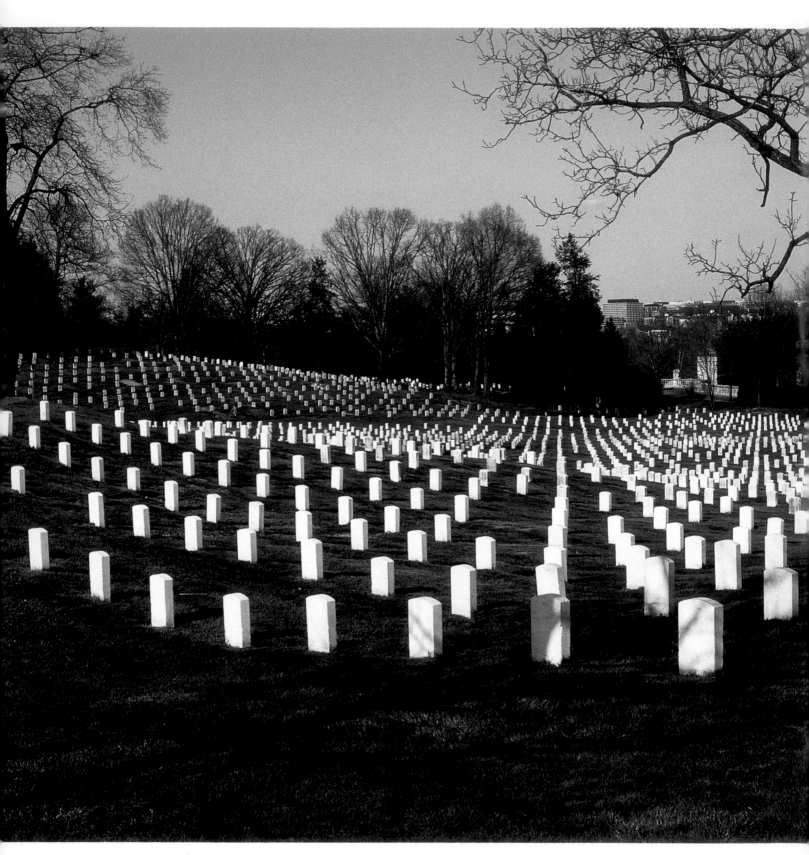

Arlington National Cemetery

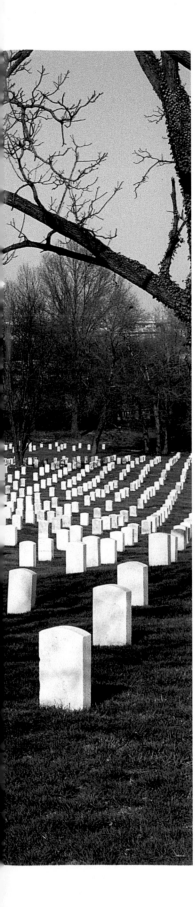

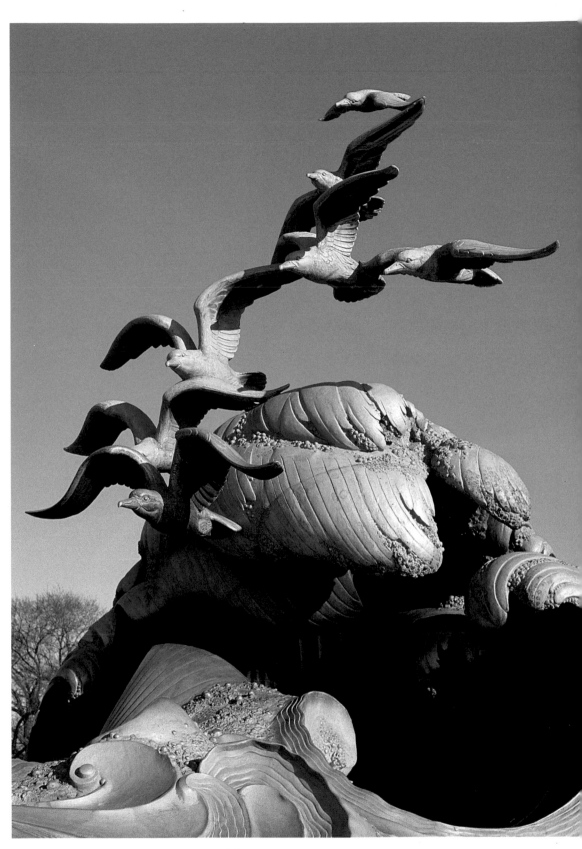

United States Navy and Marine Corps memorial

OVERLEAF: *Taking rubbings of names inscribed on the Vietnam Veterans Memorial*

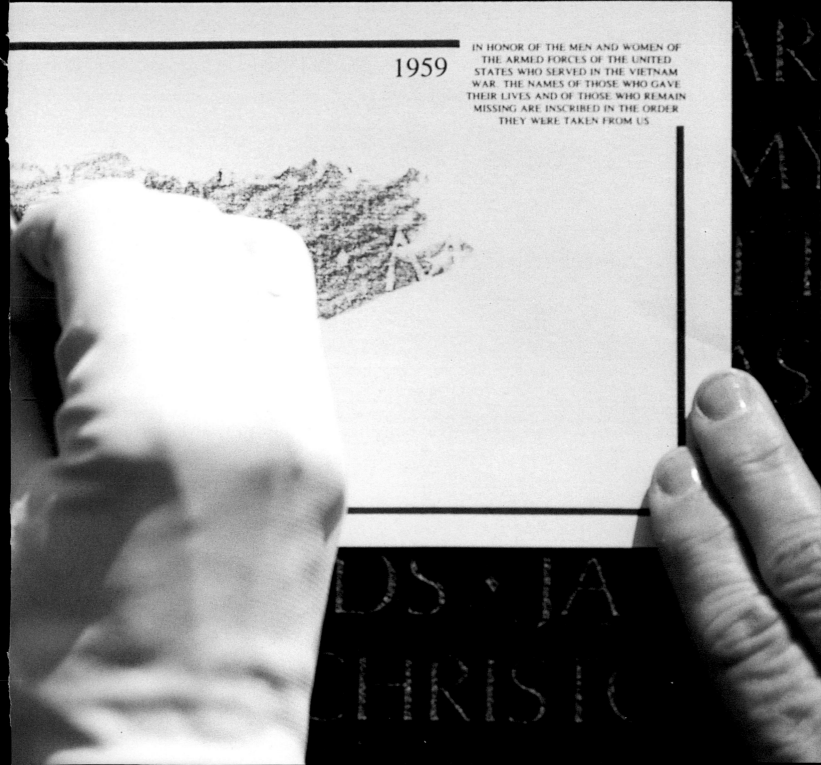

1959

IN HONOR OF THE MEN AND WOMEN OF
THE ARMED FORCES OF THE UNITED
STATES WHO SERVED IN THE VIETNAM
WAR. THE NAMES OF THOSE WHO GAVE
THEIR LIVES AND OF THOSE WHO REMAIN
MISSING ARE INSCRIBED IN THE ORDER
THEY WERE TAKEN FROM US

McCUISTON • ROBERT J NELSON • JOHN S GREEMANN • GEORGE W PEARSON Jr • JOHN D PLUMME
CHAEL E POLIQUIN • FRANKLIN D ROWELL • RUSSELL M RUFFNER Jr • DENNIS F SHINE • GUS SIAMBONE
• GERALD L SILVERSTEIN • ROBERT N SMITH • ROBERT G SOLOMON • PAUL A SPARKS • JOHN W VOYLE
▮BERT J WAGNER • JAMES R WALLAC▮ ▮MARK H WARD • JOHN R WATTS • PHILIP M WERBIS
ALD F WOOD • LEONARD J ZIGALLA • RICHARD T ALBERT • THOMAS W BAZEMORE • LESTER J BRANTLE
E BUGAR Jr • DAVID L CAUSEY • FREDERICO V DELA CRUZ • MICHAEL G DEMORE • STANISLAW J DROZD
• BOBBY JOE EVERETT • DAVID T FORD • FRANCIS B GARGUS • MICHAEL GARLO • GARY D GRABE
• WILLIAM H HAND • CARL C HARRIS • JERRY W HILL • CHRISTOPHER A JACKSON • MILTON J MENDOZ
ARDO R LATORRE • JIMMY L JONES • JOSEPH H MUSSELMAN • RICHARD R McINTOSH • FRANK R NESTO
• RANDALL I ORTIZ • JOSEPH J PAPARELLO • CLYDE E PHIFER Jr • STEVEN M POE • MAXIE D REGISTE
• JAMES E RUTTAN • FRED A SLEMSEK • JAMES D SPILKER • ARTHUR STROYMAN • MARTIN L TABE
THOMPSON • DONALD D TRIPP • GORDON J TURPIN Jr • JAMES R WALDOWSKI • RAYMOND L WILCO
• JOHN W WILSON • ROGER D WRIGHT • DAVID R BAKER • JAMES H BROWN Jr • THOMAS L BUSCH
CONNORS • DENNIS A CUNNINGHAM • JAMES M EARLY • DENNIS L ENGLISH • RUPERT A FUNDERBURK
AMES L GORDON • MICHAEL L HARP • MICHAEL J HAVARD • CHARLES T HEINEMEIER • DANIEL P HOLTRE
EY L HULBERT • ROBERT A JONES • DANIEL J KIRCHGESLER • CHARLES R LE BOSQUET • RANDY JOE LUND
LIAM D MARTIN • MICHAEL N MASUEN • EUGENE L MILLER • WILLIAM MIRANDA • MAJOR B MORGAN
ES H PARKS Jr • RUDOLPH S PARRISH • LUIS E QUINTANA-SOTO • ROBERT T RAZZANO • JAMES C TOSH
DE C SHAW • AOULIULITAU F TAUFI • WILLARD D RICHARDSON Jr • ADOLPHUS N TYLER • RAY M BARKE
• JACKIE D BIRD Jr • CURTIS P CHALLBERG • MICHAEL T BOAT • BARRETT C BROWN • ALBERT J CARRIER
Y B BLAIR • HAROLD E CUSHMAN • LAWRENCE R DETWILER Jr • MICHAEL J DUGAS • EDMUND FURMA
BERTRAND R GAGNE • DENNIS A GATTI • JOHN M HILL • LAWRENCE R GOODMAN Jr • MICHAEL J GREG
ARD R GRINNELL • STUART F HEMP • LUIS MARTINEZ GONSALEZ • JOHN L HURD • ARTHUR H JOHNSO
• ROBERT L KETELAAR • PETER A KIDD • MOSES I KUAHIWINUI Jr • ADREN A LEE • ROBERT D LING
ID L WHITMAN • DANIEL H LOVE • DOMINICK J MADONNA • ANTHONY V MIONE • STEPHEN D MOOR
• PHILLIP G McCALL • JAMES E McWHORTER • JEFFREY C PETERSON • ROY K PETERSON • DERWIN B PIT
• THOMAS M RALSTON • ERIC D SALTZ • THOMAS R SAYERS • WILLIAM R SPEIGHT • DARRELL D TAYLO
ARD F TAYLOR • BENJAMIN T WALANGITANG • PETER LOPEZ • WILLIAM J ZELTNER III • WILLIAM C ADAM
N E CUNNINGHAM • JAMES A WINGERT • TOMMY G ELLIOTT • WILLIAM W ELLIS III • DENNIS M GILLERA
GURDCILANI • RICKEY W HALL • DENNIS C HUCKABY • HAYWARD K H PELEIHOLANI • RONALD A HUN
• KENITH L JARRELL • KENNETH D JOHNSON • JOE W NORWOOD • GEORGE M LABANISH • JAMES MAC
S M MATTOX • ALEXANDER M MORALES • FREDERICK C KINSLER Jr • JON E DAVIS • NORMAN L RICHAR
R ROMO • KENNETH E SINGER • JIMMY JOE TENORIO • PHILIP J VEVERA • JUAN LEON GUERRERE DUENA
• EDWARD AMBROSE • JAMES N STEEN • WILLIAM J ANDERSON Jr • BERNARD P BAILEY • JAMES R BEAT
• STANLEY R HONEA • JIMMY M DOLAN • DANIEL E FARAN • ROY A FRYMAN • GUADALUPE GALINDO
M F GOLLIDAY • DENNIS L HENRY • WILLIAM D KAYGA • JOSEPH J MILANO • LENARD F MOEGGENBO
• ROY D McLENNAN • JESUS DIEZ NIETO Jr • GARY A OHMAN • JOSE ANGEL ORTIZ • WILLIAM F RIDO
BBY LEE ROBERTS • JOSE F ROSADO-BORGES • CHARLES H SCHAEFER • ROBERT C SC▮▮▮ ▮ARRY SHE
M SKOGERBOE • RICHARD A ANDERSON • BOBBY LEE TARTER • RICHA▮▮ ▮ WHITE • ▮▮▮MMERMA
• LA BROSSIE L BAKER • BARRY B COERS • THOMAS J DOSTAL • JAMES A ▮▮NCIS ▮▮▮▮N
RY L GEIB • TERRANCE N GENTRY • EDWARD R GRUSCZYNSKI • HERBERT ▮ ▮▮▮▮▮ ▮ANDE
E BEBOUT • ALLEN L HITES • DIXON T KINARD • PAUL F KOSTICK • MICHA▮L ▮ ▮▮▮ ▮▮AW L
DAVID M MILLER • MICHAEL G McGILL • DAVID E NELSON • DONALD W ▮
• GERALD J ROSSOW • ROBERT A RYAN • STEVEN R SANDERS • JOHN
HARD P SHELTON • JAMES STINGLEY • ALAN P STRAZZANTI • EARNEST
GUY A BLANCHETTE • DON C BROWN • GARDNER J BROWN • DENNIS
W COCKERHAM Jr • MERLIN J CRAIG • WILHIMON GARDNER • RICHARD
• GARY G GRAY • ROGER T GUEST • GEORGE E HENRY • N▮
• GUY M INKEL • VERLON D KING Jr • JIMMY T MORRIS • W
ONALD E NELSON • JUAN R PEREZ-PADIN • JOSEPH J PINTO • JAMES
RICHARDSON Jr • RUBEN RIVERA • MARSHALL E ROBERTSO
JAMES R SHIPMAN • FRANKIE STANLEY • RUSSELL A TAYL
• CHARLES L BALDWIN • LEROY L BELL • LESLIE
PETER H McMURRAY • RODGER L JAMESON • DUANE D LAND▮S

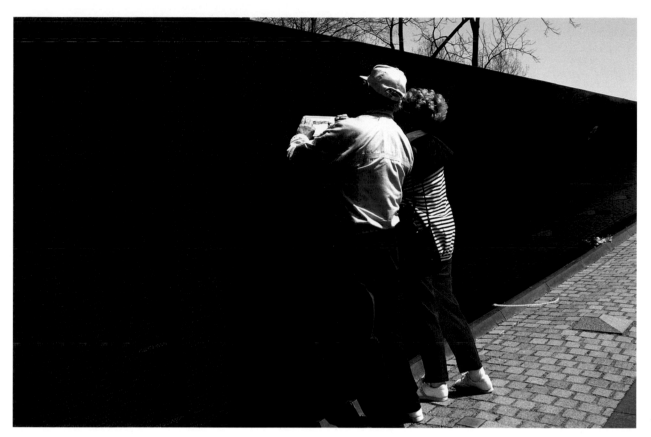

LEFT AND ABOVE: *The Vietnam Veterans Memorial*

OVERLEAF: *The Supreme Court*
SECOND OVERLEAF: *The Court Chamber in the Supreme Court; Painting of
the Battle of Lake Erie by William H. Powell, east staircase of the Senate*

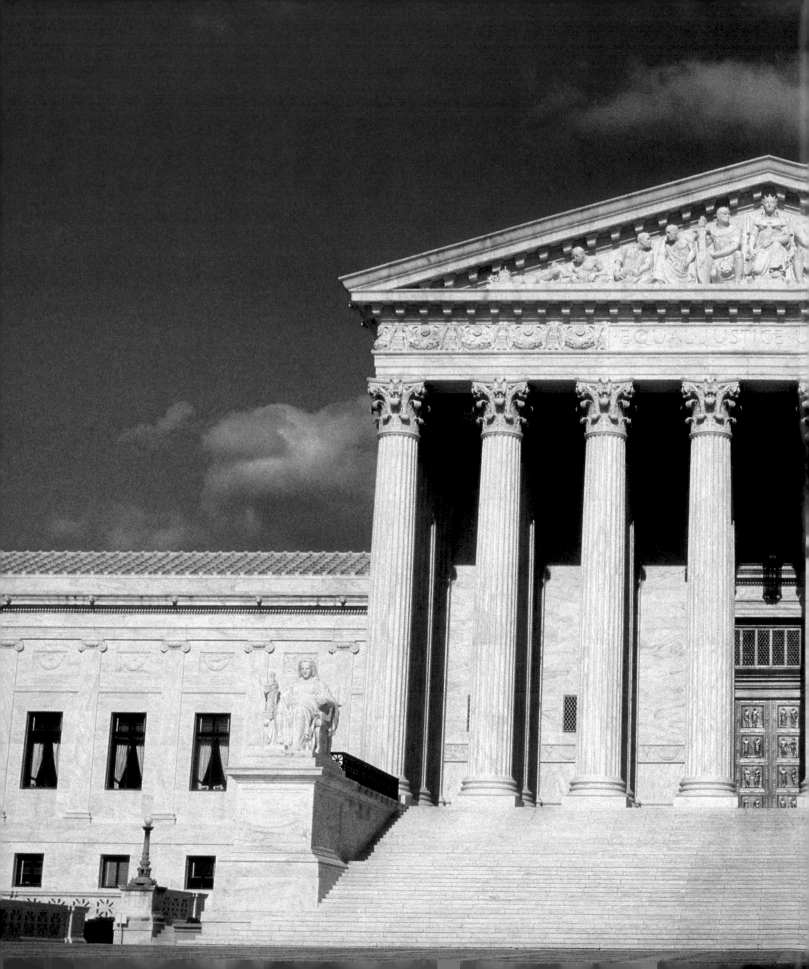

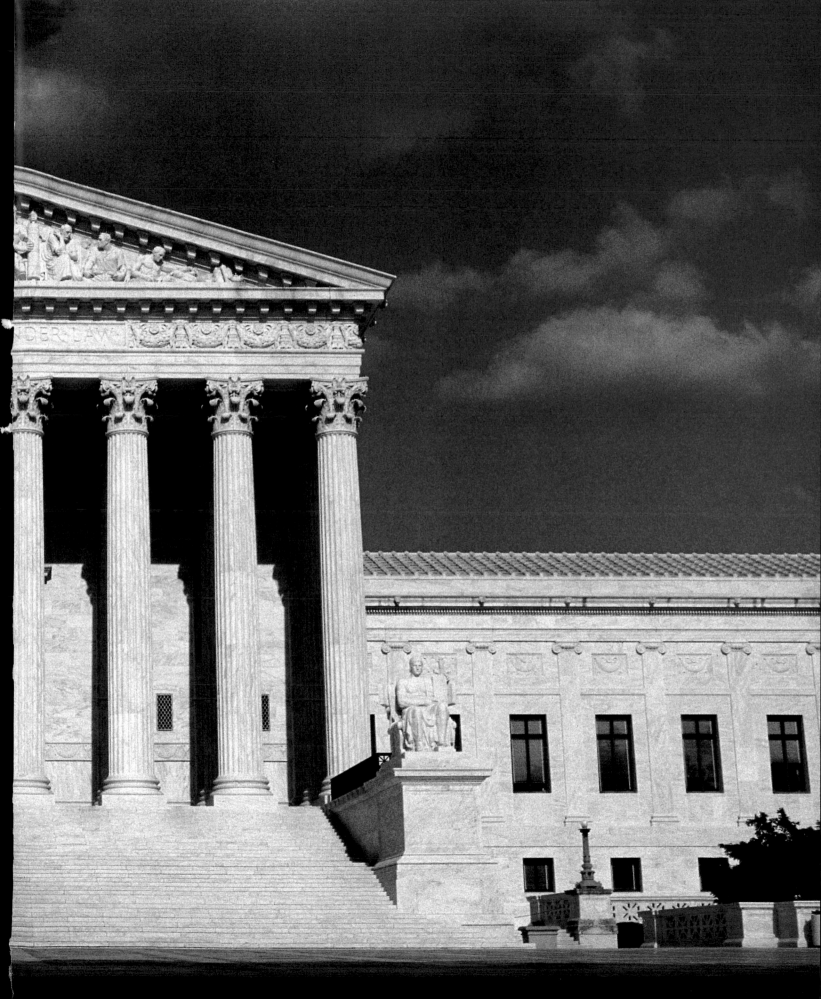

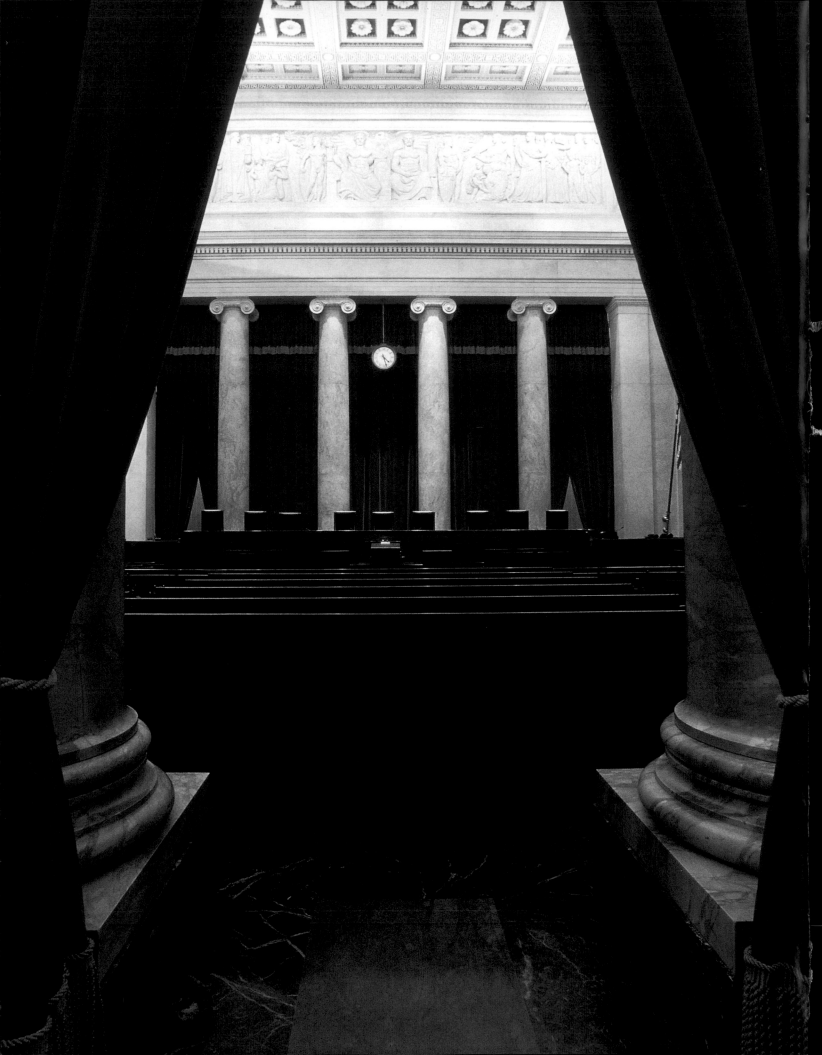

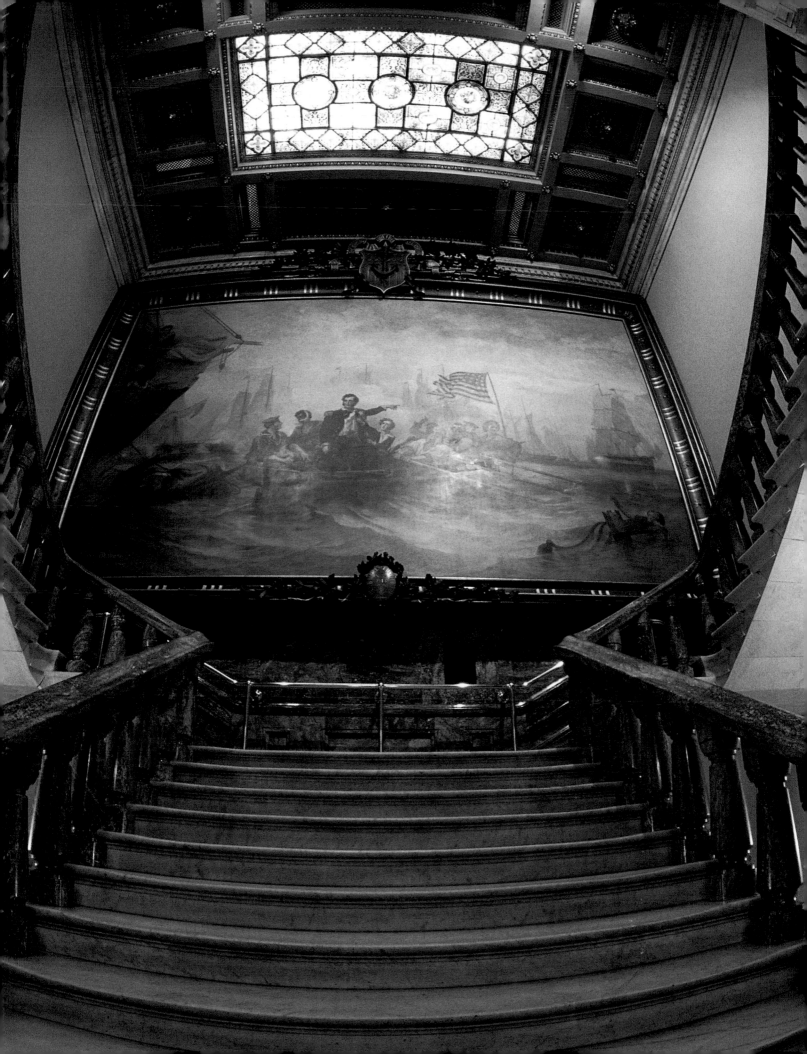

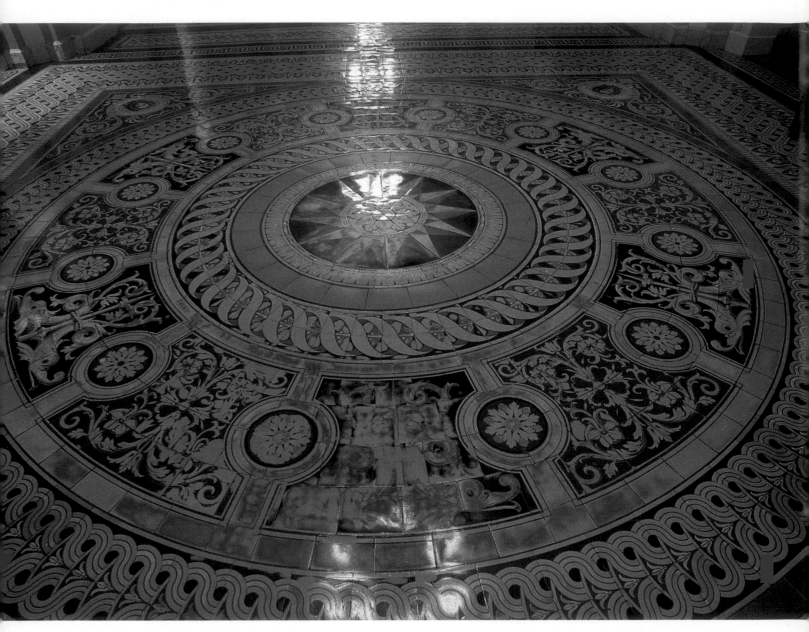

Ornate floor of the Senate Gallery

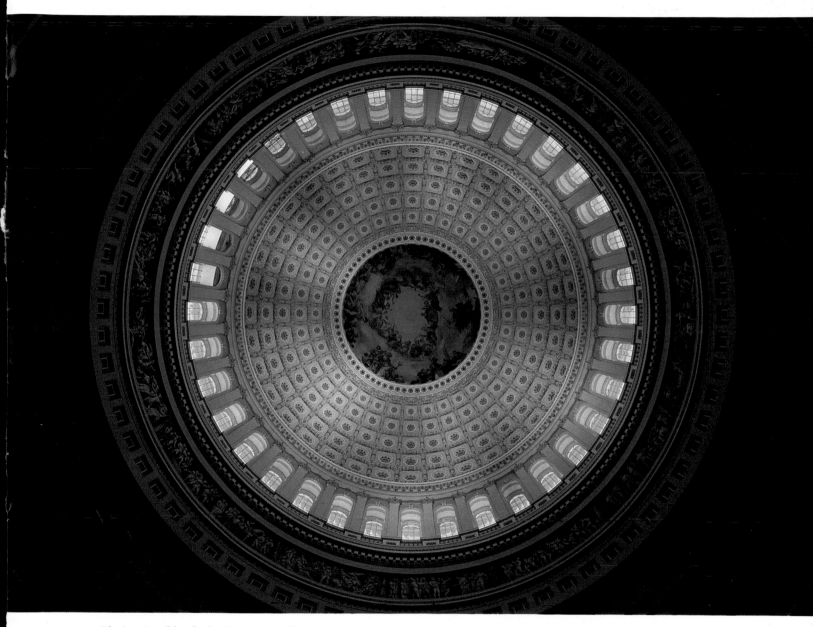

The interior of the 180-foot-high dome of the Capitol

OVERLEAF: *Statuary Hall, the Capitol*

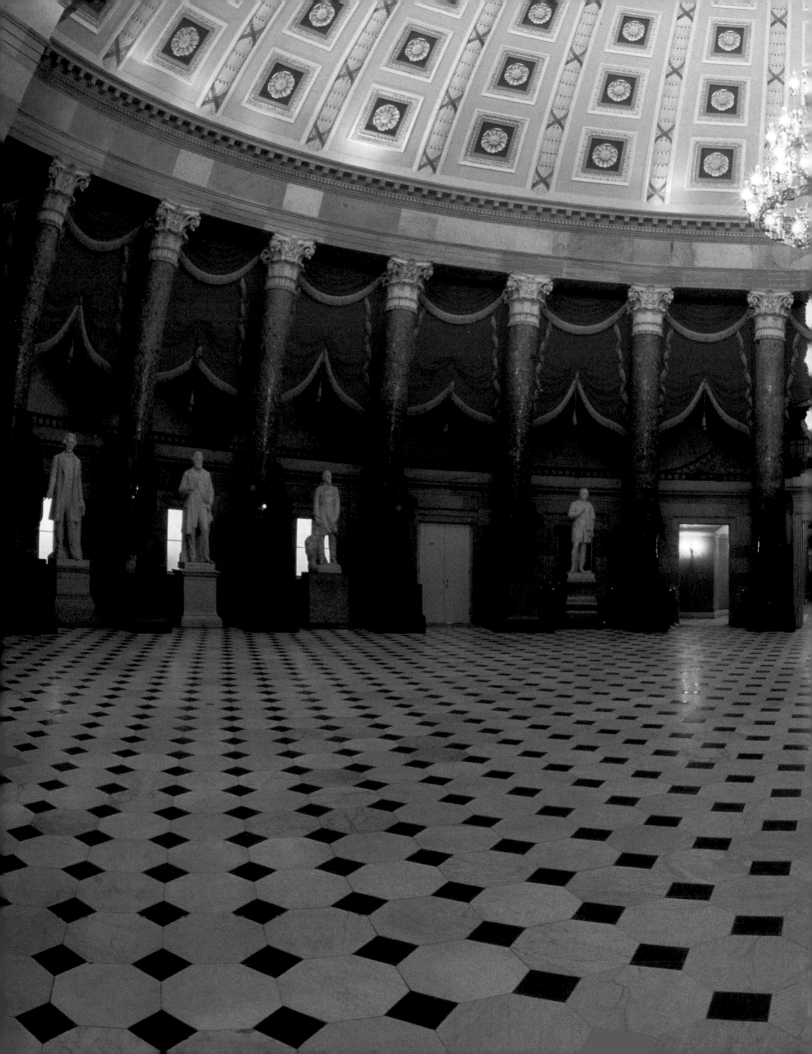

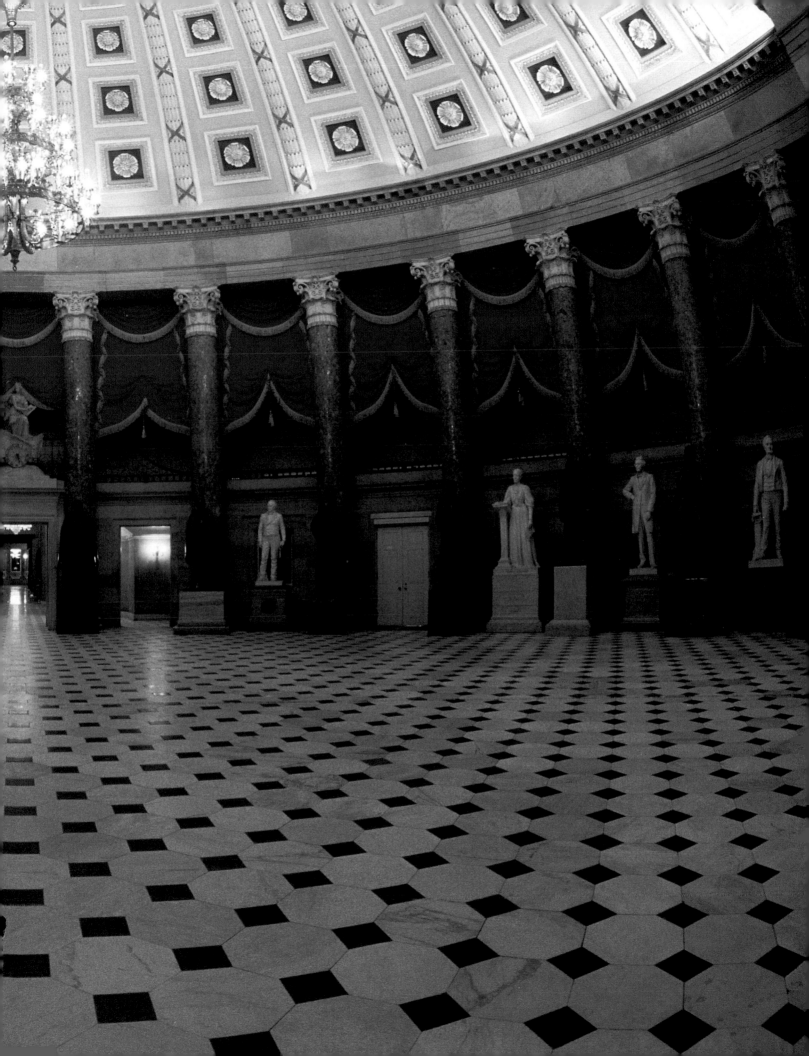

ABOVE: *Telephone in the Vice President's office*
RIGHT: *Office of the Vice President*

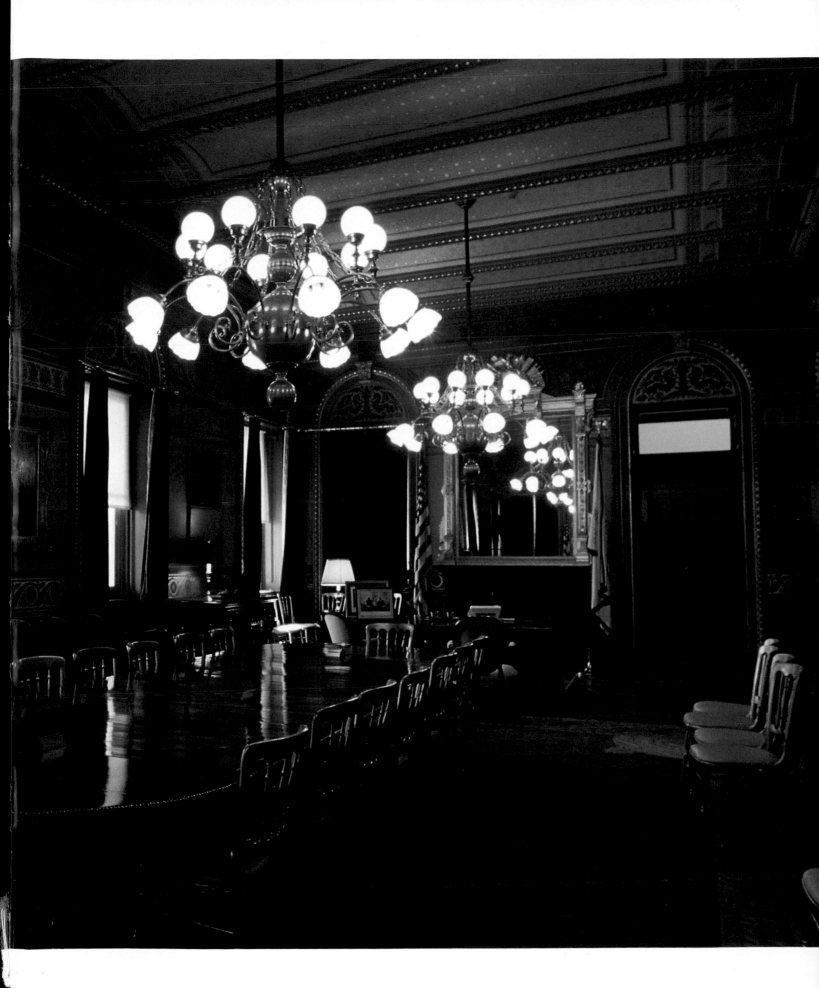

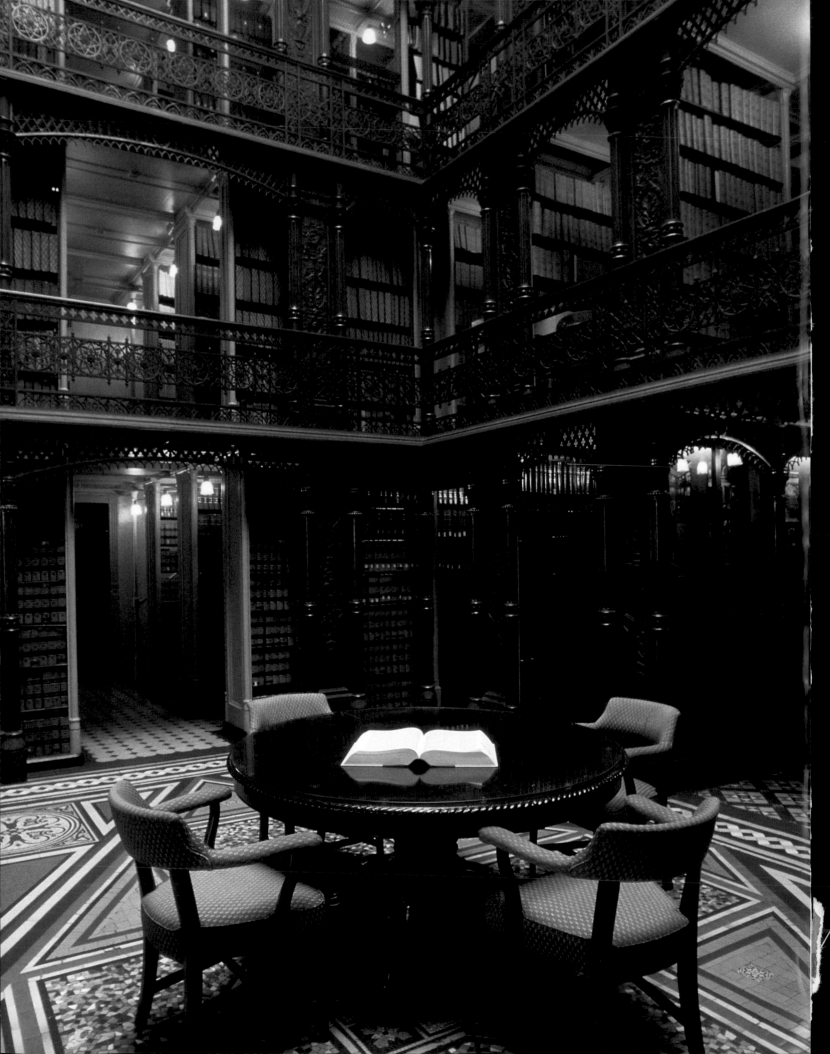

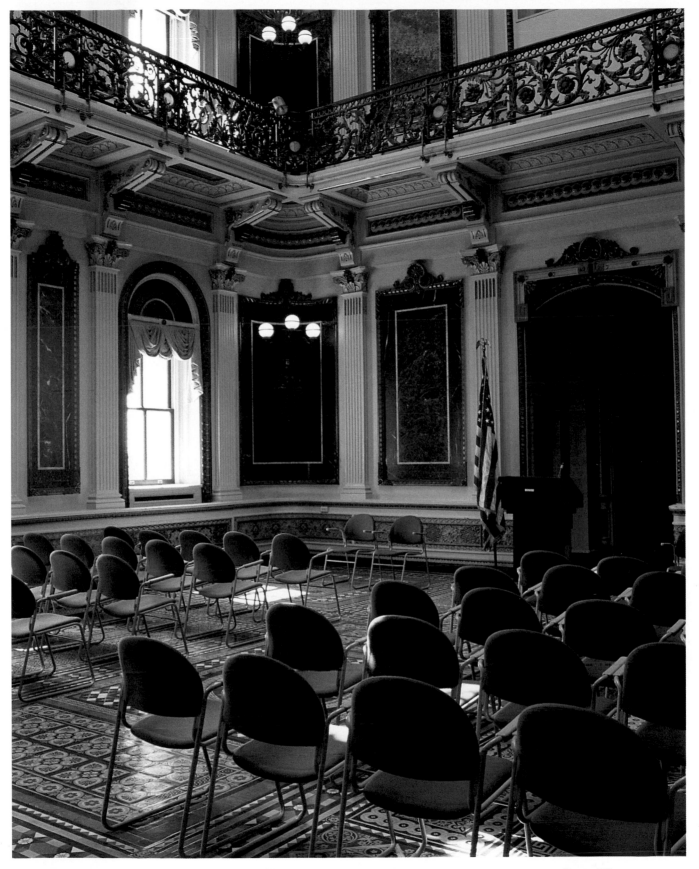

LEFT: *The law library in the Old Executive Office Building* ABOVE: *The Indian Treaty Room in the Old Executive Office Building*

OVERLEAF: *The White House* SECOND OVERLEAF: *The official Presidential seal*

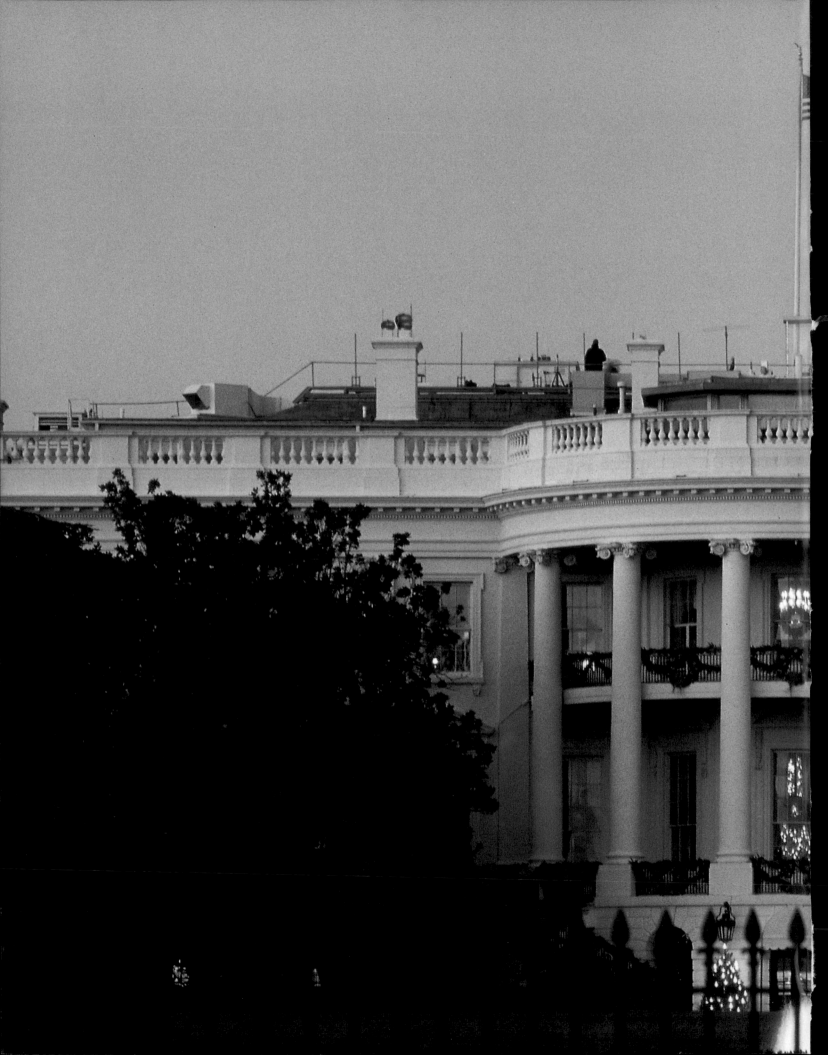

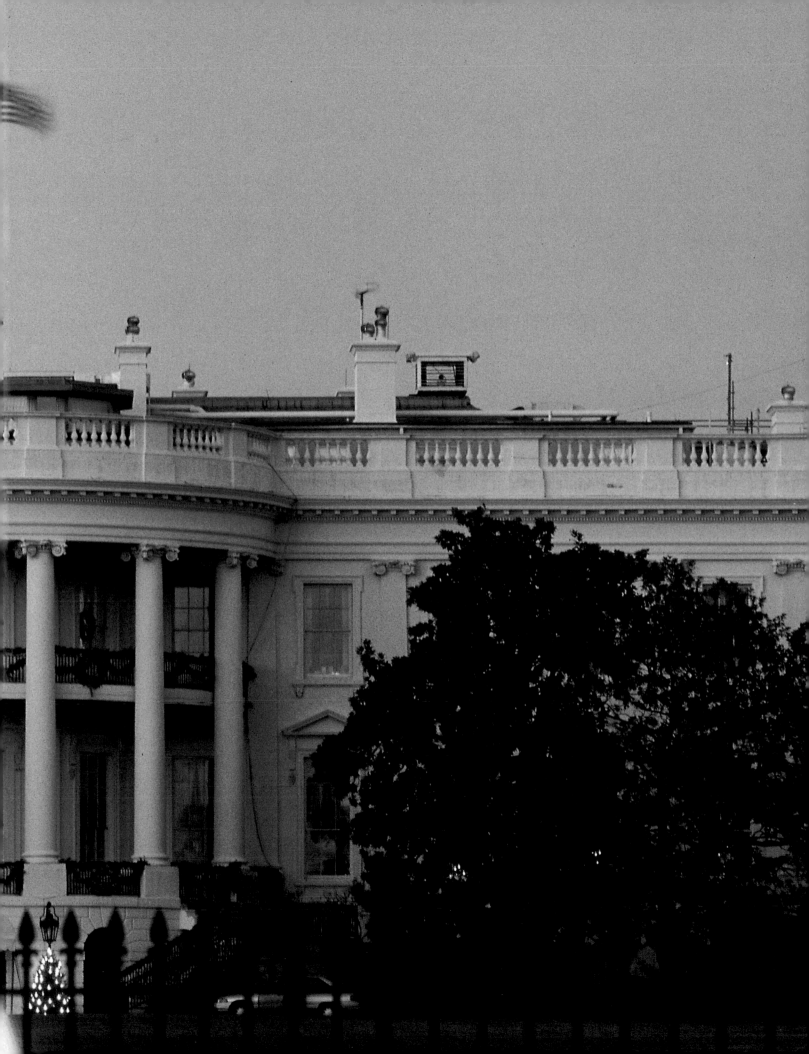

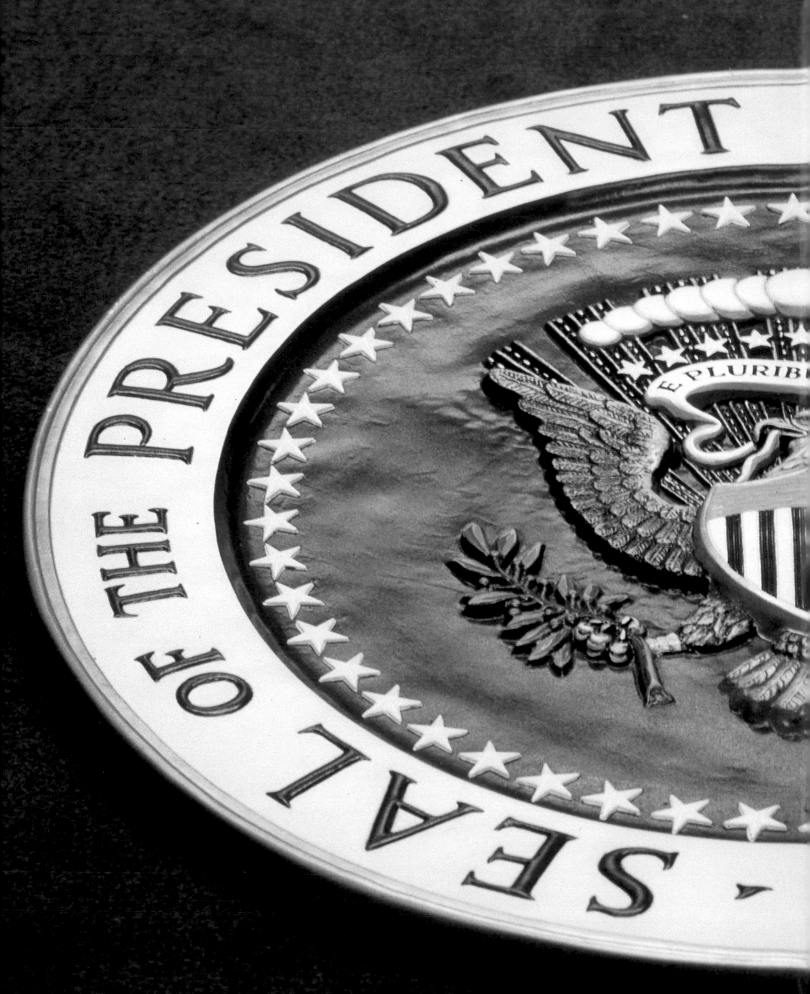

Photo by Melo Cicala

Santi Visalli

BIOGRAPHIES

Award-winning photojournalist Santi Visalli was born in Messina, Sicily, and has lived in the United States since 1959. His photographs have appeared in *Time, Newsweek,* and the *New York Times,* as well as in other leading newspapers and magazines throughout the world. Mr. Visalli is currently president of the Foreign Press Association of New York. In 1996, Santi Visalli was bestowed with the title of Knight in the Order of Merit of the Republic of Italy.

Diane Rehm is the host and executive producer of *The Diane Rehm Show,* described by *Newsweek* as one of the leading talk programs in the country. A native Washingtonian, Diane Rehm began her radio career in 1973 and has earned wide recognition for outstanding achievements in broadcast journalism. Originating at WAMU-FM, Washington, D.C., Diane Rehm's show is heard nationally on National Public Radio and in Europe via America One.

ACKNOWLEDGMENTS

Washington, D.C. evokes all the flair and grandeur of the great cities of Europe. With its heroic monuments and world-class museums, its large boulevards, its government office buildings, and its dignified, ever-present equestrian statues, Washington, at every turn, reminds you that this is not only America's capital, but also a primary center of world power.

In dealing with the people of Washington, one develops the sense of a bureaucratic, varyingly efficient, way of doing things. With the help of some friends, I was able to meet the pressure of deadlines and to complete this important assignment. For their valuable assistance, I would like to thank Ambassador Luigi Einaudi and the director of the National Park Service, Mr. Roger Kennedy. Special thanks also go to Mr. Abrahim Fahmy, General Manager of the Sheraton Carlton for his generous hospitality and to the Freedom Forum for the use of their roof, as well as to all the establishments appearing in this book.

I also extend sincere appreciation to the following individuals: Jacob Gillespie, Director of the U.S. Foreign Press Center, Andrew D. Frank, Managing Director of the New York Foreign Press Center, Dario Mariotti, Marco Troiano, Pino Cicala, Franco Nuschese, and my two assistants, Michele Troiano and Massimo Marolo. A particular thank you goes to Melo Cicala, who helped me from the very first day to the final completion of this book.

At Universe and Rizzoli, I extend sincere appreciation to Heather Keller, Charles Miers, James Stave, Elizabeth White, and to the many others for their contributions, together with my gratitude to the book's designers, Jenny Chan and Cynthia Flaxman. Finally, a very special thank you to Diane Rehm for her thoughtful foreword to this book and for putting into words what this great city means to us.